Canon® EOS Rebel T1i/500D Digital Field Guide

Charlotte K. Lowrie

WILEY

Wiley Publishing, Inc.

Canon® EOS Rebel T1i/500D Digital Field Guide

Published by
Wiley Publishing, Inc.
10475 Crosspoint Boulevard
Indianapolis, IN 46256
www.wiley.com

Copyright © 2009 by Wiley Publishing, Inc., Indianapolis, Indiana

Published simultaneously in Canada

ISBN: 978-0-470-52128-1

Manufactured in the United States of America

10 9 8 7 6 5 4 3 2 1

For general information on our other products and services or to obtain technical support, please contact our Customer Care Department within the U.S. at (877) 762-2974, outside the U.S. at (317) 572-3993 or fax (317) 572-4002.

Wiley also publishes its books in a variety of electronic formats. Some content that appears in print may not be available in electronic books.

Library of Congress Control Number: 2009929460

WILEY

About the Author

Charlotte K. Lowrie is a professional editorial, stock, and portrait photographer and award-winning writer based in the Seattle, Washington, area. Her writing and photography have appeared in numerous magazines, newspapers, books, and on Web sites. She is the author of 10 books including the best-selling *Canon Rebel XSi Digital Field Guide* and the *Canon EOS 50D Digital Field Guide*, and she is the coauthor of *Exposure and Lighting for Digital Photographers Only*.

Charlotte also teaches monthly photography courses at BetterPhoto.com. Her images have appeared on the Canon Digital Learning Center Web site, and she is a featured photographer on www.takegreatpictures.com. You can see more of her images on wordsandphotos.org.

Credits

Acquisitions Editor
Courtney Allen

Project Editor
Jama Carter

Technical Editor
G. Smith

Copy Editor
Kim Heusel

Editorial Director
Robyn Siesky

Editorial Manager
Cricket Krengel

Vice President and Group Executive Publisher
Richard Swadley

Vice President and Executive Publisher
Barry Pruett

Business Manager
Amy Knies

Senior Marketing Manager
Sandy Smith

Senior Project Coordinator
Kristie Rees

Graphics and Production Specialists
Ana Carrillo
Andrea Hornberger
Clint Lahnen
Jennifer Mayberry

Quality Control Technician
Jessica Kramer

Proofreading and Indexing
Penny Stuart
Broccoli Information Mgt.

I dedicate this book to my family, who has patiently endured missed dinner plans and holiday get-togethers while I finished just one more chapter of the book.

Acknowledgments

Every book is a team effort, and I couldn't ask for a better team to work with than the Wiley team. So Jama Carter, Courtney Allen, and Barry Pruett, thanks so much for your support and wonderful expertise in making this book happen.

Contents

Chapter 2: Using the EOS Rebel T1i/500D 41

Chapter 3: Getting Great Color 85

Chapter 4: Using Live View 107

Chapter 5: Using Movie Mode 119

Chapter 6: Customizing the EOS Rebel T1i/500D 129

Part II: Doing More with the EOS Rebel T1i/500D 143

Chapter 7: Using Flash 145

Chapter 8: Exploring Canon Lenses and Accessories 159

Chapter 9: The Elements of Exposure and Composition 177

Chapter 10: In the Field with the EOS Rebel T1i/500D 195

Part III: Appendixes 223

Appendix A: Downloading Images and Updating Firmware 225

Introduction

Welcome to the *Canon EOS Rebel T1i/500D Digital Field Guide.* Now that you have the newest and most advanced Rebel, the creative world of photography is at your fingertips promising hours of personal and professional enjoyment and beautiful images. Only a few years ago, the idea of an affordable 15.1-megapixel camera was unheard of; but today, you have not only 15.1 megapixels of resolution but also the ability to instantly switch from still shooting to shooting high-definition video clips, all using a single camera. Clearly, the Rebel T1i/500D opens the door to great creative expression for photographers, and this book is written to help you use the Rebel to its full capability.

Like its predecessors, the Rebel T1i/500D is very approachable with easy-to-use controls and camera menus, a big 3-inch high-resolution LCD, and a small, lightweight footprint. Under the hood, Canon has packed the latest technology including its DIGIC 4 image processor with 14-bit processing for smooth tonal gradations and rich color, an expanded ISO range up to ISO 12800, Live View and Movie shooting, customizable menus and Picture Styles, and the new Creative Auto shooting mode to help you get professional-looking results without needing in-depth knowledge about exposure controls. So regardless of your skill level, the Rebel makes getting great images — and videos — easy and fun.

The automatic modes of the camera replicate those on point-and-shoot cameras so that you can get started shooting with the Rebel just as soon as the battery is charged. But from my experience teaching photography courses, most Rebel photographers already know how to point and shoot. Rather, they are anxious to begin using the creative modes and controls of the camera. And that's what this book is designed to help you do.

In this book, you'll first learn to navigate and use the Rebel camera controls and menus, and then you'll explore photographic exposure, including what to look for in a good exposure and how to use the Rebel to get it. The Rebel also has several controls to help you get great color, and those controls are detailed in Chapter 3. From there you'll learn how to shoot in Live View and Movie modes, and how to customize the camera for different scenes and uses.

Then we move to using the built-in and an accessory flash in Chapter 7. Part of the advantage of shooting with the Rebel is that you can use more than 60 Canon lenses, and Chapter 8 discusses different types of lenses and what to expect from them. In Chapter 9, readers who are new to photography can get an overview of the basics of photographic exposure including an introduction to ISO, aperture, shutter speed, and how they work together. In addition, this chapter includes an introduction to classic composition techniques.

Finally in Chapter 10, you'll learn how to use multiple controls and options on the Rebel in specific shooting scenarios. Five types of common shooting areas are detailed with sample images, camera setup and exposure information, as well as tips for shooting on your own. Also, be sure to explore the appendixes for additional helpful information.

I hope that this book not only helps you master using the Rebel T1i/500D, but that the learning process will be a rewarding and enjoyable journey for you. The editor, the staff at Wiley, and I hope that you enjoy reading and using this book as much as we enjoyed creating it for you.

Quick Tour

QT

Your Canon EOS Rebel T1i/500D provides a gateway into a creative world of visual fun and excitement, and this book is designed to help you get the most from the camera. If you're new to digital photography, the thought of learning the camera may seem daunting, but the Rebel T1i/500D is designed to be easy to learn without sacrificing creative freedom. You have a powerful tool to improve your photography skills and your pictures. If you're an experienced photographer, the Rebel T1i/500D gives you complete control over the final image with features found on more expensive Canon digital single lens reflex (dSLR) cameras.

This Quick Tour introduces shooting modes so that you can begin shooting and have a little or a lot of control over the Rebel as well as provides basic setup tasks.

Choosing a Shooting Mode

The Rebel offers a bridge for those who are moving up from a point-and-shoot camera to a dSLR. If you fall into this category, then the automatic shooting modes provide simplicity that's similar to point-and-shoot cameras without requiring you to know the technical aspects of photography. On the other hand, the Rebel also offers the full creative control that's demanded by advanced photographers. The Rebel T1i/500D's Mode dial reflects the camera's dual appeal. The Mode dial groups fully automatic modes on one side of the dial for those who are making the transition to dSLR shooting. The opposite side of the Mode dial groups the semiautomatic and manual modes that advanced photographers expect. And between these groupings is the new Creative Auto mode that gives you more control without needing to understand advanced aspects of photography to get great results.

One of the first steps in shooting with the Rebel T1i/500D is choosing a shooting mode.

/**Note** Depending on the shooting mode that you choose, the menu items and the number of camera options change. You can choose more options in the semiautomatic and manual shooting modes than in the automatic shooting modes.

Automatic/Basic Zone shooting modes

If you are new to using a dSLR, then the Rebel T1i/500D helps you make the transition easily. Many newcomers to the Rebel T1i/500D begin shooting using the automatic shooting modes. Canon refers to these modes as Basic Zone modes. These modes are grouped on the Mode dial, and they are represented with icons such as a person's head to depict Portrait mode, a runner to designate Sports mode, and so on. Icons are not used for two automatic modes: Full Auto, which is designated by a green rectangle, and Creative Auto, which is designated by the letters CA within a rectangle.

In addition to Full Auto and Creative Auto, other automatic modes map to commonly photographed scenes and subjects. The modes are: Portrait, Landscape, Close-up, Sports, Night Portrait, and Flash off.

/**Note** Movie mode is next to the Flash off mode, and it is described in detail in Chapter 5.

Using the automatic modes is a good way to get comfortable handling the Rebel T1i/500D and to get a good sense of the look and feel of its images. Images taken in these modes are programmed to produce classic photographic effects based on the mode you choose.

/**Note** To learn more about aperture as well as the other elements of photographic exposure, see Chapter 9.

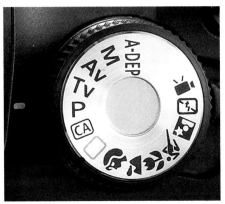

QT.1 Turn the Mode dial to set the shooting mode that you want to use. Full Auto mode, denoted as a green rectangle on the Mode dial, is a good starting point for quick snapshots.

To use the automatic modes, turn the Mode dial to the green rectangle (Full Auto mode), or to one of the modes that has an icon that looks like the scene you want to photograph. Then you use the Rebel T1i/500D in much the same way that you use a point-and-shoot camera with the advantage of being able to change lenses.

Creative Zone shooting modes

Experienced photographers will migrate to the creative side of the Mode dial where semiautomatic and manual shooting modes offer control over some or all exposure settings. These modes give you control over some or all of the exposure settings, and they enable you to control the AF point, AF mode, Drive mode, Metering mode, white balance, and more. In other words, you have full control in the Creative Zone shooting modes.

 Cross-Reference *For a complete discussion of Creative Zone modes, see Chapter 2.*

Here is a brief summary of the Creative Zone modes. Just turn the Mode dial to the shooting mode you want.

✦ **Program AE.** This mode is shown as P on the Mode dial and is a semiautomatic, but *shiftable* mode. Shiftable means that you can temporarily change the camera's suggested exposure by turning the Main dial. To shift the suggested exposure, turn the Main dial. The aperture and shutter speed both shift to an equivalent exposure as you turn the dial. Then after you make the picture, the camera reverts to its original suggested exposure. Use this mode any time you want to change the camera's suggested exposure settings with a minimum of camera adjustments.

✦ **Shutter-priority AE.** This mode is shown as Tv (Time value) on the Mode dial. In this mode, you set the shutter speed, and the camera automatically chooses the aperture. To use Tv mode, turn the Main dial to set the shutter speed you want. This is the mode of choice for controlling whether action is shown frozen with a fast shutter speed or blurred with a slow shutter speed.

✦ **Aperture-priority AE.** This mode is Av (Aperture value) on the Mode dial. In this mode, you set the aperture (f-stop) and the Rebel automatically sets the appropriate shutter speed. To use Av mode, turn the Main dial to set the aperture (f-stop) that is displayed in the viewfinder. Choose Av mode to control whether the background is shown as a blur or with acceptably sharp details.

✦ **Manual exposure.** This mode is shown as M on the Mode dial. In this mode you set both the shutter speed and the aperture. To use M mode, turn the Main dial to set the shutter speed. Then press and hold the Aperture/Exposure Compensation button on the back of the camera (denoted as Av) and turn the Main dial to set the aperture (f-stop). In the viewfinder, the marker at the bottom of the exposure level meter moves as you change the aperture. If you want to use the camera's suggested exposure, adjust the shutter speed and aperture until the marker is at the center point of the exposure level meter. This is the mode to use for advanced exposure techniques, for fireworks, celestial shots, and anytime you want to override the camera's suggested exposure.

✦ **Automatic depth of field.** This mode is shown as A-DEP on the Mode dial. It automatically calculates the best depth of field between near and far subjects. To use A-DEP mode, focus on the subject by pressing the Shutter button halfway down. The camera automatically selects the near and far points in the scene and determines the aperture that will give the maximum depth of field. Be sure to check the shutter speed in the viewfinder because it can be very slow. If the shutter speed is slow, stabilize the camera on a tripod or a solid surface. This is a great mode when the subject elements are at varying distances, and you want the most extensive depth of field possible.

 Cross-Reference *For an introduction to exposure basics, see Chapter 9.*

When you're ready to shoot, bring the camera to your eye and compose the image in the viewfinder. Unlike point-and-shoot cameras, you cannot compose by watching the scene in the LCD unless you're shooting in Live View mode. Press the Shutter button halfway to focus on the subject, and then press it completely to make the picture. Selecting an Autofocus (AF) point is discussed later in this Quick Tour.

Setting the Date and Time

Setting the date and time provides a handy record that you can use to recall when you took pictures, and using the date can help you organize pictures on the computer. When you first turn on the camera, it displays the Date/Time menu for the first setup.

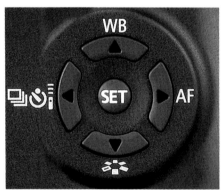

QT.2 The four keys on the back of the camera are collectively referred to as the cross keys. They function differently depending on whether you are setting camera functions, choosing menu items, or playing back images.

To set the date and time, follow these steps:

1. **Press the Menu button, and then press the right cross key to select the Setup 2 (yellow) menu.**

2. **Press the down cross key to select Date/Time, and then press the Set button.** The Date/Time screen appears with the month control field highlighted.

3. **Press the Set button.** The Month field is activated.

4. **Press the up or down cross key to change the month, and then press the Set button.**

5. **Press the right cross key to move to the next field, then press the Set button, and then press the up or down cross key to change the remaining entries.**

6. **Press the Set button to select OK.** The Setup 2 menu appears. Lightly press the Shutter button to return to shooting.

Setting the Image Recording Quality

The file format and quality level that you use to take your pictures are two of the most important decisions that you can make. These settings ultimately determine not only the number of images that you can store on the media card but also the sizes at which you can later print images from the Rebel T1i/500D. The higher the image quality that you choose, the larger and better quality the print that you can make.

 Note *RAW images, unlike JPEG images, have little or no in-camera process- ing applied. As a result, you must convert RAW images in a program that supports Canon's RAW files, such as Canon's Digital Photo Professional. RAW files are denoted with a .CR2 file extension.*

To set the image recording quality, follow these steps:

1. **Press the Menu button, and then select the Shooting 1 (red) menu.**

2. **Press the up or down cross key to select Quality, and then press the Set button.** The Quality menu appears.

3. **Press the right or left cross key to select the option that you want, and then press the Set button.** Large/Fine is the highest quality JPEG setting. Each subsequent set- ting, such as Large/Normal, repre- sents smaller file sizes with higher JPEG compression ratios. Alternately, you can select RAW or RAW + JPEG (Large Fine).

4. **Press the Set button.**

 Cross- Reference *See Chapter 1 for details on JPEG quality settings.*

Setting the ISO

In simple terms, the ISO setting determines how sensitive the Rebel T1i/500D image sensor is to light. The higher the ISO num- ber, the less light that's needed to make a picture. You can select the ISO when you're shooting in P, Tv, Av, M, and A-DEP modes.

In Basic Zone modes such as Full Auto, Portrait, and so on, the camera automati- cally sets the ISO and you cannot change it.

QT.3 The ISO button is located just behind the Main dial on top of the camera.

Cross- Reference *For more details on ISO, see Chapter 2.*

To set the ISO, follow these steps:

1. **Turn the Mode dial to P, Tv, Av, M, or A-DEP shooting mode.**

2. **If the LCD is blank, press the Display (DISP.) button, and then press the ISO button on the top of the camera.** The ISO screen appears with settings from Auto, and 100 to 3200. If you choose Auto, the camera automatically selects an ISO setting from 100 to 1600 in all shooting modes except Portrait, Manual, and when using the built-in flash.

3. **Press the right or left cross key to select the ISO, and then press the Set button.** Alternately, you can forego pressing the Set button and let the screen turn off automatically. The setting you choose remains in effect until you change it.

Setting the White Balance

Setting the white balance tells the camera the type of light that is in the scene so that images have accurate color.

To change the white balance, follow these steps:

1. **Press the White Balance (WB) button on the back of the camera, and then press the left or right cross key to select the setting that matches the light in the scene.** You can also use the Automatic White Balance setting, which is designed to give accurate image color in any type of light.

2. **Press the Set button.** The setting you choose remains in effect until you change it, so be sure to change the white balance setting when you begin shooting in a different type of light.

Setting the Autofocus Mode and Autofocus Point

When you shoot in P, Tv, Av, Manual (M), or A-DEP shooting modes, you can select one of the following three Autofocus (AF) modes:

✦ One-shot AF mode for still subjects

✦ AI Focus AF for subjects that are currently still but may begin to move, such as wildlife or children

✦ AI Servo AF to track focus on moving subjects such as athletes, race cars, and so on

 When you shoot in the fully automatic Basic Zone modes, the camera automatically sets the AF mode, and you cannot change it.

To select an AF mode, follow these steps:

1. **Set the Mode dial to P, Tv, Av, M, or A-DEP.**

2. **Press the AF button on the back of the camera.** The AF mode screen appears.

3. **Press the left or right cross key to select the AF mode you want.** The mode you select remains in effect until you change it or switch to a Basic Zone mode.

The Rebel T1i/500D offers nine AF points. Selecting and using an AF point enables you to determine where the sharpest point of focus is in the image. You can set the AF point in Creative Zone modes.

 For details on AF modes, see Chapter 2.

In Basic Zone modes and in A-DEP mode, the camera automatically selects the AF point. In all Creative Zone modes except for A-DEP, you can select the AF point.

To manually select the AF point, follow these steps:

1. **Set the Mode dial to P, Tv, Av, or M shooting mode, and then press the AF-Point Selection/Magnify button on the back of the camera.** The button is at the top right of the back of the camera and is denoted by an icon that has a plus sign inside a magnifying glass below the button.

QT.4 The AF-Point Selection/Magnify button is at the top right of the back of the camera.

If you select this option, then the camera automatically selects the AF point or points for you just as it does in the automatic shooting modes such as Portrait, Landscape, and Close-up. If you want to ensure that the point of sharpest focus is precisely where you want it, then do not choose this option, but choose a single AF point.

2. **Watch in the viewfinder as you turn the Main dial until the AF point that you want is high-lighted.** As the camera cycles through the individual AF points, there is an option where all of the AF points are highlighted. This is the automatic AF-point option.

3. **Lightly press the Shutter button to dismiss AF-point selection mode, focus on the subject by pressing the Shutter button halfway down, and then press it completely to make the picture.** To ensure the sharpest focus, do not move the camera to recompose the image after you focus on the subject.

Exploring the EOS Rebel T1i/500D

◆ ◆ ◆ ◆

◆ ◆ ◆ ◆

Navigating and Setting Up the EOS Rebel T1i/500D

CHAPTER

1

One of the most important first steps in photography is learning the camera well enough that you can operate the camera without hesitation or searching for camera controls. Then you can make camera adjustments quickly and confidently without missing a shot. Knowing your camera and lens controls not only gives you confidence but also enables you to react quickly to get those important shots that you might otherwise miss or wish had been better.

The EOS Rebel T1i/500D is both easy and fun to master, and as you learn more about the Rebel you will also find that it offers complete creative control. Regardless of how much or how little you know, Canon's 15.1-megapixel CMOS (complementary metal-oxide semiconductor) sensor, DIGIC 4 image processor, and 14-bit tonal conversion deliver rich, sharp images, especially at the highest image-quality settings.

Roadmap to the Rebel T1i/500D

Chances are good that you've already been using the Rebel T1i/500D, so by now you know that the most frequently used camera controls are conveniently located for quick adjustment

as you're shooting. Less frequently used, but no less important, functions are accessible only via the camera menus. Study the following sections to familiarize yourself with the T1i/500D controls and menus. You can refer back to the figures at any time to locate the controls you need.

Front camera controls

On the front of the camera, the controls that you'll use most often are the Lens Release button and the Depth of Field Preview button. And, of course, you'll use the lens mount each time you change lenses. If you use Canon EF-S lenses, line up the white mark on both the lens and the lens mount. Canon EF lenses have a red mark instead, which matches up to the red mark on the lens mount.

From left to right, the buttons and indicator lamps are:

✦ **Shutter button.** This button sets focus, and it fires the shutter to make an exposure. To set the focus for the image, press the Shutter button halfway. To make the picture, press the Shutter button completely.

✦ **Red-eye reduction/Self-timer lamp.** When you have Red-eye reduction turned on, this lamp burns yellow to help reduce the subject's pupils to counteract red-eye in the final image. In self-timer modes, the yellow lamp lights or flashes depending on the self-timer mode, and a beeper sounds to count down the seconds to shutter release.

✦ **EF and EF-S lens mount index markers.** Use these markers on the lens mount to line up the lens when you mount it on the camera.

Use the red EF lens mount index for all lenses that have a red marker on the lens barrel, and use the white EF-S lens mount index for lenses that have a white marker on the lens barrel.

✦ **Built-in flash and Flash pop-up button.** The flash provides illumination either as the main light source or as a fill flash. In Basic Zone shooting modes such as Full Auto, Portrait, and so on, the flash fires automatically. In Creative Zone shooting modes including P, Tv, Av, M, and A-DEP, you have to press the Flash pop-up button to use the built-in flash.

✦ **Microphone.** The built-in monoaural microphone can be turned on to record sound when you're shooting movies. Sound levels are automatically adjusted.

✦ **Mirror.** The reflex mirror reflects the image into the viewfinder as you're composing the image, and then it flips up and out of the way of the optical path when you press the Shutter button completely to make the picture.

✦ **Depth of Field Preview button.** Press this button to stop down, or adjust, the lens diaphragm to the current aperture (f-stop) so that you can preview the depth of field in the viewfinder. The larger the area of darkness in the viewfinder, the more extensive the depth of field will be. At the lens's maximum aperture, the Depth of Field Preview button cannot be depressed because the diaphragm is fully open. The maximum aperture is the widest lens opening; for example, f/2.8 or f/4.5. The maximum aperture is determined by the

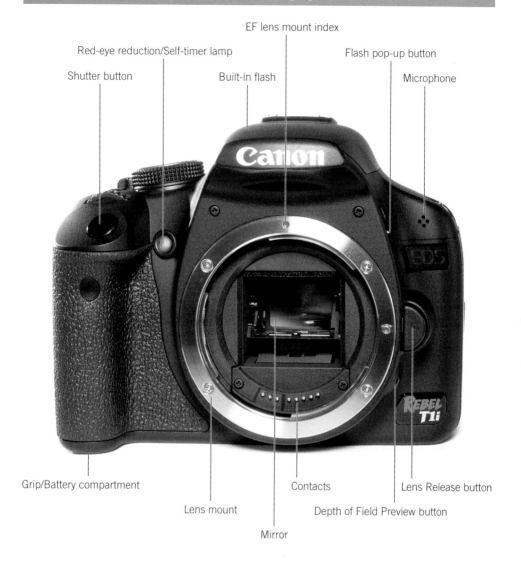

EF lens mount index

Red-eye reduction/Self-timer lamp

Flash pop-up button

Shutter button

Built-in flash

Microphone

Grip/Battery compartment

Contacts

Lens Release button

Lens mount

Depth of Field Preview button

Mirror

1.1 Rebel T1i/500D front camera controls

lens you're using. The aperture cannot be changed as long as the Depth of Field Preview button is depressed. You can also use the Depth of Field Preview button when you shoot in Live View mode.

✦ **Lens Release button.** Press this button to disengage the lens from the lens mount, and then turn the lens to the right to remove it.

Top camera controls

Controls on the top of the camera enable you to use your thumb and index finger on your right hand to control common adjustments quickly. Here is a look at the top camera controls.

✦ **Mode dial.** Turning this dial switches among shooting modes. Just line up the shooting mode you want to use with the white mark beside the dial.

✦ **Power switch.** This button switches the camera on and off.

✦ **ISO speed button.** Pressing this button displays the ISO speed screen on the LCD so that you can set the sensor's ISO setting, which determines the sensor's sensitivity to light. In Creative Zone modes such as P (Program AE), Tv (Shutter-priority), Av (Aperture-priority), and M (Manual), you can select Auto in which the

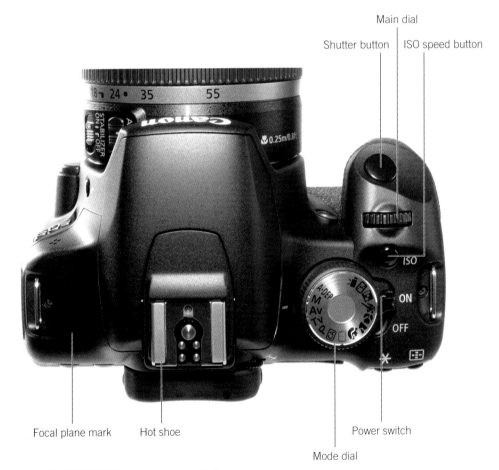

Main dial

Shutter button | ISO speed button

Focal plane mark Hot shoe Power switch

Mode dial

1.2 Rebel T1i/500D top camera controls

camera automatically determines the best ISO from 100 to 1600, or you can set it from 100 to 3200. In all automatic shooting modes such as Portrait and Landscape, the camera automatically sets the ISO between 100 and 1600. You can also turn on two additional high ISO settings, equivalent to 6400 and 12800 by setting Custom Function I-2: ISO expansion.

Cross-Reference *Custom Functions are detailed in Chapter 6.*

✦ **Main dial.** Turning this dial selects a variety of settings and options. Turn the Main dial to select options on the LCD screen; to manually select an AF (autofocus) point after pressing the AF-Point Selection/Enlarge button; and to set the aperture (f-stop) in Av mode, the shutter speed in Tv and Manual mode, and to shift the exposure program in P mode. Additionally, you can use the Main dial to scroll among the camera menu tabs.

✦ **Shutter button.** Pressing the Shutter button halfway sets the point of sharpest focus at the selected AF point in manual AF-point selection mode, and it simultaneously sets the camera's recommended exposure based on the ISO. Pressing the Shutter button completely makes the picture. In any mode except Direct Printing, you can also half-press the Shutter button to dismiss camera menus and image playback.

Rear camera controls

You use the rear camera controls most often. The Rebel T1i/500D offers buttons that are handy for making quick adjustments while

you're shooting. In particular, you'll use the WB (White Balance), Menu, Playback, and AF-Point Selection/Enlarge buttons often.

Some of the rear camera controls can be used depending on the shooting mode you set. In the automatic camera modes such as Portrait, Landscape, and Sports, the camera sets the exposure for you, so pressing the AV, WB, and Drive mode selection buttons has no effect. But in the Creative Zone modes such as P, Tv, Av, or M, these buttons function as described next.

Just remember, if you press the White Balance or other buttons and nothing happens, check the shooting mode on the Mode dial first to see if you're using an automatic mode. If you want to change the white balance, then you have to turn the Mode dial to P, Tv, Av, M, or A-DEP shooting mode. Also some settings are not available in Live View and Movie modes.

Here is a look at the controls found on the back of the camera.

✦ **Menu button.** Press the Menu button to display camera menus. To move among menu tabs, turn the Main dial or press the left or right cross keys on the back of the camera.

✦ **Display (DISP.) button.** Press this button to turn off the LCD display. If you're using the camera menus, you can press this button to display the current camera settings, space on the SD card, and other camera settings. Then press the button again to return to the menu. Or if you are in single-image playback, pressing this button cycles through the various playback display modes to show shooting information and one or more histograms displayed with an image preview. You can also use this button when you're

printing directly from the SD card to change the image between horizontal and vertical orientations.

✦ The LCD display is on by default when you turn the camera on. But if you want to maximize battery life, you can set Custom Function (C.Fn) IV-12 to Option 1: Retain power OFF status to have the display off when you turn on the camera. See Chapter 6 for details on using Custom Functions.

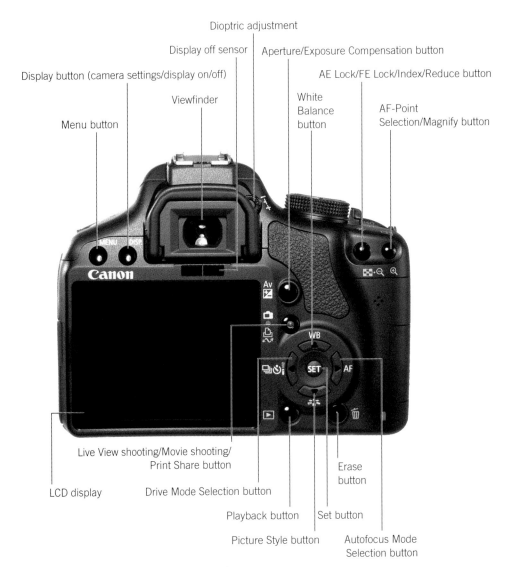

Dioptric adjustment

Display off sensor

Aperture/Exposure Compensation button

Display button (camera settings/display on/off)

AE Lock/FE Lock/Index/Reduce button

Viewfinder

White Balance button

AF-Point Selection/Magnify button

Menu button

Live View shooting/Movie shooting/ Print Share button

Erase button

LCD display

Drive Mode Selection button

Playback button

Set button

Picture Style button

Autofocus Mode Selection button

1.3 Rebel T1i/500D rear camera controls

✦ **Display off sensor.** This sensor detects when you move the camera to your eye and automatically turns off the LCD display so the light isn't bothersome. You can optionally choose to turn off the automatic sensor.

✦ **Dioptric adjustment.** Turn this knob to adjust the sharpness for your vision by -3 to +1 diopters. If you wear eyeglasses or contact lenses for shooting, be sure to wear them as you adjust the dioptric adjustment knob. To make the adjustment, point the lens to a light colored surface such as a white wall, and then turn the control until the AF points in the viewfinder are perfectly sharp for your vision.

✦ **Aperture/Exposure Compensation button.** Press and hold this button and turn the Main dial to set exposure compensation in Creative Zone modes such as P, Tv, and Av. In Manual mode, press and hold this button and turn the Main dial to set the aperture.

✦ **Live View shooting/Movie shooting/Print Share button.** Pressing this button in P, Tv, Av, M, and A-DEP shooting modes enables you to begin shooting in Live View mode, to shoot movies when the Mode dial is set to Movie mode, or to transfer all or selected images from the SD card to your computer when the camera is connected to a compatible printer.

✦ **Playback button.** Press this button to display the last captured image on the LCD. The default single-image Playback display includes a ribbon of shooting information at the top. Pressing the Index/Reduce button on the top-right back of the camera during playback displays a grid of 2 × 2 or 3 × 3 images that you can scroll through using the Main dial. Press the AF-Point Selection/Enlarge button once or twice to return to single-image display.

✦ **Erase button.** During image playback, press this button to delete the currently displayed image.

Within the circle at the back left of the Rebel T1i/500D are four buttons, collectively referred to as cross keys. The functionality of the keys or buttons changes depending on whether you're playing back images, navigating camera menus, or changing exposure settings.

During image playback, the left and right cross keys move backward and forward through the images stored on the SD/SDHC card. When you navigate through menu options, the up and down cross keys move among options.

Here is a look at the cross-key and Set button functions.

✦ **Drive Mode Selection button.** Press this button, also referred to as the left cross key, to set the Drive mode. You can choose to shoot one picture at a time, to shoot continuously at 3.4 frames per second (fps), or to shoot in one of the Self-timer/Remote control modes. The maximum burst during continuous shooting is approximately 170 Large/Fine JPEG frames or nine RAW frames. During image playback, press this button to move to a previous image.

✦ **WB (White Balance) button.** Press this button to display the White Balance screen where you can choose among seven preset White Balance options, or choose Custom White Balance.

✦ **AF (Autofocus) Mode Selection button.** Press this button to choose one of three autofocus modes: One-shot AF (also known as AI Focus) for still subjects, AI Focus AF for subjects that may start to move or move unpredictably such as kids and wildlife, or AI Servo AF for tracking focus of moving subjects.

✦ **Picture Style button.** Press this button to display the Picture Style screen where you can choose the "look" of images in terms of contrast, color rendition, saturation, and sharpness. You can choose Standard, Portrait, Landscape, Neutral, Faithful, or Monochrome Picture styles, and you can customize up to three user-defined styles displayed as 1, 2, and 3 on the Picture Style screen.

✦ **Set button.** Press this button to confirm changes you make on the camera menus, and to display submenus. You can also customize this button using C.Fn IV-11 for use while you're shooting. See Chapter 6 for details on setting Custom Functions.

At the top-right corner of the Rebel T1i/500D are two buttons that you'll use often to manually select an AF point and to enlarge images during playback to check focus.

✦ **AE Lock/FE Lock/Index/Reduce button.** Press this button and turn the Main dial to set Auto Exposure (AE) Lock or Flash Exposure (FE) Lock, to display multiple images as an index during image playback, or to reduce the size of an enlarged LCD image during image playback.

✦ **AF-Point Selection/Magnify button.** Press this button to activate the AF points displayed in the viewfinder. As you hold the button and turn the Main dial, you can select one AF point or all AF points to have the camera automatically select the AF point or points during shooting. During image playback you can press this button to enlarge the image to check focus.

Side camera controls

On the side of the T1i/500D is a set of terminals under a cover and embossed with icons that identify the terminals, which include:

✦ **Remote (E3 type) terminal.** This terminal enables connection of an accessory Remote Switch RS-60E3 or a wireless Timer Remote Controller RC-1/RC-5 to the camera.

✦ **AV Out/Digital terminal.** The AV Out terminal enables you to connect the camera to a non-high-definition (HD) television set using the AV cable supplied in the camera box to view still images and movies on the TV.

✦ **HDMI mini OUT terminal.** This is used to connect the camera to an HD television using the accessory HTC-100 cable to play back still images and movies.

Lens controls

All Canon lenses provide both automatic and manual focusing functionality via the AF/MF (Autofocus/Manual Focus) switch on the side of the lens. If you choose MF, the T1i/500D provides focus assist, shown in the view-finder, to confirm sharp focus. When sharp

focus is achieved, the Focus confirmation light in the viewfinder burns steadily and the camera emits a focus confirmation beep.

Depending on the lens, additional controls may include the following:

✦ **Focusing distance range selection switch.** This switch determines and limits the range that the lens uses when seeking focus to speed up autofocusing. The focusing distance range options vary by lens.

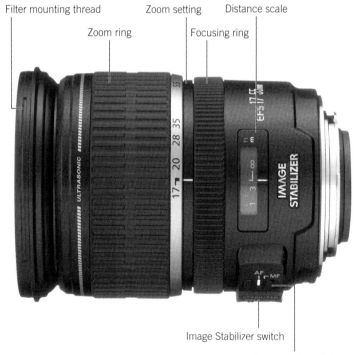

Filter mounting thread Zoom setting Distance scale

Zoom ring Focusing ring

Image Stabilizer switch

Focus Mode switch

1.4 Lens controls. All Canon lenses offer the Focus mode switch that enables you to switch between autofocus or manual focus. Image Stabilization (IS) lenses offer controls to turn stabilization on or off. Lens controls differ by lens.

✦ **Image Stabilizer switch.** This switch turns optical image stabilization on or off. Optical Image Stabilization (IS) corrects vibrations at any angle when handholding the camera and lens. IS lenses typically allow sharp handheld images of two or more f-stops over the lens's maximum aperture.

✦ **Stabilizer mode switch.** Offered on some telephoto lenses, this switch has two modes: one mode for standard shooting and one mode for vibration correction when panning at right angles to the camera's panning movement.

✦ **Zoom ring.** The zoom ring zooms the lens in or out to the focal lengths marked on the ring.

✦ **Focusing ring.** The lens focusing ring can be used at any time regardless of focusing mode by switching to MF on the side of the lens, and then turning this ring to focus.

✦ **Distance scale and infinity compensation mark.** This shows the lens's minimum focusing distance to infinity. The infinity compensation mark compensates for shifting the infinity focus point resulting from changes in temperature. You can set the distance scale slightly past the infinity mark to compensate.

The LCD

With the T1i/500D, the 3-inch LCD takes on new functions so that it not only displays captured images and current camera settings, but it also provides a live view and focusing screen with Live View and Movie mode shooting. The LCD displays 100 percent coverage of the scene.

Viewfinder display

On the Rebel T1i/500D, the optical, eye-level pentaprism viewfinder displays approximately 95 percent of the scene that the sensor captures. In addition, the viewfinder displays the AF points, a 4 percent Spot metering circle that is etched into the center of the viewfinder, as well as information at the bottom that displays the current shooting settings, a focus confirmation light, and other settings.

Nine AF points are etched in the focusing screen. When you manually select AF points by pressing the AF-Point Selection/Magnify button, the AF points are highlighted in red in the viewfinder as you turn the Main dial. If the camera automatically selects an AF point, the selected point or points display(s) in red in the viewfinder when you press the Shutter button halfway down.

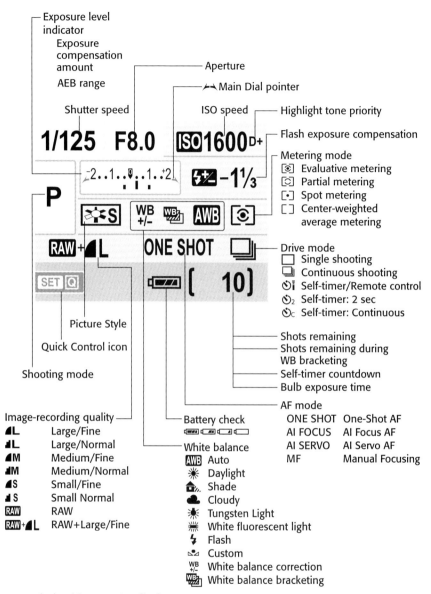

Exposure level indicator
Exposure compensation amount
AEB range
Shutter speed
Aperture
Main Dial pointer
ISO speed
Highlight tone priority
Flash exposure compensation
Metering mode
⊙ Evaluative metering
◎ Partial metering
• Spot metering
[] Center-weighted average metering
Drive mode
□ Single shooting
⊡ Continuous shooting
Self-timer/Remote control
Self-timer: 2 sec
Self-timer: Continuous
Shots remaining
Shots remaining during WB bracketing
Self-timer countdown
Bulb exposure time
AF mode

ONE SHOT	One-Shot AF
AI FOCUS	AI Focus AF
AI SERVO	AI Servo AF
MF	Manual Focusing

Picture Style
Quick Control icon
Shooting mode
Battery check
White balance

Image-recording quality

▲L	Large/Fine
▮L	Large/Normal
▲M	Medium/Fine
▮M	Medium/Normal
▲S	Small/Fine
▮S	Small Normal
RAW	RAW
RAW+▲L	RAW+Large/Fine

White balance

AWB Auto
☀ Daylight
Shade
Cloudy
Tungsten Light
White fluorescent light
Flash
Custom
WB +/- White balance correction
White balance bracketing

1.5 Rebel T1i/500D LCD display

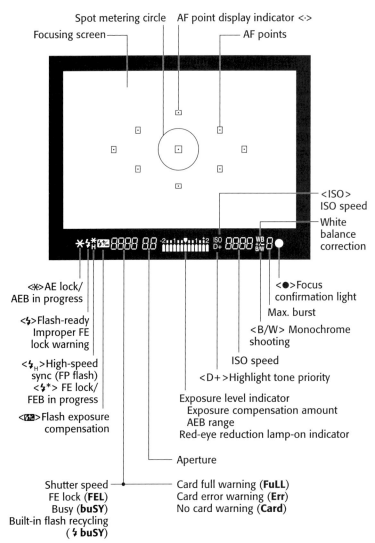

Spot metering circle AF point display indicator <⬩>

Focusing screen ──── ──── AF points

<ISO>
ISO speed
White balance correction

<✳>AE lock/
AEB in progress

<⚡>Flash-ready
Improper FE
lock warning

<⚡_H>High-speed
sync (FP flash)
<⚡*> FE lock/
FEB in progress

<▦>Flash exposure
compensation

<●>Focus confirmation light

Max. burst

<B/W> Monochrome shooting

ISO speed

<D+>Highlight tone priority

Exposure level indicator
Exposure compensation amount
AEB range
Red-eye reduction lamp-on indicator

Aperture

Shutter speed ──●──
FE lock (**FEL**)
Busy (**buSY**)
Built-in flash recycling
(⚡ **buSY**)

Card full warning (**FuLL**)
Card error warning (**Err**)
No card warning (**Card**)

1.6 Rebel T1i/500D viewfinder display. You can verify exposure settings, focus, and more in the viewfinder before making a picture. The display changes depending on the shooting mode you're using.

Setting Up the Rebel T1i/500D

If you've been using your Rebel T1i/500D already, then you've likely set the date and time, as well as other basic settings. But it's a good idea to check through this section of the book for settings that you may have missed or want to revise. The settings that I recommend are based on the philosophy of getting images that you can print at full size to take advantage of all the high resolution that the camera offers.

Many people are afraid that changing camera settings will "mess up" the pictures that they're getting, and that they will forget how to reset the camera if they don't like the changes they've made. Canon provides a reset option, which means that you can always revert to the original settings on the Rebel T1i/500D so that you can start fresh.

To reset the camera to the default settings, just press the Menu button, press the right cross key to select the Setup 3 (yellow) menu, and then press the down cross key to select Clear settings. Then press the Set button. To reset the camera to factory default settings, press the up or down cross key to select Clear all camera settings, and then press the Set button. The Clear all camera settings confirmation screen appears. Press the right cross key to select OK.

About Media Cards

The Rebel T1i/500D accepts SD and SDHC, or Secure Digital High Capacity, media cards. Not all media cards are created equal, and the type and speed of media that you use affects the Rebel T1i/500D's response and performance times including how quickly images are written to the media card, and your ability to continue shooting during the image-writing process. Memory card speed also affects the speed at which images display on the LCD, and how quickly you can zoom images on the LCD. And with the high-definition video capability of the Rebel, Canon recommends using a Class 6 or higher media card.

The type of file format that you choose also affects the speed of certain tasks. For example, when writing images to the media card, JPEG image files write to the card faster than RAW or RAW + Large JPEG files. JPEG and RAW file formats are discussed in detail later in this chapter.

Tip *For performance results of various media cards, visit Rob Galbraith's Web site at www.robgalbraith.com.*

As you take pictures, the LCD on the Rebel T1i/500D shows the approximate number of images that remain on the media card. The number is approximate because each image varies slightly, depending on the ISO setting, the file format and resolution, the Picture Style chosen on the camera, and the image itself (different images compress differently). And as you shoot video, the Rebel displays the recording time on the LCD. Video recording shuts off automatically when the size of the movie file reaches 4GB. For still and video shooting, a 4GB card is good and an 8GB card is better.

When you buy a new card, always format it in the camera and never on your computer. However, be sure that you off-load all

images to the computer before you format the card because formatting erases images even if you've set protection on them. Also be sure to format cards that you've used in other cameras when you begin using them in the Rebel T1i/500D. Formatting a media card in the camera also cleans any image-related data freeing up space on the card, and it manages the file structure on the card so the Rebel T1i/500D and media card work properly together.

Tip *If you get a card-related error on the camera, first try formatting the card if you don't already have images on the card.*

To format a card in the camera, be sure that you download all images to your computer first, and then follow these steps:

1. **Press the Menu button, and then turn the Main dial to select the Setup 1 (yellow) menu.**

2. **Press the down cross key to select Format, and then press the Set button.** The Format screen appears asking you to confirm that you want to format the card and lose all data on the card.

You can optionally choose the Low-level format option that erases the recordable sectors on the card. While Low-level format takes a bit longer, it can improve the perfor-mance of the card, and it ensures that all information on the card is permanently erased.

3. **To do a low-level format, press the Erase button to place a checkmark next to Low level for-mat, and then press the right cross key to select OK.**

4. **Press the Set button.** The camera formats the card, and then displays the Setup 1 menu.

It is generally a good idea to format media cards every few weeks to keep them clean.

Note *To avoid taking pictures when no memory card is in the camera, press the Menu button, choose the Shooting 1 (red) menu, and then press the down cross key to select Release shutter without card. Press the Set button, press the down cross key to select Disable, and then press the Set button again. Now you cannot release the shutter unless a card is in the camera.*

Avoid Losing Images

When the camera's red access light — located on the back of the camera — is blinking, it means that the camera is recording or erasing image data. When the access light is blinking, do not open the SD card slot cover, do not attempt to remove the SD card, and do not remove the camera battery. Any of these actions can result in a loss of images and damage to the media card and camera. There is an audible warning to let you know that images are being written to the card, but make it a habit to watch for the access light anyway to know not to open the media card slot cover or turn off the camera.

Choosing the File Format and Quality

The file format, either JPEG or RAW, and the JPEG quality level that you choose determine not only the number of images that you can store on the media card, but also the sizes at which you can later print images from the Rebel T1i/500D. Table 1.1 details the available options.

The Rebel T1i/500D delivers very high-quality images that make beautiful prints at approximately 10 × 15 inches. Even if you don't foresee printing images any larger than 4 × 5 inches, you may get a once-in-a-lifetime shot and want to print it as large as possible. For this reason, and to take advantage of the Rebel T1i/500D's fine image

detail and high resolution, you'll want to choose a high-quality setting and leave it there for all of your shooting. The high image-quality settings take more space on the SD/SDHC card, but the price of the card is small compared to missing out on a great image that you can't print full size.

The JPEG quality options on the Rebel T1i/500D are displayed with icons on the Quality screen that indicate the compression level of the files and the recording size. For example, a solid quarter circle and "L" indicate the largest JPEG file size and the solid quarter circle indicates the lowest level of file compression with highest image quality. Likewise, a jagged quarter circle indicates higher compression levels and relatively lower quality, and "M" indicates medium quality. File formats and compression are discussed next.

Table 1.1
Rebel T1i/500D File Quality and Size

Image Quality	Approximate File Sizes in Megabytes (MB)	Image Size in Pixels	Approximate Image Capacity for a 4GB SD/SDHC card
L (Large/Fine) JPEG	5.0MB (15.1 megapixels)	4752 × 3168	595
L (Large/Normal) JPEG	2.5MB (15 megapixels)	4752 × 3168	1199
M (Medium/Fine) JPEG	3.0MB (8 megapixels)	3456 × 2304	1028
M (Medium/ Normal) JPEG	1.6MB (8 megapixels)	3456 × 2304	2067
S (Small/Fine) JPEG	1.7MB (3.7 megapixels)	2352 × 1568	1849
S (Small/Normal) JPEG	0.9MB (3.7 megapixels)	2352 × 1568	3729
RAW	20.2MB (15.1 megapixels)	4752 × 3168	126

JPEG format

JPEG, which stands for Joint Photographic Experts Group, is a popular file format for digital images that provides not only smaller file sizes than the RAW files, but it also offers the advantage of being able to display your images straight from the camera on any computer, on the Web, and in e-mail messages. To achieve the small file size, JPEG compresses images, and, in the process, it discards some data from the image – typically data that you would not easily see anyway. This characteristic of discarding image data during compression gains JPEG its *lossy* moniker. The amount of data discarded depends on the level of JPEG compression. High compression levels discard more image data than low levels. The higher the compression level, the smaller the file size and the more images that you can store on the media card, and vice versa.

As the compression level increases to make the file size smaller, more of the original image data is discarded, and the image quality degrades. Compression also introduces defects, referred to as *artifacts*, that can create a blocky, jagged look, blurring, and diminished color fidelity in the image. At low compression levels, artifacts are minimal, but as the level increases, they become more noticeable and objectionable. You'll see the effects of high compression ratios when you enlarge the image to 100 percent in an image-editing program on the computer. To get the highest-quality images, use the lowest compression and the highest quality settings, such as Large/Fine. If space on the card is tight, then use the next lower setting, Large/Normal. If you use lower quality settings, beware that the image quality diminishes accordingly.

Tip *If you edit JPEG images in an editing program, image data continues to be discarded each time you save the file. I recommend downloading JPEG files to the computer, and then saving them as TIFF (Tagged Image File Format) or PSD (Photoshop's file format) files. TIFF is a lossless file format that does not discard image data. PSD, available in Adobe's Photoshop image-editing program, is also a lossless file format.*

Also, when you shoot JPEG images, the camera's internal software processes, or edits, the images before storing them on the media card. This image preprocessing is an advantage if you routinely print images directly from the SD card, and if you prefer not to edit images on the computer. And because the T1i offers a variety of Picture Styles that change the way that image contrast, saturation, sharpness, and color are rendered, you can get very nice prints with no editing on the computer.

Cross-Reference *Picture Styles are detailed in Chapter 3.*

RAW format

RAW files store image data directly from the camera's sensor to the media card with a minimum of in-camera processing. Unlike JPEG images, which you can view in any image-editing program, you must view RAW files using the Canon Image Browser, Digital Photo Professional or another RAW-compatible program such as Adobe Bridge and Camera Raw. More operating systems, such as the Mac, are providing regular updates so that you can view RAW images without using a RAW conversion program.

And you must also convert the RAW image data to a standard file format using a program that supports the T1i/500D's RAW file format using Canon's Digital Photo Professional program or a third-party RAW-conversion program.

You may wonder why you'd choose RAW shooting. RAW files offer the highest image quality and the ultimate flexibility because you can change key camera settings after you take the picture. For example, if you didn't set the correct white balance or exposure, you can change it when you convert the image on the computer. Canon includes its Digital Photo Professional program on the disc included in the Rebel T1i/500D box, and that program enables you to convert RAW files. In addition, you can adjust the exposure, contrast, and saturation – in effect, you have a second chance to correct underexposed or overexposed images, and to correct the color balance, contrast, and saturation after you take the picture. The only camera settings that the Rebel T1i/500D applies to RAW files are aperture, ISO, and shutter speed. Other settings such as White Balance, Picture Style, and so on are "noted," but not applied to the file. As a result, you have a great deal of control over how image data looks when you convert a RAW image.

Because RAW is a lossless format (no loss of image data), image quality is not degraded by compression. However, RAW files are larger, as indicated in Table 1.1, so you can store fewer RAW images on the media card than JPEG images.

RAW files are denoted with a .CR2 filename extension. After converting the RAW data, you can save the image in a standard file format such as TIFF or JPEG.

RAW + JPEG

On the Rebel T1i/500D, you can also choose to shoot RAW+JPEG, which records the RAW file and Large/Fine JPEG image of the quality and size you specify. The RAW+JPEG option is handy when you want the advantages of a RAW file, and you also want a JPEG image to quickly post on a Web site or to send in e-mail. If you choose RAW+JPEG, the two images are saved in the same folder on the SD/SDHC card with the same file number. While both images have an IMG_ prefix, you can tell the files apart by the file extensions. RAW files have a .CR2 extension, and JPEG files have a .JPG extension.

Note *Movie files are prefixed with MVI_ and have a .MOV file extension.*

To set the image quality in both Basic and Creative Zone modes, follow these steps:

1. **Press the Menu button, and then turn the Main dial to select the Shooting 1 (red) menu.**

2. **Press the down cross key to select Quality.**

3. **Press the Set button.** The Quality screen appears with the currently selected quality setting displayed along with the image dimensions in pixels and the approximate number of images you can store on the current SD/SDHC card in the camera.

4. **Press the left or right cross key to select the size and quality that you want.**

5. **Press the Set button.**

Changing File Numbering

When you begin shooting images, the Rebel T1i/500D automatically creates a folder on the SD/SDHC card to store the images. The folder is named 100Canon, and you see the folder when you download images from the camera to the computer. In addition, the camera numbers the images and assigns prefixes and file extensions. Both JPEG and RAW files begin with the prefix IMG_. Movie files begin with MVI_ and have a .MOV file extension.

While much of the file management on the camera is automatic, you can choose how the camera numbers images, and your choice can help you manage images on your computer. The file numbering options are: Continuous, Auto reset, and Manual reset. Here is how each file numbering option works.

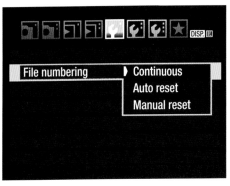

1.7 The File numbering options screen

Continuous file numbering

This is the default option for file numbering on the T1i/500D where the camera numbers images sequentially. When you replace the SD/SDHC card, the camera remembers the last highest image number and continues numbering from the last file number. Images are numbered sequentially using a unique, four-digit number from 0001 to 9999. The camera continues sequential numbering until you shoot image number 9999. At that point, the camera creates a new folder named 102, and images you shoot restart with number 0001.

This file numbering works great until you insert an SD card that has images on it. When you take another picture, the new image file number continues from the highest numbered image that's already stored on the card if it is higher than the highest image number stored in the camera's memory. In other words, the camera uses the highest number whether that high number is stored in internal memory or is stored on the card. Then the camera uses that number to continue file numbering. If you want to continue continuous numbering, be sure to insert formatted/empty SD cards into the camera.

To a point, this file-numbering option ensures unique filenames, so that managing and organizing images on the computer is easier because there is less chance that images will have duplicate filenames.

Auto reset

With this option, you can have the file numbering restart with 0001 each time you insert a different SD/SDHC card. If the SD/SDHC card has images stored on it, then numbering continues from the highest image number stored on the card. So if you want the images to always begin at 0001 on each SD/SDHC card, then be sure to insert formatted SD/SDHC cards each time you replace the card.

If you like to organize images by media card, this is a good option. However, be aware that multiple images that you store on the computer will have the same filename. This means that you should create separate folders on the computer and follow scrupulous folder organization to avoid filename conflicts and potential overwriting of images with the same filename.

Manual reset

If you choose this option, then the camera creates a new folder on the SD/SDHC card, and images are saved to the new folder starting at file number 0001. After Manual reset, file numbering returns to Continuous or Auto reset — whichever option you used previously.

The Manual reset option is handy if you want the camera to create separate folders for images that you take over a span of several days.

On the Rebel T1i/500D, up to 999 folders can be created automatically by the camera with up to 9,999 images stored in each folder. If you reach these capacities, a message appears telling you to change the SD/SDHC card even if there is room remaining on it. Until you change the SD/SHDC card, you can't continue shooting.

To change the file-numbering method on the T1i/500D, follow these steps:

1. **Press the Menu button, and then turn the Main dial to select the Setup 1 (yellow) menu.**

2. **Press the down cross key to select File numbering, and then press the Set button.** Three file numbering options appear with the current setting highlighted.

3. **Press the down cross key to select Continuous, Auto reset, or Manual reset, and then press the Set button.** The option you choose remains in effect until you change it with the exception of Manual reset as noted previously.

General Setup Options

There are a number of very straightforward setup options that will make your shooting easier and more efficient. You may have already set some of these options, but in case you missed some, you can check the Table 1.2 and see which ones you want to change.

The general setup options are typically those that you set up only once, although there are some that you may revisit in specific shooting scenarios. For example, I prefer to turn on the autofocus confirmation beep in

most shooting situations. But in situations such as weddings or at an event when the sound of the beep is intrusive, I turn it off.

Also, you may prefer to have vertical images automatically rotated on the LCD to the correct orientation. However, this rotation makes the LCD image smaller, so you may prefer to rotate vertical images only for computer display.

Table 1.2 provides a guide for the setup options. If you don't see an option listed in the table, check to see which shooting mode

you've set on the Mode dial. Some options are not available in the automatic, or Basic Zone, shooting modes such as Portrait, Landscape, Sports, and so on. Just change the Mode dial to P, Tv, Av, M, or A-DEP and the option will be displayed. In other instances, the options are detailed in later chapters of this book.

To change these options, press the Menu button, and then follow the instructions in Table 1.2.

Table 1.2
Selecting General Setup Options

Turn the Main dial to choose this Menu tab.	Press a cross key to select this Menu option.	Press the Set button to display these Menu Sub-options or screen.	Press a cross key to select the option you want, and then press the Set button.
Shooting 1	Beep	On/Off	Choose On for audible confirmation that the camera achieved sharp focus. Choose Off for shooting scenarios where noise is intrusive or unwanted.
	Release shutter without card	Enable/ Disable	Choose Disable to prevent inadvertently shooting when no SD/SDHC card is inserted. The Enable option is marginally useful, and then only when gathering Dust Delete Data.
	Review Time	Off, 2, 4, 8 sec., and Hold	Longer durations of 4 or 8 seconds to review LCD images have a negligible impact on battery life except during travel when battery power is at a premium. I use 4 sec. unless I'm reviewing images with a subject, then I choose 8 sec.
Playback 1	Rotate		Choosing this option rotates vertical images to the correct orientation on the LCD, albeit at a smaller size. Movies cannot be rotated. If you set the Auto rotate option (below), you do not need to use this option.

Turn the Main dial to choose this Menu tab.	Press a cross key to select this Menu option.	Press the Set button to display these Menu Sub-options or screen.	Press a cross key to select the option you want, and then press the Set button.
Setup 1	Auto Power off	30 sec., 1, 2, 4, 8, 15 min., Off	This setting determines when the camera turns off after you haven't used it. Shorter times conserve battery power. To turn the camera back on, lightly press the Shutter button or press the Menu, DISP., a cross key, and so on. Even if you choose the Off option, the LCD turns off automatically after 30 minutes.
	Auto rotate	On the LCD and computer, On for the computer only, or Off	Two On options let you choose to automatically rotate vertical images to the correct orientation on the LCD and computer monitors, or only on the computer monitor. If you choose the first option, the LCD preview image is displayed at a reduced size. Or choose Off for no rotation on the camera or computer.
	LCD auto off	Enable, Disable	Enable is the default that turns the LCD off as you move the camera to your eye to avoid the bright monitor interfering with seeing through the viewfinder. If you want the LCD monitor to remain on, choose Disable.
	Screen color	1, 2, 3, or 4	Choose the screen color for the Shooting settings screen.
Setup 2	LCD brightness	7 levels of brightness	Watch both the preview image and the grayscale chart as you turn the left or right cross key to adjust the LCD brightness. As you adjust brightness, ensure that all tonalities on the grayscale chart are clearly distinguishable.

Viewing and Playing Back Images

On the Rebel T1i/500D, you can not only view images after you take them, but you can also magnify images to verify that the focus is sharp, display and page through multiple images that you have stored on the SD/SDHC card, display an image with a brightness or RGB histogram, display images as a slide show, and display the image along with its exposure settings. The following sections describe viewing options and suggestions for using each option.

 Note *You can also play back movies, as detailed in Chapter 5.*

Single-image playback

Single-image playback is the default play-back mode, and it briefly displays the image on the LCD after you take the picture. Canon sets the initial display time to 2 seconds, hardly enough time to move the camera from your eye and to see the image preview. The display time is intentionally set to 2 seconds to maximize battery life, but a longer display time of 4 seconds is more useful. You can also choose to set the Hold option to display the image until you dismiss it by lightly pressing the Shutter button.

To turn on image review, press the Playback button on the back of the camera. If you have multiple pictures on the SD/SDHC card, you can use the left and right cross keys or the Main dial to move forward and backward through the images.

If you want to change the length of time that images display on the LCD, follow these steps:

1. **Press the Menu button.**

2. **Turn the Main dial to select the Shooting 1 (red) menu, then press the down cross key to select Review time.**

3. **Press the Set button.** The Review time options appear.

4. **Press the down cross key to select Off, 2, 4, 8 sec., or Hold.** The num-bers indicate the number of sec-onds that the image displays. Off disables image display, while Hold displays the image until you dismiss it by pressing the Shutter button.

5. **Press the Set button.** Lightly press the Shutter button to return to shooting.

Index display

Index display shows thumbnails of four or nine images stored on the SD/SDHC card at a time on the LCD. This display is handy when you need to ensure that you have a picture of everyone at a party or event, or to quickly select a particular image on a card that is full of images.

To turn on the Index display, follow these steps:

1. **Press the Playback button on the back of the camera.**

2. **Press the AE/FE Lock button on the back of the camera.** This but-ton has an asterisk displayed above it. The LCD displays the last four images stored on the SD card. If you don't have four images on the card, it displays as many images as are stored on the card.

3. **Press the cross keys to move among the images.** The selected image has a blue border. You can press the AE/FE Lock button again to display an index page of nine images.

4. **To move through individual images, press a cross key, or to move to the next page of images, turn the Main dial.**

5. **Press the Magnify button one or more times to return to single-image display.**

6. **Lightly press the Shutter button to cancel the display.**

Slide show

When you want to sit back and enjoy all the pictures on the SD/SDHC card, the Slide show option plays a slide show of images on the card. Use this option when you want to share pictures with the people that you're photographing, or to verify that you've taken all the shots that you intended to take during a shooting session.

During the slide show, the camera does not go to sleep to interrupt the image or movie playback.

You can start a slide show by following these steps:

1. **Press the Menu button, and then turn the Main dial to select the Playback 2 (blue) menu.**

2. **Press the down cross key to select Slide show, and then press the Set button.** The Slide show screen appears.

3. **Press the up or down cross key to select All images, and then press the Set button.** Up and down arrow controls appear to the right of the All images text.

4. **Press the up or down cross key to select from the options: All images, Stills, Movies, or Date, and then press the Set button.** If you select Date, press the Display (DISP.) button, and then press the up or down cross key to select the date from the Select date screen. Then press the Set button.

5. **Press the down cross key to select Set up, and then press the Set button.** The Slide show screen appears with options to set the Play time and Repeat.

6. **Press the down cross key to select Play time, and then press the Set button.** The Play time options appear and are 1, 2, 3, or 5 seconds.

7. **Press the down cross key to select the Play time duration you want, and then press the Set button.**

8. **Press the down cross key to select Repeat, and then press the Set button.**

9. **Press the up or down cross key to select On or Off for the Repeat option, and then press the Set button.**

10. **Press the Menu button, and then press the down cross key to select Start.**

11. **Press the Set button to begin the slide show.** You can pause and restart the slide show by pressing the Set button. If you're playing back movies, turn the Main dial to adjust the volume. Press the Menu button to stop the slide show and return to the Slide show screen.

Image jump

When you have a lot of images on the SD/SDHC card, it can be hard to find a picture that you're looking for. On the Rebel T1i/500D, you can jump through images by 1, 10, or 100 images at a time, or by date, movies, or still (images).

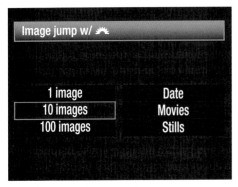

1.8 The Image jump options screen

Tip During playback, you can press the up cross key to display a jump bar that enables you to move forward and backward among images by the jump options described previously. To change the jump method, press the up or down cross key one or more times to select the increment you want. Then you can turn the Main dial to browse through images. To return to single-image browsing, press the left or right cross key.

Here is how to choose the jump method and then move through images using that method:

1. **Press the Menu button, and then turn the Main dial to select the Playback 2 (blue) menu.**

2. **Press the up or down cross key to highlight Image jump w/[Main dial], and then press the Set button.** The Image jump with Main dial screen appears. You can choose 1, 10, 100 images, or Date, Movies, Stills (still images).

3. **Press the up or down cross key to select the jump method, and then press the Set button.** The Playback 2 (blue) menu appears.

4. **To jump through images, press the Playback button on the back of the camera.** The most recent image is displayed on the LCD.

5. **Turn the Main dial to jump through images by the option you selected in Step 3.** The LCD displays the jump method and relative progress through the images on the card at the lower right of the LCD. You can change the jump option by pressing the up cross key.

Using the Display (DISP.) button

In image playback mode, you can use the Display (DISP.) button to sequence through different displays in Playback mode. In Single-image playback mode, press the Display button once to display basic shooting information overlaid on the image preview. Press it again to display shooting information, a small image preview, and the image brightness histogram. Press it once more to display abbreviated shooting information with the RGB and brightness histograms. Or press the Display button again to return to single-image review with minimal shooting information displayed. You can use the cross keys to move forward and backward through pictures in this display.

Erasing and Protecting Images

If you often keep multiple images on one or more media cards for days, weeks, or months, then it's important to take advantage of the options that enable you to manage the number of images on the card by

either deleting one or multiple images, or ensuring that the images you want to keep are not accidentally erased. The following sections detail how to erase one or multiple images and how to protect images.

Erasing images

Erasing images is useful only when you know without a doubt that you don't want the image that you're deleting. From experience, however, I know that some images that appear to be mediocre on the LCD can very often be salvaged with some judicious image editing on the computer. For that reason, I recommend erasing images with caution.

With the Rebel T1i/500D, you can choose to erase images one at a time or mark multiple images to erase at the same time.

If you want to delete an image, follow these steps:

1. **Press the Playback button on the back of the camera, and then press the left and right cross keys to select the picture that you want to delete.**

2. **Press the Erase button, and then press the right cross key to select Erase.**

3. **Press the Set button to erase the image.** When the access lamp stops blinking, lightly press the Shutter button to continue shooting.

To select and erase multiple images at one time, follow these steps:

1. **Press the Menu button, and then turn the Main dial to select the Playback 1 (blue) menu.**

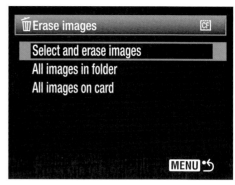

1.9 Choosing the Select and erase images option enables you to mark multiple images to erase as a group.

2. **Press the down cross key to high-light Select and erase images, and then press the Set button.** The Erase images screen appears on the LCD with the last image displayed.

3. **To select the current image, press the up or down cross key to place a checkmark in the box at the top left of the screen.**

4. **Press the left or right cross key to move to the next image, and then press the up or down cross key to mark it for deletion.**

5. **Continue pressing the left or right cross key to move through images and mark the ones you want to erase.**

6. **When all the images you want to erase are marked, press the Erase button on the back of the camera.** The Erase images screen appears with a confirmation message asking if you want to erase the selected images.

7. **Press the right cross key to select OK, and then press the Set button.** All check-marked images are erased.

Protecting images

On the other end of the spectrum from eras-ing images is protecting images to ensure that images are not accidentally deleted. Setting protection means that no one can erase the image when using the Erase or Erase All options.

 Caution *Even protected images are erased if you or someone else formats the SD/SDHC card.*

You can protect an image by following these steps:

1. **Press the Menu button, and then turn the Main dial to select the Playback 1 (blue) menu.**

2. **Press the up or down cross key to select Protect images, and then press the Set button.** The last image taken is displayed on the LCD with a protection and a SET icon in the upper-right corner. If this isn't the image you want to protect, press the left or right cross key to display the image you want to protect.

3. **Press the Set button to protect the displayed image.** A protection icon denoted by a key appears above the thumbnail display and to the left of the image number.

4. **Press the left or right cross key to scroll to other images that you want to protect, and then press the Set button to add protection to the images.** If you want to remove protection, scroll to a pro-tected image, and then press the Set button. Protection is removed and is indicated by the protection icon being removed.

Add copyright information

One of the basic workflow steps that you can accomplish on the camera is adding your copyright information to the image metadata so that it is carried with each image you shoot with the Rebel T1i/500D. Including your copyright is a great first step to identify ownership of the images you make. And if your name changes or you need to delete or change the information for any reason, you can do so.

Tip *Metadata is simply information about the image. The copyright information is included in the Creator field of the user-defined IPTC meta-data. IPTC is a standardized meta-data format initially developed by the Newspaper Association of America (NAA) and the International Press Telecommunications Council (IPTC). IPTC metadata is displayed in many image-editing programs and is stored with the image.*

Before you begin this task, ensure that you have:

✦ Installed the Canon EOS Utility that is included with the EOS Digital Solution Disk that comes in the Rebel T1i/500D box

✦ The USB Interface cable handy

✦ A good charge on the camera battery

To include your copyright and the camera owner's name on your images, follow these steps:

1. **Turn off the camera, and insert the USB Interface cable to the Digital terminal on the side of the camera.**

2. **Insert the other end of the Interface cable to a USB port on the computer.**

3. **Turn on the camera, and then on the Control Camera tab of the EOS Utility, click Camera settings/Remote shooting.** The EOS Rebel T1i/500D control panel appears.

4. **Click the Setup button.** This is the middle of three buttons to the left and below the exposure meter on the panel. The Setup menu appears.

5. **Click the Owner's name field, type your name in the box, and then click OK.**

6. **Click the Copyright notice field, type your name next to the Copyright: text, and then click OK.** The information is recorded on the Rebel T1i/500D and is included for each image.

7. **Click the Close button on the EOS Utility panel, turn off the camera, and detach the Interface cable.**

To change the copyright name, repeat these steps and type a new name in Step 6.

To view or delete the copyright information on the camera, follow these steps.

1. **Press the Menu button, highlight the Setup 3 tab, and then press the down cross key to highlight Clear settings.**

2. **Press the Set button.** The Clear settings screen appears.

3. **To display the existing copyright information, press the Diplay button.** The Display copyright info. screen appears with the copyright name. Or to delete the copyright information, highlight Delete copyright information, and then press the Set button. The Delete copyright information screen appears.

4. **Highlight OK, and then press the Set button.**

1.10 The Copyright options you can set using Canon's EOS Utility program

Using the EOS Integrated Cleaning System

Each time you change the lens on the camera, dust can filter into the lens chamber and settle on a filter in front of the image sensor. These dust spots on the image sensor appear as spots on your images. With the Rebel T1i/500D, a two-step automated cleaning system addresses both small, light particles and sticky particles that adhere to the filter in front of the image sensor.

The first step is automatic cleaning that uses ultrasonic vibrations to shake off dust from the filter in front of the image sensor, capturing it on a sticky material that surrounds the filter. Each time you turn the camera on and off, the self-cleaning unit runs. You can suspend automatic cleaning by pressing the Shutter button, and you can initiate cleaning via the camera menu.

The second step of the camera's Integrated Cleaning System addresses larger, sticky particles that can't be shaken off by vibration. This step, called Dust Delete Data, identifies the size and position of large dust particles from a picture that you take of a white piece of paper. The camera then appends a small file that identifies the dust data to all upcoming JPEG and RAW images. Then you use Canon's Digital Photo Professional Copy Stamp tool and apply the Dust Delete Data that removes the spots from your images. Dust Delete Data can be updated at any time, and you can stop the camera from appending the data to images if you want.

Automatic sensor cleaning

Automatic sensor cleaning can be initiated and turned off at any time. To reduce the risk of overheating the cleaning element, self-cleaning can't be operated more than five consecutive times in a 10-second period.

To manually initiate sensor cleaning, follow these steps:

1. **Press the Menu button, and then turn the Main dial to select the Setup 2 (yellow) menu.**

2. **Press the down cross key to select Sensor cleaning, and then press the Set button.** The Sensor cleaning screen appears.

3. **Press the up or down cross key to select the option you want:**

 • **Auto Cleaning.** Select this option if you want to turn off the default sensor cleaning when the power switch is turned on and off. Press the Set button, select Disable, and then press the Set button.

 • **Clean now.** Select this option to clean the sensor now, and then press the Set button to select OK on the Clean now screen.

 • **Clean manually.** If the camera is in a Creative Zone mode (P, Tv, Av, M, and A-DEP), you can also select this option. Then press the Set button. The reflex mirror flips up and the shutter opens to allow you to use appropriate cleaning tools and materials to clean the sensor. When you finish, turn the power off.

Obtaining Dust Delete Data

To erase larger, sticky dust particles, you can have the camera locate dust. To do this, you take a picture of a white piece of paper. (Although you take a picture of the paper, no image is recorded to the SD/SDHC card.) From the picture, the T1i/500D maps the coordinates of dust particles that are stuck to the low-pass filter, and the Rebel creates a tiny data file that is appended to future images. To erase the dust, use Canon's Digital Photo Professional, an editing program that is included on the Canon EOS Digital Solution Disk that comes with the Rebel T1i/500D.

Before you begin:

✦ Have a clean piece of white paper that will fill the viewfinder if you position it approximately 1 foot from the lens. Ensure that the paper is evenly lit by any light source.

✦ Set the lens focal length to 50mm or longer. On a zoom lens, the focal-length settings are displayed on the lens ring. Turn the lens ring to a focal length of 50mm or longer.

✦ Set the lens to Manual Focus by turning the switch on the side of the lens to MF.

✦ With the camera facing forward, set the focus to infinity by turning the lens-focusing ring all the way to the left.

To obtain Dust Delete Data, follow these steps:

1. **Press the Menu button, and then select the Shooting 2 (red) menu.**

2. **Press the down cross key to select Dust Delete Data, and then press the Set button.** The Dust Delete Data screen appears.

3. **Press the right cross key to select OK, and then press the Set button.** The camera initiates the automatic sensor self-cleaning. A message appears telling you to press the Shutter button when you're ready to take the picture.

4. **With the camera approximately 1 foot from the white paper and the paper filling the viewfinder, press the Shutter button completely to take a picture of the paper.** The T1i/500D captures the Dust Delete Data and displays a confirmation message.

5. **Select OK by pressing the Set button.** The Shooting menu appears. Lightly press the Shutter button to return to shooting. A tiny file containing a map of the dust particles is appended to all image files. You should periodically repeat these steps to update the Dust Delete Data file.

Applying Dust Delete Data

After you acquire Dust Delete Data, you can use Canon's Digital Photo Professional program to apply the data to images. Be sure that you have installed Digital Photo Professional from the Canon EOS Digital Solution Disk that comes with the camera. You can apply Dust Delete Data to either JPEG or RAW images.

To apply Dust Delete Data in Digital Photo Professional, follow these steps:

1. **Start Digital Photo Professional, and then navigate to the folder that contains images with Dust Delete Data appended.**

2. **Select an image, and then click in the Edit image window in the toolbar.** The image-editing window appears.

3. **On the menu, click Tools, and then click Start Stamp tool.** A new window appears with the image and a tool palette on the right side.

4. **Click Apply Dust Delete Data.** A progress pane appears, and then a confirmation message that tells you that the data has been applied.

5. **Click OK.** You can repeat these steps to apply the Dust Delete Data to the remaining images in the folder.

Using the EOS Rebel T1i/500D

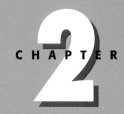

CHAPTER 2

✦ ✦ ✦ ✦

In This Chapter

Choosing a shooting mode

Setting the ISO sensitivity

Metering light to determine exposure settings

Evaluating and modifying exposure

Getting tack-sharp focus

Selecting a drive mode

✦ ✦ ✦ ✦

In this chapter, you begin the exciting journey into shooting with the Rebel T1i/500D. Contrary to what you may have heard, you don't need to know everything there is to know about photography or have a bag full of lenses and accessories to use the Rebel T1i/500D creatively. And if you haven't used a digital single lens reflex (dSLR) camera before, then you are in for a treat in terms of the creative results you can get with the Rebel T1i/500D.

The first step in shooting and controlling exposure is choosing a shooting mode. The Rebel T1i/500D offers shooting modes ranging from fully automatic to fully manual, and many in between. You can choose among different shooting modes at any time. You may find that you enjoy using the automated Sports mode, but for other shots, you may prefer using Aperture-priority (Av) mode. With the T1i/500D, you can switch between modes and be assured of getting great shots regardless of the mode you use.

This chapter explains each of the shooting modes on the Rebel T1i/500D as well as other camera features and controls to help you use the camera to its full potential.

Choosing a Shooting Mode

One of the terms that I use throughout the book is *shooting mode*. A shooting mode determines how and what kinds of exposure settings are set and whether you or the camera sets them. Most of the automatic shooting modes are fully automatic, much like a point-and-shoot camera. Other shooting modes are semiautomatic, giving you control over some or all of the exposure settings and other camera settings.

/Note *Shooting modes are shown on the Mode dial. You set a shooting mode by turning the Mode dial to line up a shooting mode with the white line on the camera body.*

The Mode dial is divided into two sections: the automatic Basic Zone shooting modes and the semiautomatic and manual modes, or the Creative Zone modes. Most automatic modes are denoted with icons such as a person's head to designate Portrait mode, a running person to designate Sports mode, and so on. The exceptions are Full Auto mode, designated by a green rectangle, and Creative Auto, designed with the letters CA.

In most of these Basic Zone modes, everything is set automatically so that you can concentrate on capturing the moment. However, you can change lenses and zoom the lens to bring the subject closer or to get a wider view of a scene. Each shooting mode is designed for photographing specific scenes or subjects. For example, if you're shooting fast action, the T1i/500D's Sports mode automatically sets the camera to shoot in rapid-fire sequence, and it tracks the subject movement to maintain focus on the subject. In the automatic Basic Zone modes, you cannot control camera settings including the white balance, drive mode, and autofocus (AF) mode or select AF points and other settings. Basic Zone modes are shown in figure 2.1.

Creative Zone: manual and semiautomatic shooting modes

Basic Zone: automatic and movie shooting modes

2.1 Rebel T1i/500D Mode dial

The other half of the dial groups the semiautomatic and manual, or Creative Zone, shooting modes, which are designated by letter abbreviations such as P for Program AE (Auto Exposure), Tv for Shutter-priority, Av for Aperture-priority, M for Manual, and A-DEP for Automatic depth of field. If you are an experienced photographer, or if you're anxious to move beyond the automated modes to have more creative control, then the Creative Zone modes are the ticket. They give you partial or full control over some or all of the exposure settings. For example, in Aperture-priority AE (Av) mode you can set the aperture, or f-stop, and the camera automatically sets the appropriate shutter speed that's needed to make a well-exposed image. Unlike the automatic modes, the Creative Zone modes enable you to control the focus, white balance, drive mode, and many more camera settings.

How shooting modes relate to exposure

The shooting mode that you choose enables you to control some or all of the elements of exposure. Every exposure is the precise combination of four elements: the light in the scene you're shooting, the ISO, the aperture, and the shutter speed. While the shooting modes are detailed later in this chapter, now is a good time to go through a brief summary of the exposure elements.

To make a good exposure, the camera requires that the ISO (International Organization for Standardization), aperture, or f-stop, and shutter speed be set correctly based on the amount of light in the scene or the light from the flash or studio lighting system. And when the ISO, f-stop, and shutter speed are set correctly, you get a well-exposed picture. Here is a brief overview of these elements:

Cross-Reference *If you are new to photography, be sure to read Chapter 6, which gives much more detail about each exposure element.*

✦ **ISO.** The ISO setting determines how sensitive the image sensor is to light. A high ISO of 400 or higher means that the sensor is sensitive to light and needs less light to make the exposure. A low ISO, such as 100, means that the sensor is less sensitive to light and needs more light to make the exposure.

Note *On digital cameras, high ISO sensitivity settings amplify the output of the sensor so that less light is needed. Be aware, however, that this amplification also increases digital noise, which creates a grainy appearance as well as unwanted color flecks, particularly in the shadow areas in an image.*

✦ **Aperture.** The aperture determines how much the lens diaphragm opens or closes to let more or less light into the camera. The diameter of the lens opening is determined by the aperture, or f-stop. The aperture is also a key factor in controlling depth of field, or how much of the scene is in acceptably sharp focus from front to back from the plane of sharp focus. Each change in aperture, or "stop," doubles or halves the exposure.

✦ **Shutter speed.** The shutter speed determines how long the camera shutter stays open to let light into the sensor. Shutter speeds are expressed as fractions of a second, such a 1/60, 1/125, 1/250 second, and so on. Controlling shutter speed is most commonly associated with the ability to control how motion is shown in an image and the ability to handhold the camera in low-light scenes. Each shutter speed change either doubles or halves the exposure.

To make a well-exposed picture, all of the exposure elements must be set in the correct proportion. If one element such as the f-stop changes, then the shutter speed must change proportionally assuming that the ISO remains the same. But you have a lot of latitude in making changes to the aperture and shutter speed because many different combinations of f-stop and shutter speed produce an equivalent and correct exposure, assuming the same ISO setting.

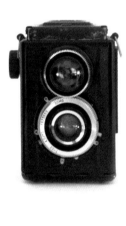

2.2 In this image taken at f/11, the camera in the background shows moderate sharpness so that you can see some of the details.

For example, at the same ISO setting, f/11 at 1/15 second is equivalent to f/4 at 1/125 second. In other words, both of these exposures let the same amount of light into the camera. However the resulting pictures look very different. With a narrow aperture, or large f-stop number, such as f/11, the scene will have sharper detail from front to back than it will with a wide aperture, or small f-stop number of f/4. In photographic terms, f/11 provides an extensive depth of field where detail is rendered in acceptably sharp focus from back to front in the image in most cases. F/4 creates a shallow depth of field where detail behind and in front of the plane of sharp focus is shown as a soft blur.

While it's helpful to know about exposure settings, you don't have to master them immediately to use even the semiautomatic shooting modes, except perhaps M (Manual) mode. Even in P, Tv, and Av shooting modes, you can set the setting that you want to control, and the Rebel automatically sets the other exposure element. For example, if you choose Av mode, you set the f-stop, and the camera automatically sets the correct shutter speed. This makes it easy to use the Rebel's creative controls immediately, and it helps you learn about them as you continue shooting.

2.3 In this image taken at f/4, the details of the camera in the background are almost completely blurred because the wide aperture (f-stop) creates a shallow depth of field.

Keep this exposure summary in mind as you read about shooting modes. It will help you understand what types of control you have and what to expect with each mode.

Basic Zone shooting modes

The automatic, or Basic Zone, shooting modes are grouped together on one side of the Mode dial. They are denoted by pictorial icons, a green rectangle for Full Auto, and CA for Creative Auto mode. Just choose the mode that matches the type of scene you're shooting. For example, if you're photographing a landscape, then use the shooting mode with the mountain icon. Because landscape images characteristically show the scene with all parts of the image in acceptably sharp focus, with an extensive depth of field, the Rebel automatically sets a narrow aperture (large f-stop number such as f/11 or f/16) depending on the light to provide an extensive depth of field. Each of the other Basic Zone modes except CA and Full Auto make similar adjustments to give you a classic photographic result for each type of scene.

In Basic Zone modes, the camera automatically sets all of the exposure settings, ISO, aperture, and shutter speed, as well as the focus, drive mode, white balance, and other camera settings. With the exception of Full Auto mode (denoted by the green rectangle), and CA shooting modes, the only control you have is to specify the type of scene that you're shooting by selecting the shooting mode on the Mode dial.

Basic Zone modes are a good choice for quick shots. For example, if you're making a portrait, select Portrait mode, which sets a wide aperture (f-stop) to blur the background, creating a shallow depth of field. Conversely, if you are shooting a football game and you want the motion of the players to be crisp and without blur, then choose Sports mode, which sets as fast a shutter speed as possible given the light in the scene.

In addition to setting the ISO, f-stop, and shutter speed, the Rebel T1i/500D also automatically sets:

✦ Automatic (Auto) white balance

✦ Auto Lighting Optimizer, an automatic adjustment that lightens images that are too dark and increases the contrast in low-contrast images

✦ Long Exposure Noise Reduction to reduce digital noise when the exposure time is 1 second or longer

✦ The AF point or points

✦ The light-metering mode, which is set to Evaluative

✦ The drive mode that determines how many images the Rebel T1i/500D takes when you press and hold the Shutter button. The drive mode changes depending on the automatic shooting mode you choose.

✦ Use of the built-in flash that's used in some Basic Zone modes, detailed later

✦ The sRGB (standard Red, Green, Blue) color space detailed in Chapter 3

In most Basic Zone modes, you cannot change the camera settings that the camera chooses. Also, you cannot use Live View shooting in the automatic Basic Zone modes.

Creative Auto mode

The first shooting mode that loosely falls within the automatic shooting mode category is Creative Auto, denoted as CA on the camera Mode dial. If you're new to using a dSLR, and you want to get the creative effects that are commonly associated with dSLR shooting, then CA mode is a good shooting mode to choose. CA shooting mode displays visuals and text on the LCD to help you understand the results you'll get from making various adjustments. This shooting mode also offers more control than the other automatic modes, but it offers less control than the Creative Zone shooting modes (detailed later in this section).

To use CA mode, follow these steps:

1. **Turn the Mode dial to CA.** The CA screen appears on the LCD.

2. **Press the Set button, and then press a cross key to select the function you want to change.**

3. **Turn the Main dial to adjust the setting.** If you want to return to the initial CA screen, press the Shutter button halfway down.

In CA shooting mode, you can adjust the following settings:

✦ **Flash control.** With this control, you can have the built-in flash fire automatically when the light is too low to get a sharp, handheld image; choose to have the flash fire with every image, or choose to turn off the flash completely. If you choose to turn off the flash in low-light scenes, be sure to stabilize the camera on a tripod or on a solid surface.

✦ **Background control.** If you are not using the flash, you can adjust this control to blur the background or render it with more sharpness. Just adjust the marker to the left to blur the background or to the right to increase background sharpness. As discussed earlier, the relative blurring or sharpening of the background is referred to as depth of field, and it's controlled in large part by the f-stop. Thus this control enables you to change the aperture.

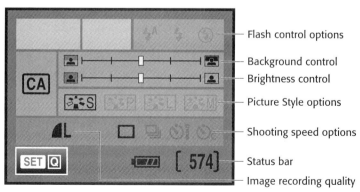

Flash control options
Background control
Brightness control
Picture Style options
Shooting speed options
Status bar
Image recording quality

2.4 The Creative Auto screen offers a visual gateway to make exposure and other camera setting changes without needing to understand photographic exposure concepts.

✦ **Brightness control.** As the name implies, this control enables you to modify the image so that it is brighter or darker by moving the index mark to the right or left respectively. This control is combined with Auto Lighting Optimizer (detailed later in this chapter) that automatically brightens images that are too dark and adjusts the contrast if necessary.

✦ **Image effects/Picture Style options.** You can choose from four of the six Picture Styles. Picture Styles are a collection of preset adjustments that determine the level of sharpness, contrast, saturation, and color tone of images. In CA mode, you can choose Standard, Portrait, Landscape, or Monochrome Picture Styles.

✦ **Shooting speed (drive mode).** The speed, or number of images the camera takes with each press of the Shutter button, is determined by the drive mode. This control enables you to choose Continuous shooting at 3.4 frames per second (fps), Self-timer/Remote control mode with a 10-second delay before the image is made or making the image with a remote control, or Self-timer Continuous mode that takes the number of images that you choose from two to ten images at 10-second intervals. Alternately, when this control is selected, you can press the Set button to display the Drive mode selection screen.

✦ **Image recording quality.** By activating this control, you can change the image recording quality. To display the Quality screen, press the Set button.

The remaining Basic Zone modes or automatic modes are designed to provide point-and-shoot functionality so that the camera sets all camera and exposure settings.

Full Auto mode

In the Full Auto shooting mode, the Rebel T1i/500D automatically selects all exposure and camera settings. This can be a good mode to use for quick snapshots. However, keep in mind that the camera defaults to using the built-in flash in low-light scenes, although you may not want or need to use the flash. Also remember that in all modes, the lens that you choose enhances your creative control.

In Full Auto mode, the camera is set to AI Focus AF mode, which means that if the subject begins moving, the camera automatically switches to AI Servo AF mode to track the subject's movement and maintain focus. Autofocus modes are detailed later in this chapter.

The camera also automatically selects the AF point or points. It may choose one or multiple AF points that are typically determined by what is closest to the lens and/or that has the most readable contrast in the scene. The camera displays the selected AF points in red in the viewfinder so that you can see where the camera will set the point of sharpest focus.

Tip *If the camera doesn't set the point of sharpest focus where you want, you can try to force it to choose a different AF point by moving the camera position slightly one or more times. If you want to control where the point of sharpest focus is set in the image, then it is better to switch to a Creative Zone mode and set the AF point manually.*

In Full Auto mode, the camera automatically sets:

✦ Standard Picture Style

✦ Single-shot (one image at a time) Drive mode with the option to set 10-second Self-timer/Remote control mode

✦ Automatic flash with the option to turn on Red-eye reduction

 Cross-Reference *Picture Styles are detailed in Chapter 3.*

Portrait mode

In Portrait mode, the Rebel T1i/500D sets a wide aperture (small f-stop number) providing a shallow depth of field to blur background details and prevent them from distracting from the subject. The Rebel also uses the Portrait Picture Style, which is designed to enhance the skin tones. Obviously, Portrait mode is great for people portraits, but it's also a great mode for taking pet portraits, indoor and outdoor still-life shots, and nature shots such as flowers that you photograph from a moderate distance. However, if you use Portrait mode for nature shoots, the Portrait Picture Style may render the color less vivid than if you use other modes that use other Picture Styles.

In Portrait mode, the camera automatically sets:

✦ Portrait Picture Style.

✦ One-shot autofocus mode and automatic AF-point selection.

✦ Continuous drive mode so that you can shoot at 3.4 frames per second (fps) up to 170 Large JPEG images in a burst. Alternately, you can choose to use the 10-second Self-timer/Remote control Drive mode.

✦ Automatic flash with the option to turn on Red-eye reduction.

Tip *To enhance the effect that Portrait mode provides in blurring the background, use a telephoto lens or move the subject farther from the background.*

In Portrait mode, the camera automatically selects the AF point or points. When the camera chooses the AF point, it looks for points in the scene where lines are well defined, for the object that is closest to the lens, and/or for points of strong contrast. In a portrait, the point of sharpest focus should be on the subject's eye. But the eyes may not fit the camera's criteria for setting focus. As a result, the camera often focuses on the subject's nose, mouth, or clothing. So as you shoot, watch in the viewfinder to see which AF points the camera chooses when you half-press the Shutter button. If the AF point or points aren't on the eyes, then shift your shooting position slightly to try to force the camera to reset the AF point to the eyes. If you can't force the camera to refocus on the eyes, then switch to Av mode, set a wide aperture such as f/5.6, and then manually select the AF point that is over the subject's eyes. Manually selecting an AF point is detailed later in this chapter.

Landscape mode

In Landscape mode, the Rebel T1i/500D chooses the exposure so that both background and foreground details are acceptably sharp for extensive depth of field. To do this, the camera sets a narrow aperture (large f-stop number). And in Landscape mode, the camera gives you the fastest shutter speed possible given the amount of light in the scene. The fast shutter speed helps ensure sharp handheld images.

In lower light, the Rebel T1i/500D tries to maintain as narrow an aperture as possible, and due to low light, the shutter speed will be slower, or the camera will increase the ISO, or both. So as the light fades, be sure to monitor the shutter speed in the viewfinder. If the shutter speed is 1/30 second or slower, or if you're using a telephoto lens, then steady the camera on a solid surface or use a tripod for shooting. As it does in all Basic Zone modes, the camera uses Evaluative metering (described later in this chapter) to measure the light in the scene to determine the exposure settings.

This mode works well not only for landscapes but also for cityscapes and portraits of large groups of people.

In Landscape mode, the camera automatically sets:

✦ Landscape Picture Style

✦ One-shot autofocus mode and automatic AF-point selection

✦ Single-shot drive mode with the option to set 10-second self-timer/ Remote control mode

✦ The flash to not fire

Close-up mode

In Close-up mode, the Rebel T1i/500D allows a close focusing distance, and it sets a wide aperture (small f-stop number) to create a shallow depth of field that blurs background details. It also sets as fast a shutter speed as possible given the light. This mode produces much the same type of rendering as Portrait mode. In Close-up shooting mode, the camera uses the Standard Picture Style. You can further enhance the close-up effect by using a macro lens. If you're using a zoom lens, zoom to the telephoto end of the lens.

Tip *All lenses have a minimum focusing distance that varies by lens. This means that you can't get sharp focus at distances closer than the minimum focusing distance of the lens. You know that the camera has achieved good focus — and thus, you're not closer than the minimum focusing distance — when you hear the autofocus confirmation beep from the camera and when the focus indicator light in the viewfinder burns steadily.*

In Close-up mode, the camera automatically sets:

✦ Standard Picture Style

✦ One-shot autofocus mode with automatic AF-point selection

✦ Single-shot drive mode with the option to set 10-second Self-timer/ Remote control mode

✦ Automatic flash with the option to turn on Red-eye reduction

Sports mode

In Sports mode, the Rebel T1i/500D sets a fast shutter speed to freeze subject motion. This mode is good for capturing athletes in midair, a player sliding toward a base, or the antics of pets and children.

In this mode, when you half-press the Shutter button, the camera focuses and automatically tracks focus on the moving subject. The focus is locked at the moment you fully press the Shutter button. And if you're shooting a burst of images, you can continue to hold the Shutter button down, and the camera will maintain focus. In Sports mode, the camera automatically sets:

✦ Standard Picture Style.

✦ AI Servo AF autofocus mode with automatic AF-point selection.

✦ Continuous drive mode.
Continuous drive mode enables you to shoot at 3.4 fps for a maximum burst rate of 170 Large/Fine JPEG images. You also have the option to use the 10-second self-timer/Remote control mode.

✦ The flash to not fire.

Night Portrait mode

In Night Portrait mode, the Rebel T1i/500D combines flash with a slow speed so that both the subject and the background are correctly exposed. This combination prevents the subject from being very bright against a very dark background. However, because this mode uses a longer exposure, it's important that the subject remain still during the entire exposure to avoid blur. Be sure to use a tripod or set the camera on a solid surface to take night portraits.

You should use this mode when people are in the picture, rather than for general night shots, because the camera blurs the background similar to the way it does in Portrait mode. For night scenes without people, use Landscape mode or a Creative Zone mode and a tripod.

In Night Portrait mode, the camera automatically sets:

✦ Standard Picture Style

✦ One-shot autofocus mode with automatic AF-point selection

✦ Single-shot drive mode with the option to set 10-second Self-timer/Remote control mode

✦ Automatic flash with the option to turn on Red-eye reduction

Flash-off mode

In Flash-off mode, the Rebel T1i/500D does not fire the built-in flash or an external Canon Speedlite, regardless of how low the scene light is. In low-light scenes using Flash-off mode, be sure to use a tripod.

In Flash-off mode, the camera automatically sets:

✦ Standard Picture Style.

✦ AI Focus AF autofocus mode with automatic AF-point selection. This means that the camera uses One-shot AF designed for still subjects, but it automatically switches to the focus tracking mode AI Servo AF if the subject begins to move. The camera automatically selects the AF point.

✦ Single-shot drive mode.

You can easily change to any of the Basic Zone modes: Turn the Mode dial so that one of the Basic Zone modes lines up with the white mark on the camera. Then press the Shutter button halfway down to focus, and press it completely to make the picture.

Movie mode

One of the new modes on the Rebel T1i/500D is Movie mode, which enables you to capture full high-definition (full HD) quality video clips at 20 fps. Alternately, you can choose to shoot movies at high-definition (HD) quality or at standard recording quality, both at 30 fps. You can then play back the movies on a television, computer, or on the Rebel's LCD screen.

Because shooting with Movie mode differs significantly from the other Rebel shooting modes, I've devoted Chapter 5 to using Movie mode.

Creative Zone shooting modes

When you want more control over your images, the semiautomatic and manual, or Creative Zone, shooting modes put creative control in your hands. And contrary to what you may think, you don't have to know everything there is to know about photography to use these shooting modes. Rather, you can choose a mode to control the exposure element that's important for the scene or subject. For example, you'd choose Av when you want to blur the background or to show the background with acceptably sharp detail. Or you can choose Tv mode and set a fast shutter speed to freeze the motion of a player in mid-jump or mid-run. In each case, the camera sets the other settings for you automatically.

Here is a summary of each Creative Zone shooting mode.

P mode

Program AE, shown as P on the Mode dial, is a semiautomatic but shiftable mode. Shiftable means that you can change the camera's suggested exposure by changing or shifting to an equivalent exposure just by turning the Main dial.

Here is how P mode works. In P mode, you press the Shutter button halfway, and the camera shows you its ideal exposure settings in the viewfinder. Say that the camera recommends using f/4 at 1/400 second, but you want more sharpness in the background (a more extensive depth of field) than f/4 provides. Just turn the Main dial five clicks to the right. This shifts the program to f/8 at 1/125 second to get a more extensive depth of field. Turning the Main dial to the left shifts the exposure again to another equivalent exposure; in this case, to f/6.3 at 1/60 second.

But there is a catch. The shift in exposure that you make in P mode is maintained for only one shot, after which the T1i/500D reverts to the camera's suggested ideal exposure. So if you don't take the shot at the shifted exposure within 2 or 3 seconds, when you refocus, the camera reverts to the initial settings. It's also important to know that if you're using the built-in flash, you can't shift the exposure in P mode.

P mode is handy when you want to quickly change the depth of field and shutter speed for one shot with a minimum of camera adjustments.

Tip *If you see 30 and the maximum lens aperture or 4000 and the minimum lens aperture blinking in the viewfinder, this indicates an underexposure and overexposure, respectively. In these instances, you can increase or decrease the ISO, accordingly.*

To use P mode:

1. **Turn the Mode dial to line up P with the white mark on the camera.** The T1i/500D displays its ideal suggested exposure settings in the viewfinder.

2. **To shift the program, or change the exposure, press the Shutter button halfway, and then turn the Main dial until the aperture or shutter speed that you want displays in the viewfinder.** You cannot shift the program if you're using the flash.

How Is Program Mode Different from Full Auto Mode?

These two modes are similar, but they vary greatly in the amount of control you have. In Full Auto mode, the camera sets the exposure for you and you cannot change it. However, in Program (P) mode, you can temporarily change the camera's suggested shutter speed and aperture settings. Equally important, P mode enables you much more control over camera functions — none of which you can set in Full Auto mode. Here is a look at the settings you can control in P mode, but that you can't control in Full Auto mode.

✦ **Shooting settings.** AF mode and AF-point selection, Drive mode, Metering mode, Program shift, Exposure Compensation, Auto Exposure Bracketing, AE Lock, Depth-of-field preview, Clear all camera settings, Custom Functions, Clear all Custom Functions, and Sensor cleaning

✦ **Image settings.** ISO, White balance, Custom white balance, White Balance Correction, White Balance Bracketing, Color Space, and Picture Style

2.5 The camera originally suggested an exposure of f/2.8 at 1/800 second. In P mode, I turned the Main dial to set the aperture to f/8 to get more extensive depth of field throughout the flower bud. Exposure: ISO 100, f/8, 1/125 second.

Tv mode

Shutter-priority AE mode, shown as Tv on the Mode dial, is the semiautomatic mode where you set the shutter speed and the camera automatically sets the aperture. Controlling the shutter speed enables you to freeze subject motion at a fast shutter speed or to show motion as a blur at a slow shutter speed.

Tv mode is also helpful when you want to ensure that the shutter speed is within the limits for handholding the camera and getting a sharp image. For example, if you're shooting an indoor event and don't want the shutter speed to go below, say, 1/60 second, you can set 1/60 second in Tv mode to maintain that shutter speed.

Tip How fast a shutter speed is neces-
sary to avoid camera shake from
handholding the camera? If you're
not using an Image Stabilization
(IS) lens, or a monopod or tripod,
then the general rule is that you
can handhold the camera and get
a sharp image at the reciprocal of
the focal length: 1/[focal length].
So if you're using a non-IS zoom
lens zoomed to 200mm, then
1/200 second is the slowest shutter
speed at which you can handhold
the lens and not get blur from cam-
era shake. For details on different
types of lenses, see Chapter 8.

In Tv mode, you have full control over cam-
era settings including the AF mode, AF point,
Metering and Drive modes, Picture Style,
and using the built-in flash. The shutter
speeds that you can choose depend on the
light in the scene. In low-light scenes with-
out a flash, you may not be able to get a fast
enough shutter speed to freeze the action.
In Tv mode, the shutter speeds range from
1/4000 to 30 seconds, and Bulb. Shutter
speed increments can be changed from the
default 1/3-stop to 1/2-stop increments
using Custom Function (C.Fn) I-1. Flash sync
speed is 1/200 second or slower.

2.6 This image was taken in Tv mode using a moderately fast 1/250 second shutter speed.
I also panned, or moved the camera with the dog's motion, and that creates a streaked
effect to the background grass. Exposure: ISO 100, f/18, 1/250 second.

Shutter Speed Tips

If you're shooting action scenes and want a shutter speed fast enough to stop subject motion with no motion blur, then the following guidelines provide a good starting point.

✦ Use 1/250 second when action is coming toward the camera.

✦ Use 1/500 to 1/2000 second when action is moving side to side or up and down.

✦ Use 1/30 to 1/8 second when panning with the subject motion. Panning with the camera on a tripod is a really good idea.

✦ Use 1 second and slower shutter speeds at dusk and at night to show a water-fall as a silky blur, to capture light trails of moving vehicles, to capture a city skyline, and so on.

You can also use a polarizing or neutral density filter to capture moving water as a blur earlier in the day, both of which reduce the amount of light to give you a slower shutter speed. Besides reducing the light by 2 stops, a polarizer has the additional benefit of reducing reflections on the water.

To use Tv mode:

1. **Turn the Mode dial to line up Tv with the white mark on the camera.**

2. **Turn the Main dial to the shutter speed that you want.** As you set the shutter speed, the camera sets the aperture automatically. At the default settings, shutter speed values display in the viewfinder and on the LCD in 1/3-stop increments. And fractional shutter speeds show only the denominator. For example, 125 indicates 1/125 second, "0"6" indicates 0.6 seconds, and ""20"" indicates 20 seconds. If the f-stop blinks in the viewfinder, it means that a suitable aperture is not available at that shutter speed under the existing light. Switch to a higher ISO or to a slower shutter speed.

Av mode

Av mode is another semiautomatic shooting mode where you set the aperture (f-stop) and the camera automatically sets the correct shutter speed. Aperture-priority AE mode is shown on the camera Mode dial as Av.

Aperture is the primary factor that controls the depth of field. A wide aperture, such as f/5.6, creates a shallow depth of field with a softly blurred background. A narrow aperture, such as f/8, f/11, f/16, and so on, creates an extensive depth of field that shows both foreground and background elements sharper than when you set a wide aperture.

For most day-to-day shooting, Av mode is a good shooting mode because in many scenes, you want to control the depth of field. And in Av mode, you can quickly change the aperture to do so.

Tip *The apertures that you can choose depend in part on the lens that you're using. If you're using the Canon EF-S 18-55mm f/3.5-5.6 IS lens, then when you have the lens set to 18mm you can select f/3.5 as an aperture. But when you have the lens set to 55mm, the widest aperture you can choose is f/5.6, and you can't choose f/3.5 at this zoom setting. This is called a vari-able-aperture lens. For more details on lenses, see Chapter 8.*

2.7 This image was taken in Av mode at a wide aperture that created the shallow depth of field that I wanted so that the dryers in the distance would gradually blur. Exposure: ISO 100, f/2.8, 1/40 second.

Additionally, you may want to use Av mode to set and maintain the aperture at the *sweet spot* of the lens that you're using. The sweet spot is the aperture at which the lens provides the best detail, contrast, and sharpness, and it varies by lens. In low-light scenes, you may want to use Av mode because you know that you'll need to shoot consistently at the largest aperture.

In Av mode, you have control over all the camera settings including the AF mode, AF point, drive and metering modes, white balance, Picture Style, and use of the built-in flash.

Tip *You can preview the depth of field for an image by pressing the Depth of Field Preview button on the front of the camera. When you press the button, the lens diaphragm closes to the aperture that you've set so that you can see the range of acceptable focus.*

In Av mode, be sure to monitor the shutter speed in the viewfinder; if it is 1/30 second or slower, use a tripod. Or if you're shooting with a telephoto lens, then use the hand-holding rule provided earlier in the Tv section. Aperture increments can be changed from the default 1/3-stop to 1/2-stop increments using C.Fn I-1.

Cross-Reference *For details on setting Custom Functions, see Chapter 6.*

To change to Av mode, follow these steps:

1. **Turn the Mode dial to line up Av with the white mark on the camera.**

2. **Turn the Main dial to the aperture that you want.** The camera automatically sets the shutter speed. At the default settings, aperture values display in the viewfinder and LCD in 1/3-stop increments, such as 5.6, 6.3, 7.1, and so on. The higher the f-number, such as f/8, f/16, and so on, the smaller the aperture and the more extensive the depth of field. The smaller the f-number, such as f/5.6, f/4.0, and so on, the larger the aperture and the shallower the depth of field.

M mode

Manual mode, indicated by an M on the Mode dial, enables you to set both the aperture and the shutter speed (and the ISO) manually. But first, you have to know what exposure to use. Sometimes, you already know the exposure such as when a friend recommends the ISO, shutter speed, and aperture for shooting fireworks, for example. But when you don't know what exposure settings to use, then you base them on the camera's light meter reading. The camera takes a light meter reading when you press the Shutter button halfway. The camera measures the light, looks at the ISO that is currently set, and then calculates the exposure needed. Then you set the aperture and shutter speed to the camera's suggested exposure by adjusting the aperture and/or shutter speed until the tick mark is at the center of the exposure level meter that's displayed in the viewfinder. You can also vary from the camera's ideal exposure by adjusting the aperture and/or shutter speed so

the tick mark is to the left or right of the center of the exposure level meter.

M mode is helpful in difficult lighting situations when you want to override the camera's recommended exposure and in situations where you want consistent exposures across a series of photos, such as for a panoramic series. M mode is also used for fireworks and other low-light and night scenes where you know in advance the exposure that you want to use.

Note *Because it takes more time to set all the exposure settings yourself in M mode, many people prefer to routinely use semiautomatic modes such as Av and Tv.*

Many of my photography students are anxious to shoot in Manual mode because they see it as a sort of "badge of honor" in mastering the camera. Certainly there are many times when Manual mode is the best choice, especially if you used advanced exposure techniques. But many times, the camera's suggested exposure is the best choice. In those cases, using Manual mode requires more steps than Tv or Av mode require. I recommend using Manual mode when you truly need it — to make pictures of a moon eclipse, fireworks, when you want to make a Bulb exposure, or when you want to override the camera's suggested exposure.

In M mode, you also have control over the camera settings including AF mode, AF point, drive and metering modes, white balance, Picture Style, and use of the built-in flash.

2.8 This image of the solstice moon was shot in Manual mode. Exposure: ISO 200, f/11, 1/6 second.

To use Manual mode, follow these steps:

1. **With the Mode dial set to M, press the Shutter button halfway down.** The exposure level index in the viewfinder and on the LCD has a tick mark that indicates how far the current exposure is from the camera's ideal or suggested exposure. Keep your eye on this index as you complete Step 2.

2. **Turn the Main dial to the shutter speed that you want, and then press and hold the Aperture/ Exposure Compensation (Av) button on the back of the camera as you turn the Main dial to set the aperture.** If you want to use the camera's ideal exposure, then adjust the shutter speed or aperture until the tick mark is at the center of the exposure level index. You can also set the exposure above (to overexpose) or below (to

underexpose) the ideal exposure. If the amount of under- or overexposure is +/- 2 Exposure Values (EV), the Exposure Level Indicator bar blinks to show the amount of plus or minus EV in the viewfinder. You can then adjust either the aperture or shutter speed until the exposure level you want is displayed.

A-DEP mode

A-DEP, or Automatic Depth of Field, mode automatically calculates the optimum depth of field between near and far subjects in the scene. As a result, both near and far elements will be in acceptably sharp focus. To do this, A-DEP mode uses the camera's nine AF points to detect near and far subject distances, and then calculates the aperture needed to keep the subjects in sharp focus.

While the automatic depth-of-field calculation is handy, getting the maximum depth of field typically means that the camera must

set a narrow aperture, and that can result in a slow shutter speed. If the shutter speed is slow, say slower than 1/30 second with a nontelephoto lens, then use a tripod, monopod, and/or IS lens to avoid getting a blurry picture, or increase the ISO sensitivity setting. With non-IS telephoto lenses, see the handholding guideline in the Tv section.

In A-DEP shooting mode, you cannot control the aperture, shutter speed, or AF points. While you can use the built-in flash in this mode, the maximum depth of field is sacrificed and A-DEP mode performs more like P mode.

To change to A-DEP mode, follow these steps:

1. **Turn the Mode dial to line up A-DEP with the white mark on the camera.**

2. **Focus on the subject.** In the viewfinder, verify that the AF points displayed in red cover the subjects, and then take the picture. If the AF points aren't on the elements in the scene that you want, shift your shooting position slightly and refocus. Also, if the aperture blinks, it means the camera can't get the maximum depth of field. Move back or switch to a wide-angle lens or zoom setting.

2.9 This image was taken using A-DEP mode to provide the optimum depth of field in the near and far elements of the home and surroundings. Exposure: ISO 100, f/18, 1/100 second.

Setting the ISO Sensitivity

Setting the ISO, another element of overall exposure, determines the sensitivity of the image sensor to light. The higher the ISO, the less light the sensor needs to make the picture, and the faster the shutter speed you'll get in low-light scenes, and vice versa. However, the ISO setting also affects the digital noise in images, and the following sections explore ISO in more detail.

About ISO settings

The Rebel T1i/500D has a wide ISO range, and it offers the ability to expand the range to settings up to 12800 in P, Tv, Av, M, and A-DEP shooting modes. That ability is great for allowing you to shoot in very low light; however, as you move to higher ISO settings, the output of the sensor is also amplified and that increases the digital noise in images. So while you have the option of increasing the ISO sensitivity at any point in shooting, the tradeoff is an increase in digital noise from the increased amplification or the accumulation of an excessive charge on the pixels. And depending on the appearance and severity, the result of digital noise is an overall loss of resolution and image quality. Digital noise appears as unwanted colorful flecks and as grain that's much like film grain. It most commonly appears in shadow areas, but at high ISO settings, it may also appear in lighter tones within the image.

As a result, you have to weigh the ability to use high ISO settings to get shots in low-light scenes against the resulting digital noise. In practice, the most compelling benchmark in evaluating digital noise is the quality of the image at the final print size. If the digital noise is visible and objectionable in an 8 × 10-inch or 11 × 14-inch print when viewed at a standard viewing distance of approximately a foot or more, then the digital noise degraded the quality to an unacceptable level. It is worthwhile to test the camera by using all of the ISO settings, processing and printing enlargements at the size as you typically print, and then evaluating how far and fast you want to take the T1i/500D's ISO settings.

The Rebel T1i/500D offers two useful Custom Functions that help counteract noise: C.Fn II-4: Long-exposure noise reduction, and C.Fn II-5 High ISO speed noise reduction.

 Cross-Reference *See Chapter 6 for details on each of these Custom Functions and how to set them.*

Note *The ISO sensitivity setting affects the effective range of the built-in flash, and the range depends on the lens that you're using. In general, the higher the ISO speed, the greater the effective flash range.*

There really is no substitute for knowing how far and fast to push the ISO settings on the T1i/500D unless you test it at each of the ISO settings and compare the results. To compare the results, view the images at 100 percent enlargement in an image-editing program, and then compare the shadow areas. If you see grain and colorful pixels where the tones should be continuous and of the same color, then you're seeing digital noise. Having low levels of digital noise won't spoil prints from the image, but high levels of digital noise can be objectionable in prints of 8 × 10 inches and larger.

The Rebel T1i/500D offers Auto ISO, a setting where the Rebel automatically sets the ISO from 100 to 1600 in all shooting modes except Portrait, Manual, and when using a flash. In Portrait shooting mode, the Rebel fixes the ISO at 100. In Manual mode and when using the flash, the Auto setting is fixed at ISO 400.

To change the ISO sensitivity setting, follow these steps.

1. **Set the camera to P, Tv, Av, M, or A-DEP shooting mode, and then press the ISO button on the top of the camera.** The ISO speed screen appears on the LCD. If the ISO screen doesn't appear on the LCD, it's because the shooting information display on the LCD was not active when you began. Press the Display (DISP.) button to display the shooting information on the LCD, and then press the ISO button.

2. **To change the ISO setting turn the Main dial to the setting you want.** ISO settings are displayed in the viewfinder and on the LCD. Options include Auto (the camera automatically selects an ISO between 100 and 1600 in most shooting modes) and individual settings from 100 to 3200. If you've enabled expanded ISO settings, then you can also choose ISO 6400 and H, equivalent to ISO 12800. The ISO option you select remains in effect until you change it or switch to a Basic Zone shooting mode. The current ISO is displayed in the viewfinder and on the LCD during shooting.

Tip *You can quickly change the ISO on the Quick Control screen displayed on the LCD. Just press the Set button to activate the screen, and then press a cross key to highlight the ISO setting. Then turn the Main dial to set the ISO setting that you want. The Quick Control screen is displayed unless you've turned it off by pressing the Display button. To turn it on, press the Display button again.*

Expanded ISO settings

The Rebel T1i/500D offers the ability to expand the ISO range to ISO 6400 and ISO 12800, which is denoted as H on the camera displays. With the excellent noise performance of the T1i/500D, these settings are useful in low-light scenes when you might not otherwise be able to take a sharp image.

To access these two expanded ISO settings, you have to turn on C.Fn I-2 ISO expansion. While Custom Functions are detailed in Chapter 6, I include the steps here for convenience.

To enable the expanded ISO range, follow these steps.

1. **Set the camera to P, Tv, Av, M, or A-DEP shooting mode.**

2. **Press the Menu button and then turn the Main dial to select the Setup 3 (yellow) menu.**

3. **Press the down cross key to highlight Custom Function (C.Fn), and then press the Set button.** The C.Fn I: Exposure screen appears, or the last accessed Custom Function screen appears.

4. **Press the left or right cross key until the number 2 appears in the box at the top right of the screen, and then press the Set button.**

5. **Press the down cross key to highlight On, and then press the Set button.** The expanded ISO settings remain available until you repeat these steps and choose Off to turn off the expanded settings.

Metering Light to Determine Exposure Settings

As mentioned earlier in this chapter, all photographic exposures are based on the amount or intensity of light in the scene. And with this section, we circle back around to the first element of exposure light. Before the camera can give you its recommended exposure, it must first measure the amount of light in the scene. The Rebel T1i/500D uses its built-in reflective light meter for this task. After the camera measures the light in the scene, it factors in the current ISO and calculates the aperture and shutter-speed combinations that are necessary to make a good exposure.

Note *A reflective light meter measures the amount of light that's reflected from the subject back to the camera. Other types of light meters measure the light falling on the subject.*

Because the light in various scenes differs, there are times when you want the camera to measure the light in the entire scene, with emphasis on the main subject. But in other scenes, such as when the background light is much brighter than the light on the subject, you want the camera to bias the light reading for the light on the subject to ensure that the subject is exposed properly. In this case, the background may be too bright in the final image, but the subject will be exposed properly, and that is ultimately what you care about most. So as you can see, there are times when you want more or less of the overall scene light to be weighted when the camera calculates the exposure.

The Rebel T1i/500D provides four metering modes that enable you to control how the camera meters light for the variety of different scenes and subjects you'll encounter. In simple terms, a metering mode determines how much of the scene light the Rebel T1i/500D measures to calculate exposure. With these different modes, you have the flexibility to choose the mode that best suits your needs when you encounter backlit subjects, challenging lighting situations, or when you want to use advanced exposure techniques. To use the metering modes successfully, it's helpful to first understand more about how light meters work and what you can expect from the Rebel's onboard light meter.

How the Rebel T1i/500D meters light

The reflective light meter used on the Rebel T1i/500D is calibrated to assume that all scenes are "average." This means that the light meter expects that every scene you shoot will have a mix of light, medium, and dark tones that, when averaged together, result in medium, or 18 percent, gray. It's confusing for us to think of light in terms of tones but the camera's light meter is color-blind — it only cares about tones such as those on a grayscale. So if you are shooting an average scene, the camera produces a properly exposed image.

However, not all scenes have average tonality; for example, a snow scene has predominantly light/white tones, while a scene where a black train engine fills most of the frame has predominantly dark/black tones. The light meter doesn't know about or factor in these variances. Left to its own calibration, the light meter renders the scene

medium gray regardless of the subject. And this explains why pictures of snow scenes come out with gray instead of white snow. And it explains how a solid black train engine, or a black tuxedo, is gray instead of solid black.

In other scenes, the subject may be positioned against a very dark or very light background. In these scenes, you may want the camera to weight the light meter reading for the subject light (or reflectance) and downplay the brighter or darker background. That's where different metering modes and exposure modification techniques come into play.

/ **Note** *If learning to use different metering modes seems daunting, you can rest easy. Canon's venerable Evaluative metering mode, which is the default mode, does an admirable job in 98 percent of the scenes you'll photograph. So if you're just starting out, read about the different metering modes, and then you'll know that you can use them when you encounter particularly challenging scenes and subjects.*

Four metering modes

The T1i/500D offers four metering modes that are differentiated by how much viewfinder area the camera uses to meter light. If you're shooting in P, Tv, Av, M, or A-DEP shooting modes, you can choose any of the four metering modes as you shoot. But if you're shooting in the automatic shooting modes, such as Full Auto, Portrait, Landscape, CA, and so on, you cannot change the metering modes. In the automatic modes, the Rebel T1i/500D uses only Evaluative metering.

Here is a summary of the four metering modes. Figures 2.10 through 2.14 show the differences in exposures using each metering mode. In these figures, the subject is intentionally placed in the center of the frame, because Partial, Spot, and Center-Weighted Average metering modes meter the light from the center AF point.

Evaluative metering mode

Evaluative metering mode partitions the entire viewfinder into 35 zones to evaluate light throughout the scene. But in this metering mode, the camera biases its reading based on the subject position. And it determines the subject position according to what AF point or points are active. (Active AF

2.10 This image was made using Evaluative metering mode. The mannequin's face is properly exposed, and the highlights on the hair maintain detail while the background also has good exposure. Exposure: ISO 100, f/4.5, 1/500 second.

points are those that light in red in the viewfinder when you half-press the Shutter button.) It also takes into account the scene or subject brightness, the background, and back- and front lighting. Evaluative metering mode works well in scenes with the proverbial average scene that has an average distribution of light, medium, and dark tones, and it functions well in backlit scenes, and in scenes with reflective surfaces such as glass or water.

> **Note** If pictures are slightly underexposed, the camera automatically corrects them using Auto Lighting Optimizer. This optimization is applied to all images taken in Basic Zone modes, and to JPEG images taken in Creative Zone modes except M mode, unless you turn off this feature. Auto Lighting Optimizer can be a handy feature if you print directly from the media card. But if you prefer to see the original exposure, you can turn off the optimization by disabling C.Fn II-7. See Chapter 6 for details on Custom Functions.

Partial metering mode

This metering mode hones in on a much smaller area of the scene, or approximately 9 percent of the scene at the center of the viewfinder. By concentrating the meter reading more specifically, this mode gives good exposures for backlit and high-contrast subjects, and when the background is much darker than the subject. Again, this metering mode assumes that the subject is in the center of the frame. If the subject isn't in the center, then you can meter using the center AF point, lock in the exposure settings using Auto Exposure Lock (AE Lock is detailed later in this chapter), recompose, focus, and shoot.

Partial metering mode is a good choice for food photography, some macro subjects, and some portraits. Partial metering isn't a good choice for landscape, architecture, and interiors where you want the camera to meter light from throughout the scene.

> **Tip** While Partial, Spot, and Center-weighted Average metering modes can be considered as advanced metering modes, don't be afraid to experiment with them. Give yourself a self assignment to use all the metering modes with different subjects, and then evaluate the images. Trying out these modes on appropriate subjects is one of the best ways to learn the camera and open up your creative options.

2.11 This image was taken using Partial metering. Exposure: ISO 100, f/4.5, 1/400 second.

2.12 This image was taken using Spot metering. Exposure: ISO 100, f/4.5, 1/400 second.

/Note *The T1i/500D's exposure meter is sensitive to stray light that can enter through the viewfinder. If you're using the self-timer or you don't have your eye pressed against the viewfinder, then stray light entering the viewfinder can result in underexposed images. Be sure to use the viewfinder eyepiece cover that is attached to the camera strap, or cover the viewfinder with your hand.*

Spot metering mode

In Spot metering mode, the metering concentrates on a small, approximately 4 percent area at the center of the viewfinder — the circle that's etched in the center of the viewfinder. This advanced metering mode is great for exposure techniques where you meter from a middle-gray area in the scene or from a photographic gray card to calculate the exposure settings. Spot metering is also useful when you're shooting backlit subjects against a dark background.

For example, if you're shooting a portrait and you want to ensure that the skin tones are properly exposed, then you can switch to Spot metering mode, move in close and fill the frame with the subject's skin, and then use that meter reading to make the exposure. The reading is taken at the center AF point. If that's not where you want to set the AF point, then you can use AE Lock, described later in this chapter, to retain the Spot meter reading, and then recompose and focus using an off-center AF point. I used this technique for Figure 2.20. You can use Spot metering mode for theater and stage shots to meter for and get good exposure on the performer while letting the surrounding areas go dark.

Center-weighted Average metering mode

This metering mode weights exposure calculation for the light reading at the center of the viewfinder, while evaluating light from the rest of the viewfinder to get an average for the entire scene. The center area encompasses an area larger than the 9 percent Partial metering area. As the name implies, the camera expects that the subject will be in the center of the viewfinder, and it gives approximately 75 percent of the exposure bias to a circle bounded by the seven center AF points in the viewfinder.

/Note *There are nine AF points, but in Center-weighted metering not all of the AF points are used — only the seven AF points in the center; hence the name, Center-weighted.*

2.13 This image was taken using Center-weighted Average metering. Exposure: ISO 100, f/4.5, 1/640 second.

To change to a different metering mode, follow these steps.

1. **Set the Mode dial to P, Tv, Av, M, or A-DEP, and then press the Menu button.**

2. **Turn the Main dial to select the Shooting 2 (red) menu.**

3. **Press the down cross key to highlight Metering mode, and then press the Set button.** The Metering mode screen appears on the LCD with text and icons identifying the four metering mode options.

4. **Press the left or right cross key to select the metering mode you want.** The mode you choose remains in effect until you change

it. If you switch to an automatic Basic Zone mode such as CA, Portrait, Landscape, and so on, then the camera automatically uses Evaluative metering mode.

Evaluating and Modifying Exposure

Now that you know how to control exposure using shooting modes, setting the ISO, and using metering modes, the question is how to evaluate and adjust exposures that need adjustment. In this section, you learn to use features and techniques that modify the camera's standard exposures.

But first you have to know if the exposure is spot-on or needs adjustment. The way you know that is by checking the images on the LCD for proper exposure. The goal is to get the best exposure possible in the camera.

If you're new to photography, it's important to know what to look for in evaluating an image exposure. Aesthetically, you might say that a great exposure is one that captures and expresses the scene as you saw and envisioned it. Technically — and assuming skillful composition — a great exposure has several characteristics including:

✦ **Highlights that maintain detail either throughout the image, or at least in the main subject.** Highlights that do not retain detail go completely white, and they are referred to as being "blown out" or "blown." Particularly with JPEG capture, if you don't retain detail in the highlights, that detail is gone forever.

✦ **Shadows that show detail.** If the shadows go dark too quickly, they are referred to as being "blocked up." For example, if you're photographing a groom in a black tuxedo, a good exposure shows detail within the shadowy folds of the coat or slacks.

✦ **Visually pleasing contrast, accurate color, good saturation, and, of course, tack-sharp focus.**

While the fundamental goal is to capture a good exposure, there are times when your creative vision will override these technical goals. More often, however, the dynamics of the scene itself may simply not allow you to achieve all of these goals. For example, in a scene where the range from highlight to shadow is beyond the capability of the Rebel T1i/500D to maintain detail in both the highlights and shadows, then one or another technical characteristic must be sacrificed. In those situations, your aim is to get a proper and pleasing exposure on the subject.

With that as an introduction, the next sections show you how to evaluate exposures as you're shooting, and how to modify exposures when necessary.

Evaluating exposure

Following each exposure, you can best evaluate the exposure by looking at the histogram. A histogram is a graph that shows either the brightness levels in the image — from black (level 0) to white (level 255) for an 8-bit image — or the Red, Green, Blue (RGB) brightness levels, along the bottom. The vertical axis displays the number of pixels at each location. The T1i/500D offers both types of histograms, a brightness (or luminance) histogram, and RGB (Red, Green, and Blue color channel) histograms.

The histograms are the most useful tools that you can use, especially if you're shooting JPEG images, to ensure that highlights are not blown, and that shadows are not blocked up while you're shooting and while you have an opportunity to reshoot if necessary. Here is an overview of each type of histogram.

 Note *Although the Rebel T1i/500D captures 14-bit RAW images, the image preview and histogram are based on an 8-bit JPEG rendering of the RAW file.*

Brightness histogram

A brightness histogram shows grayscale brightness values in the image along the horizontal axis of the graph. The values range from black (level 0 on the left of the graph) to white (level 255 on the right of the graph) for an 8-bit JPEG image. This histogram shows you the exposure bias and the overall tonal distribution in the image. In an image of a black train engine, for example, the histogram shows more pixels toward the left side of the graph, and an image of a white lily has more pixels on the right side of the graph. However, if the histogram has pixels crowded against the far-right side of the graph and forming a "spike" against the side, then the image has some highlight values that are blown out; in other words, they are at 255, or totally white with no detail. If the histogram has pixels crowded against the far-left side of the graph, and forming a spike against the side of the graph, then some of the shadows are blocked up and will not show image detail.

In a proverbial average scene with normal brightness, good exposure is shown with pixels spread across the graph from side to side and with no spikes on the extreme left or right sides.

RGB histogram

An RGB histogram shows the distribution of brightness levels for each of the three color channels — Red, Green, and Blue. Each color channel is shown in a separate graph so you can evaluate the color channel's saturation, gradation, and color bias. The horizontal axis shows how many pixels exist for each color brightness level, while the vertical axis shows how many pixels exist at that level.

More pixels to the left indicate that the color is darker and more prominent, while more pixels to the right indicate that the color is brighter and less dense. If pixels are spiked on the left or right side, then color information is either lacking or oversaturated with no detail, respectively. If you're shooting a scene where color reproduction is critical, the RGB histogram is likely most useful.

The histogram is a very accurate tool to use in evaluating JPEG captures. If, however, you shoot RAW capture, the histogram is based on the JPEG conversion of the image. So if you shoot RAW, remember that the histogram is showing a less robust version of the image than you get during image conversion.

2.14 The histogram inset in this picture shows that the tones are distributed across the full range of levels. The highlights retain detail and the shadows are open showing good detail. Exposure: ISO 100, f/1.6, 1/500 second, -1 Exposure Compensation.

2.15 This image is underexposed with blocked-up shadows due to the dark background. Exposure: ISO 100, f/5, 1/400 second.

2.16 The bright highlights on the water the bird is splashing and on the birdbath indicate some blown highlights. Exposure: ISO 100, f/5.6, 1/200 second.

To set the type of histogram displayed during image playback, follow these steps:

1. **Press the Menu button, and then turn the Main dial to highlight the Playback 2 (blue) menu.**

2. **Press the down cross key to highlight Histogram, and then press the Set button.** Two histogram options appear.

3. **Press the up or down cross key to select either Brightness or RGB, and then press the Set button.**

To display the histogram during image playback, follow these steps:

1. **Press the Playback button on the back of the camera.** The most recent image appears on the LCD.

2. **Press the Display (DISP.) button on the top-left back of the camera once to display the file capture type and current number of images on the SD card.**

3. **Press the Display button again to display the brightness histogram with more extensive shooting and file information.** This display also has a highlight alert that flashes to show areas of the image that are overexposed (or areas that have no detail in the highlights).

4. **Press the Display button again to display the RGB histograms along with the brightness histogram in addition to more limited shooting information.**

Differences in Exposing JPEG and RAW Images

When you shoot JPEG images, it's important to expose for the highlights so that highlight detail is retained. If you don't capture detail in the highlights, it's gone forever. To ensure that images retain detail in the brightest highlights, you can use one of the exposure techniques described in this chapter such as AE Lock or Exposure Compensation.

With RAW capture, you have more exposure latitude because some highlights can be recovered during RAW image conversion in Canon's Digital Photo Professional or Adobe Camera Raw. Without going into detail, it's important to know that fully half of the total image data is contained in the first f-stop in RAW capture. This underscores the importance of capturing the first f-stop of image data by not underexposing the image. In everyday shooting, this means biasing the exposure slightly toward the right side of the histogram, resulting in a histogram in which highlight pixels just touch or almost touch, but are not crowded against, the right edge of the histogram.

With this type of exposure, the image preview on the LCD may look a bit light, but in a RAW conversion program, you can bring the exposure back slightly. So for RAW exposure, expose with a slight bias toward the right side of the histogram to ensure that you capture the full first f-stop of image data.

Now that you know more about evaluating exposure, the next question is what should you do if the exposure needs adjustment? Canon includes a variety of options for modifying the camera's recommended exposure including Auto Lighting Optimization, Highlight Tone Priority, Exposure Compensation, Auto Exposure Bracketing (AEB), and Auto Exposure (AE) Lock. These options are detailed in the following sections.

Auto Lighting Optimizer

Auto Lighting Optimizer is a built-in image-correction feature that boosts contrast and brightens images that are too dark. This is one of the goof-proof features that can be useful if you print images directly from the SD/SDHC card. However, if you edit images on the computer, you will likely prefer to see the image without automatic corrections, and you can turn off Auto Lighting Optimizer for P, Tv, Av, and A-DEP shooting modes.

 Cross-Reference *For details on setting Custom Functions, see Chapter 6.*

Auto Lighting Optimizer is used when you shoot in all Basic Zone modes such as Portrait, Landscape, Sports mode, and so on. It is also used when you shoot JPEG images in Creative Zone modes including P, Tv, Av, and A-DEP. It is not used in M mode or when you shoot RAW or RAW+JPEG format images. When you shoot in P, Tv, Av, or A-DEP shooting modes, then you can set the optimization to Standard, Low, or Strong. Alternately, you can turn off this adjustment. You can make adjustments to Auto Lighting Optimizer using C.Fn II-7. And if you shoot RAW capture, you can apply Auto Lighting Optimizer in Canon's supplied Digital Photo Professional program.

2.17 This image was taken without using Auto Lighting Optimizer. Exposure: ISO 100, f/2.5, 1/125 second.

2.18 This image was taken using Auto Lighting Optimizer at the Standard setting. The brightness increased significantly. It's a good idea to test the three settings for the optimization before you use it on a routine basis. Exposure: ISO 100, f/2.5, 1/125 second.

While automatic brightening may be handy, it also tends to reveal any digital noise in the image. Digital noise appears with a grainy look and as multicolored flecks, particularly in the shadow areas of the image. Also, by using Auto Lighting Optimizer, the effect of exposure modification may not be evident depending on the level of optimization chosen. For

example, if you set negative Exposure Compensation (detailed later in this section), then Auto Lighting Optimizer automatically brightens the image and the effect of compensation is masked. The same happens for other exposure modifications such as AEB and AE Lock. If you prefer to see the effect of exposure modifications, then you can turn off Auto Lighting Optimizer but only for Creative Zone shooting modes.

To adjust the level of or to turn off Auto Lighting Optimizer for Creative Zone shooting modes, follow these steps:

1. **Set the Mode dial to a Creative Zone mode such as P, Tv, Av, or A-DEP.**

2. **Press the Menu button, and turn the Main dial until the Setup 3 (yellow) menu is displayed.**

3. **If necessary, press the up or down cross key to highlight Custom Functions (C.Fn), and then press the Set button.** The Custom Functions screen appears.

4. **Press the right or left cross key until the number "7" is displayed in the box at the top right of the screen, and then press the Set button.** The Custom Function option control is activated and the option that is currently in effect is highlighted.

5. **Press the down cross key to highlight the level you want or option 3:Disable to turn off Auto Lighting Optimizer, and then press the Set button.** The setting you choose remains in effect until you change it by repeating these steps. Lightly press the Shutter button to return to shooting.

Highlight Tone Priority

Highlight Tone Priority is designed to improve or maintain highlight detail by extending the range between 18 percent middle gray to the maximum highlights. This effectively increases the dynamic range, or the range of highlight to shadow tones as measured in f-stops in a scene, to reduce the incidence of blown highlights. In addition, the gradation between grays and highlights is finer. Using Highlight Tone Priority, however, limits the ISO range from 200 to 3200, and it can increase noise in the shadow areas.

Highlight Tone Priority helps ensure that the image sensor pixel wells do not fill, or saturate, blowing out highlight details. Also with the Rebel's 14-bit images, the camera sets a tone curve that is relatively flat at the top in the highlight area to compress highlight data. The tradeoff, however, is a more abrupt move from deep shadows to black, which increases shadow noise. The result is an increase in dynamic range, disregarding, of course, the potential for increased shadow noise.

Highlight Tone Priority is turned off by default. You can turn on Highlight Tone Priority by following these steps:

1. **Set the Mode dial to a Creative Zone mode such as P, Tv, Av, M, or A-DEP.**

2. **Press the Menu button, and then press the right cross key until the Setup 3 (yellow) menu is displayed.**

3. **If necessary, press the up or down cross key to highlight Custom Functions (C.Fn), and then press the Set button.** The Custom Functions screen appears.

4. **Press the right or left cross key until the number "6" is displayed in the box at the top right of the screen, and then press the Set button.** The Custom Function option control is activated and the option that is currently in effect is highlighted.

5. **Press the down cross key to highlight 1: Enable, and then press the Set button.** This turns on Highlight Tone Priority in Creative Zone shooting modes. Lightly press the Shutter button to return to shooting.

As a reminder that Highlight Tone Priority is enabled, a "D+" designation is displayed in the viewfinder and on the LCD.

Exposure Compensation

When you evaluate an image and the image or subject is too light (overexposed), too dark (underexposed), or has blown highlights or blocked shadows, then you can change the camera's recommended exposure using Exposure Compensation. Exposure Compensation enables you to purposely and continuously modify the camera's standard exposure by a specific amount up to +/- 2 f-stops in 1/3-stop increments.

Tip *The Rebel T1i/500D is set to make exposure changes by 1/3 f-stops by default. If you want larger changes, then you can set C.Fn I-1 to Option 1: 1/2-stop increments.*

Scenarios for using Exposure Compensation vary widely, but a common use is to override the camera's suggested ideal exposure in scenes that have large areas of white or dark tones. In these types of scenes, the camera's reflective meter averages light or dark scenes to 18 percent gray to render large expanses of whites as gray and large expanses of black as gray. To avoid this, you can use Exposure Compensation. For a snow scene, a +1 to +2 stop of Exposure Compensation will render snow as white instead of gray. A scene with predominately dark tones might require -1 to -2 stops of Exposure Compensation to get true dark renderings.

Here are some things that you should know about Exposure Compensation:

✦ Exposure Compensation works in P, Tv, Av, and A-DEP shooting modes, but it does not work in Manual mode and during Bulb exposures. In Tv shooting mode, Exposure Compensation changes the aperture by the specified amount of compensation. In Av shooting mode, it changes the shutter speed. In P mode, compensation changes both the shutter speed and aperture by the exposure amount you set.

✦ The amount of Exposure Compensation you set remains in effect until you reset it. This applies whether you turn the camera off and back on, change the SD/SDHC card, or change the battery. So remember to set the compensation back to zero when you finish shooting in scenes where you need compensation.

✦ You can combine Exposure Compensation with Auto Exposure Bracketing (AEB) detailed next.

2.19 To get true whites in this scene, I used a +1 Exposure Compensation setting. Exposure: ISO 100, f/6.3, 1/60 second.

> **Note** *Bulb is an exposure where the shutter remains open as long as you press the Shutter button. Bulb exposures are used for some fireworks and astral photography. You can set Bulb using M shooting mode. When you set the shutter speed in M mode, turn the Main dial to the left until Bulb appears as an option. Of course, always use a tripod for Bulb exposures.*

You can set Exposure Compensation by following these steps:

1. **With the Mode dial set to P, Tv, Av, or A-DEP, press the Display button if the Quick Control screen isn't already displayed on the LCD.**

2. **Press the Set button, and then press a cross key to highlight the Exposure Level Indicator.** The Exposure Level Indicator is highlighted in blue.

3. **Turn the Main dial to the left to set negative Exposure Compensation or to the right to set positive compensation.**

To turn off Exposure Compensation when you finish shooting, repeat these steps, but in Step 3, turn the Main dial until the tick mark is at the center of the exposure level meter that's displayed in the viewfinder.

Auto Exposure Bracketing

While not directly modifying the camera's metered exposure, Auto Exposure Bracketing (AEB) fits in the category of exposure modification because it enables you to capture a series of three images at different exposures: one at the camera's standard exposure, one picture at an increased (lighter) exposure, and another picture at a decreased (darker) exposure. This ensures that one of the three exposures will be acceptable. While bracketing isn't necessary in all scenes, it's a good technique to use in scenes that are difficult to set up or that can't be reproduced. It is also useful in scenes with contrasty lighting such as a landscape with a dark foreground and a much lighter sky.

The camera is initially set to 1/3 f-stop increment exposure changes. If you want a greater level of exposure difference, you can set C.Fn I-1 to Option 1: 1/2-stop. With either setting, you can bracket image series up to +/- 2 f-stops.

Here are some things to know about AEB:

✦ You can't use AEB with the built-in or an accessory flash or when the shutter is set to Bulb. If you set AEB, and then pop up the built-in flash or pop it up while you're making one of the three bracketed images, the AEB settings are automatically and immediately cancelled.

✦ AEB is available in P, Tv, Av, and A-DEP shooting modes, but it is not available in Manual shooting mode.

✦ The order of bracketed exposures begins with the standard exposure followed by decreased (darker) and increased (lighter) exposures.

✦ You can use AEB in combination with Exposure Compensation. If you combine AEB with Exposure Compensation, the shots are taken based on the compensation amount.

✦ If Auto Lighting Optimizer is turned on, the effects of AEB may not be evident in the darker image because the camera automatically lightens dark images. You can turn off Auto Lighting Optimizer as described previously in this chapter.

Note *AEB is handy because it produces three different exposures that you can combine in an image-editing program. For example, if a scene has a wide difference between highlight and shadow areas, bracketed exposures provide exposures of both extremes as well as the standard exposure. In an image-editing program, you can then composite the bracketed exposures to get the best of the highlights, midtones, and shadows.*

Here's how AEB works in the different drive modes:

✦ In Continuous and Self-timer modes, pressing the Shutter button once automatically takes three bracketed exposures. In the Self-timer drive modes, the three bracketed shots are taken in succession each after the timer interval has elapsed.

✦ In Single-shot drive mode, you have to press the Shutter button three times to get the three bracketed exposures.

✦ If C.Fn III-9 is set for Mirror Lockup, and you're using AEB and Continuous drive mode, only one of the bracketed shots is taken at a time. You press the Shutter button once to lock up the mirror and again to make the first bracketed exposure. The Exposure Level Indicator in the viewfinder flashes after each exposure until all three bracketed images have been made. The exposure index on the LCD also shows which of the exposures is currently being made, for example, the decreased exposure.

AEB settings are cancelled if you pop up the built-in flash or mount an accessory flash, or turn off the camera.

You can set AEB by following these steps:

1. **With the Mode dial set to P, Tv, Av, or A-DEP, press the Display button if the Quick Control screen isn't already displayed on the LCD.**

2. **Press the Set button, and then press the up or down cross key to activate the Exposure Level Indicator.**

3. **Hold down the Av button on the back of the camera as you turn the Main dial to the right to set the bracketing amount.** Markers that show increased and decreased exposure settings are displayed on the bracketing scale. You can set bracketing up to +/- 2 stops.

 If you want to shift the bracketed exposures so they all are in the negative or positive range, then release the Av button, and turn the Main dial to the left to set negative exposure bracketing, or to the right to set positive exposure bracketing.

4. **If you're in One-shot drive mode, press the Shutter button to focus, and then press it completely to take the picture. Continue pressing the Shutter button two more times to take all three bracketed shots. In Continuous or a Self-timer mode, the three shots are taken by pressing the Shutter button once.**

Auto Exposure Lock

Many times you don't want to set or bias the exposure metering at the same point where you set the focus. For example, if you're taking a portrait, you may want to set or bias the exposure for the person's skin so that it's properly exposed. But you want to focus on the person's eyes. To meter on one area but focus on another area, you can use Auto Exposure (AE) Lock that keeps the exposure at the locked level even if you move the camera to another lighter or darker area of the scene.

By pressing the Shutter button halfway down and then holding the AE Lock button, the camera sets and retains the exposure, and then you can move the camera and focus on a different area of the scene. You can use AE Lock to meter on a gray card or a middle-gray area in the scene, to help prevent blowout of detail in the highlights, to ensure proper exposure for a backlit subject, and anytime you want to ensure correct exposure of a critical area in the scene. The camera maintains the locked exposure for one to two seconds, and then releases it and starts metering again.

2.20 For this image, I used Spot metering mode, came in close to the mannequin to take a light meter reading on the face, and then I locked that exposure using AE Lock. Exposure: ISO 100, f/4.5, 1/640 second.

 Note *You cannot use AE Lock in the automatic Basic Zone shooting modes such as Portrait, Landscape, Close-up, and so on.*

Table 2.1 shows how AE Lock works with each metering mode and AF point selection method and with manual focus.

Table 2.1
AE Lock Behavior with Metering Mode and AF-Point Selection

Metering Mode	Manual AF-Point Selection	Automatic AF-Point Selection	Manual Focus (Lens switch is set to MF)
Evaluative metering mode	AE Lock is set at the selected AF point	AE Lock is set at the AF point that achieves focus	AE Lock is set at the center AF point
Partial metering mode	AE Lock is set at the center AF point		
Spot metering mode			
Center-weighted Average metering mode			

You can use AE Lock by following these steps:

1. **Set the Mode dial set to P, Tv, Av, or A-DEP shooting mode, set the metering mode to Evaluative, and then manually select the AF point that you want to use.** Note that in A-DEP mode, the camera automatically selects the AF points. If you want to use Partial, Spot, or Centered-weighted Average metering modes, then AE Lock is set at the center AF point.

2. **Point the selected AF point to the part of the scene where you want to set the exposure, and then press the Shutter button halfway down.** The exposure is displayed in the viewfinder.

3. **Continue to hold the Shutter button halfway down as you press the AE Lock button.** The AE Lock button has an asterisk icon above it on the camera. When you press this button, an asterisk icon appears in the viewfinder to indicate that AE Lock is activated.

4. **Release the Shutter button, and then move the camera to compose the shot.**

5. **Half-press the Shutter button to focus on the subject, and then press it completely to make the picture.** As long as you see the asterisk in the viewfinder, you can take additional pictures using the locked exposure. After a few seconds, AE Lock shuts off automatically.

Getting Tack-Sharp Focus

Whether you're shooting one image at a time or you are blasting out a burst of images during a soccer match, the Rebel T1i/500D's quick focus can keep up and

provide tack-sharp focus. The camera provides three autofocus modes that are suited to different types of shooting. In addition, you can choose any of the nine AF points, or you can have the camera automatically choose the AF points.

The following sections help you get the best performance from the Rebel T1i/500D's autofocus system.

Choosing an autofocus mode

The Rebel T1i/500D's three autofocus modes are designed to help you achieve sharp focus based on the type of subject you're photographing. Here is a brief summary of the autofocus modes and when to use them. In any of these modes, you can manually select an AF point or have the camera automatically select the AF point(s). Selecting an autofocus point is detailed later in this chapter.

✦ **One-shot AF.** This mode is designed for photographing stationary subjects that are still and will remain still. Choose this mode when you're shooting landscapes, macro subjects, architecture, interiors, and portraits of adults. Unless you're shooting sports or action, One-shot AF is the mode of choice for everyday shooting. In this autofocus mode, the camera won't allow you to make the picture until the camera achieves sharp focus. Sharp focus is confirmed when the focus confirmation light in the viewfinder is lit and when the beeper sounds if you have the beeper turned on.

✦ **AI Servo AF.** This mode is designed for photographing action subjects. Focus is tracked regardless of the changes in focusing distance from side to side or approaching or moving away from the camera. The camera sets both the focus and the exposure at the moment the image is made. In this mode, you can press the Shutter button completely even if the focus hasn't been confirmed. You can use a manually selected AF point in this mode although it may not be the AF point that ultimately achieves sharp focus. Or if you use automatic AF selection, the camera starts focus using the center AF point and tracks movement as long as the subject remains within the other eight AF points in the viewfinder.

✦ **AF Focus AF.** This mode is designed for photographing stationary subjects that may begin moving. This mode starts out in One-shot AF mode, but it automatically switches to AI Servo AF if the subject begins moving. Then the camera tracks focus on the moving subject. When the switch happens, a soft beep alerts you that the camera is shifting to AI Servo AF, and the focus confirmation light in the viewfinder is no longer lit. (The beeper beeps only if you have turned on the beeper on the Shooting 1 camera menu.) This is the mode to choose when you shoot wildlife, children, or athletes who alternate between stationery positions and motion. In this mode, focus tracking is activated by pressing the Shutter button halfway down.

Tip *If you routinely set focus and then keep the Shutter button pressed halfway down, you should know that this shortens battery life. To maximize power, anticipate the shot and press the Shutter button halfway down just before making the picture.*

In P, Tv, Av, M, and A-DEP shooting modes, you can select among these AF modes. In Basic Zone modes, the camera automatically chooses the autofocus mode.

To change AF modes in Creative Zone modes, ensure that the lens switch is set to AF (auto-focus), and then follow these steps:

1. **With the camera set to P, Tv, Av, M, or A-DEP shooting mode, press the AF (right cross key) button on the back of the camera.** The AF mode screen appears.

2. **Press the right or left cross key to change the AF mode, and then press the Set button.** The mode you choose remains in effect for shooting in Creative Zone modes until you change it.

As you've learned by now, almost every function of the camera relates to other functions, and the same is true for AF modes.

Tip *You can switch to manual focus at any time by setting the switch on the side of the lens to the MF (Manual Focus) setting. Then just turn the focusing ring on the lens to focus on the subject.*

Selecting a single autofocus point

One of the requirements for a successful picture is getting tack-sharp focus. When you're shooting in P, Tv, Av, and M modes, you can manually choose one of the nine AF points shown in the viewfinder. In the automatic Basic Zone and in A-DEP shooting modes, the camera automatically selects the AF point or points for you. Once you or the camera selects an AF point or points, it is used to establish the point of sharpest focus in the image.

2.21 Nine AF points are shown on the focusing screen on the Rebel T1i/500D.

Tip *The center AF point is the most sensitive AF point especially if you're using a lens with a maximum aperture of f/2.8 or faster.*

Having the camera automatically choose the AF points may or may not set sharp focus where you want it to be in the scene. When the camera chooses the AF points automatically, it focuses on whatever is nearest the lens or has the most readable contrast. This may or may not be the area that should have the point of sharpest focus. Because sharp focus is critical to the success of any image, you may want to switch to P, Tv, Av, or M mode and manually select a single AF point.

Does Focus-Lock and Recompose Work?

Some suggest that you can use the standard point-and-shoot technique of focus-lock and recompose with the Rebel T1i/500D. This is the technique where you lock focus on the subject, and then move the camera to recompose the image. In my experience, however, the focus shifts slightly during the recompose step regardless of which AF point is selected. As a result, focus is not tack sharp.

Some Canon documents note that at distances within 15 feet of the camera and when shooting with large apertures, the focus-lock-and-recompose technique increases the chances of *back-focusing*. Back-focusing is when the camera focuses behind where you set the AF point. Either way, the downside of not using the focus-lock-and-recompose technique is that you're restricted to composing images using the nine AF points in the viewfinder. The placement of the nine AF points isn't the most flexible arrangement for composing images. But manually selecting one AF point, locking focus, and then not moving the camera is the best way that I know to ensure tack-sharp focus in One-shot AF mode.

You can manually select the AF point by following these steps:

1. **Set the Mode dial to P, Tv, Av, or M mode.** In A-DEP shooting mode, the camera automatically sets the AF point or points for you.

2. **Press the AF-Point Selection/ Magnify button on the back upper-right corner of the camera.** The AF-Point Selection button has a magnifying glass with a plus sign in it icon below the button. The currently selected AF point lights in red.

3. **As you look in the viewfinder or watch the LCD, turn the Main dial until the AF point that you want to use is highlighted in the viewfinder.** You can also use the cross keys to select an AF point. If you select the option where all of the AF points are highlighted, then the camera automatically selects the AF point or points. If you want to control the point of sharpest focus in the image, then do not choose this option. Rather, choose an option where one AF point is highlighted. To quickly move to the center AF point, press the Set button once.

4. **Move the camera so that the AF point you selected is over the point in the scene that should have sharp focus, press the Shutter button halfway down to focus on the subject, and then press it fully to make the picture.**

You can verify image sharpness by pressing the Playback button, and then pressing and holding the AF-Point Selection/Magnify button on the back of the camera.

Improving Autofocus Accuracy and Performance

Autofocus speed depends on factors including the size and design of the lens, the speed of the lens-focusing motor, the speed of the AF sensor in the camera, the amount of light in the scene, and the level of subject contrast. Given these variables, it's helpful to know how to get the speediest and sharpest focusing. Here are some tips for improving overall autofocus performance.

✦ **Light.** In low-light scenes, the autofocus performance depends in part on the lens speed and design. In general, the faster the lens or the larger the maximum aperture of the lens, such as f/2.8, the faster the autofocus performance. But regardless of the lens, the lower the light, the longer it takes for the system to focus.

Low-contrast subjects and/or subjects in low light slow down focusing speed and can cause autofocus failure. In low light, consider using the built-in flash or an accessory EX Speedlite's AF-assist beam as a focusing aid. By default, the Rebel T1i/500D is set to use the AF-assist beam for focusing. This is controlled by C.Fn III-8.

✦ **Focal length.** The longer the lens, the longer the time to focus. This is true because the range of defocus is greater on telephoto lenses than on normal or wide-angle lenses. You can improve the focus time by manually setting the lens in the general focusing range and then using autofocus to set the sharp focus.

✦ **AF-point selection.** Manually selecting a single AF point provides faster autofocus performance than using automatic AF-point selection because the camera doesn't have to determine and select the AF point or points to use first.

✦ **Subject contrast.** Focusing on low-contrast subjects is slower than on high-contrast subjects. If the camera can't focus, shift the camera position to an area of the subject that has higher contrast, such as a higher contrast edge.

✦ **EF Extenders.** Using an EF Extender reduces the speed of the lens-focusing drive.

✦ **Wide-angle lenses and small apertures.** Sharpness can be degraded by diffraction when you use small apertures with wide-angle or wide-angle zoom lenses. Diffraction happens when light waves pass around the edges of an object and enter the shadow area of the subject producing softening of fine detail. To avoid diffraction, avoid using apertures smaller than f/16 with wide-angle prime (single-focal length) and zoom lenses.

Selecting a Drive Mode

A drive mode determines how many shots the camera takes at a time, or, in a Self-timer mode, it sets the camera to fire the shutter automatically after a 10- or 2-second delay. The Rebel T1i/500D offers three drive modes for different shooting situations: Single-shot, Continuous, and three self-timer modes. If you're shooting one image at a time, then the 3.4 fps speed applies. But if you're shooting in Continuous drive mode, then you can fire off a burst of up to 170 JPEG images or 9 RAW images.

In Basic Zone modes, the camera automatically chooses the drive mode. In CA shooting mode, you can choose the drive mode, and you can select the drive mode in P, Tv, Av, M, and A-DEP modes.

Here is a summary of each drive mode.

Single-shot mode

As the name implies, Single-shot means that the T1i/500D takes one picture each time you press the Shutter button. In this mode, you can shoot 3.4 fps, depending on shutter speed for the image you're shooting. This is the default mode on the camera in P, Tv, Av, M, and A-DEP modes. In the automatic Basic Zone modes, Single-shot drive mode is used for all except Full Auto and Sports shooting modes. In CA mode, you can choose Single-shot, Continuous, and two of the self-timer drive modes.

Continuous mode

In Continuous drive mode, you can shoot at 3.4 fps, or, if you press and hold the Shutter button, you shoot a continuous burst of

170 or more JPEG Large images, 9 RAW, or 4 RAW+JPEG Large images. This is the mode to choose for sports shooting or for other moving subjects such as children, pets, and wildlife.

 Note *In AI Servo AF mode, the burst rate may be less, depending on factors including the lens and the subject.*

When you're shooting a burst of images and the buffer fills up, you can't shoot until some of the images are offloaded to the SD/SDHC card. Thanks to Canon's smart-buffering capability, you don't have to wait for the buffer to empty all the images to the media card before you can continue shooting. After a continuous burst sequence, the camera begins offloading pictures from the buffer to the card. As offloading progresses, the camera indicates in the viewfinder when there is enough buffer space to continue shooting. When the buffer is full, a "busy" message appears in the viewfinder, but if you keep the Shutter button pressed, the number of pictures that you can take is updated in the viewfinder. This is where it is useful to have a fast SD/SDHC card, which speeds up image offloading from the buffer. You can use the flash with Continuous mode, but due to the flash recycle time, shooting will be slower than without the flash.

 Note *If the AF mode is set to AI Servo AF, the T1i/500D focuses continually during continuous shooting. However, in One-shot AF mode, the camera only focuses once during the burst.*

Self-timer modes

In self-timer modes, the camera delays making the picture for 10 or 2 seconds after the Shutter button is fully depressed. In addition, you can use 10-second delay plus Continuous shooting. For self-timer shots,

be sure to use the eyepiece cover included with the camera to prevent stray light from entering through the viewfinder.

Here is a summary of the self-timer modes:

✦ **10-second self-timer.** In this mode, the camera waits 10 seconds before the shutter is fired giving you time to get into the picture. In addition, you can use the accessory wireless Remote Controller RC-1 or RC-5 that trips the shutter immediately or after 2 seconds, or the corded Remote Switch RS-60E3 with this mode. This mode is useful when you want to be in the picture with others, and for nature, landscape, and close-up shooting. It can be combined with Mirror Lockup (C.Fn III-9). With this combination, you have to press the Shutter button once to lock the mirror, and again to make the exposure.

✦ **2-second self-timer.** In this mode, the camera waits for 2 seconds before firing the shutter. This is a good choice when you're photographing documents or artwork. If you use the 2-second self-timer with Mirror Lockup, the mirror locks up when you press the Shutter button completely, and then the image is made after the 2-second delay.

✦ **10-second self-timer plus continuous shots.** In this mode, you can choose to have the camera take two to ten shots in sequence, each with a 10-second delay.

To change the drive mode, follow these steps:

1. **If the Quick Access screen isn't displayed, press the Display button to display it, and set the Mode dial to P, Tv, Av, M, or A-DEP shooting mode.** You can also set the Mode dial to CA.

2. **Press the Set button to activate the controls on the Quick Access screen, and then press a cross key to activate the Drive mode control displayed at the bottom right of the screen.** A single rectangle indicates Single-shot, tiled rectangles indicate Continuous mode, and stop watches with or without a numeral or the letter "C" denote the self-timer modes. In the Self-timer Continuous mode, the Rebel is set to shoot two images, but you can change the number of images to ten by pressing the up or down cross keys.

3. **Turn the Main dial to change the drive mode.** As you turn the Main dial, the icons indicating each drive mode cycle through. A single rectangle indicates Single-shot, tiled rectangles indicate Continuous mode, and stop watches with or without a numeral or the letter "C" denote the self-timer modes. Alternately, you can press the Drive mode button to the left of the Set button to display the Drive mode screen where you can set the drive mode. The mode you choose remains in effect until you change it.

Getting Great Color

With all the options for setting and refining color on the Rebel T1i/500D, you'll get excellent color in any type of light. Getting great color begins during shooting by selecting a white balance and Picture Style. And you can choose a color space to best match your printing needs. In this chapter, you learn how each option is useful in different shooting scenarios as well as learning some techniques for ensuring accurate color in any light. But before we talk about camera controls and options that ensure accurate color, it's important to understand the concepts of light and its colors.

Working with Light

One of the characteristics that will set your images apart from others is great light — looking and waiting for or setting up beautiful light makes all the difference. In addition, you can use the qualities of light to set the mood; control the viewer's emotional response to the subject; reveal or subdue the subject's shape, form, texture, and detail; and render scene colors as vibrant or subdued. This section provides the basics for exploring and using the characteristics of light.

Understanding color temperature

Few people think of light as having color until the color becomes obvious, such as at sunrise and sunset when the sun's low angle causes light to pass through more of the earth's atmosphere, creating visible and often dramatic color. However, regardless of the time of day, natural light has a color temperature, and each color, or hue, of sunlight renders subjects differently. Likewise, household and commercial light bulbs, candlelight, flashlights, and electronic flashes all have distinct color temperatures.

How Color Temperature Is Determined

Unlike air temperature, which is measured in degrees Fahrenheit (or Celsius), light temperature is based on the spectrum of colors that is radiated when a black body radiator is heated. Visualize heating an iron bar. As the bar is heated, it glows red. As the heat intensifies, the metal color changes to yellow, and with even more heat, it glows blue-white. In this spectrum of light, color moves from red to blue as the temperature increases.

This concept can be confusing because "red hot" is often thought of as being significantly warmer than blue. But in the world of color temperature, blue is, in fact, a much higher temperature than red. That also means that the color temperature at noon on a clear day is higher (bluer) than the color temperature of a fiery red sunset. And the reason that you should care about this is because it affects the color accuracy of your images.

The color of the light is not always obvious to us. As humans, our eyes automatically adjust to the changing colors of light so that white appears white, regardless of the type of light in which we view it. Digital image sensors are not, however, as adaptable as the human eye. For example, when the Rebel T1i/500D is set to Daylight White Balance, it renders color in a scene most accurately in the light at noon on a sunny, cloudless day. But the Daylight White Balance setting does not render color as accurately under household light because the temperature of the light is different.

Because different times of day and different light sources have different color temperatures, the camera must be set to match the temperature of the light in the scene to get accurate color in images.

Color temperature is measured on the Kelvin temperature scale and is expressed in units that are abbreviated simply as K. For example, sunlight on a clear day can range between 5200K and 5500K, and the Daylight White Balance setting on the Rebel is roughly set to that temperature range.

3.1 Late-afternoon light provided bright light and high contrast for this image of spring flowers. Exposure: ISO 100, f/5.6, 1/1000 second.

When learning about color temperatures, keep in mind this general principle: The higher the color temperature is, the cooler (or bluer) the light; the lower the color temperature is, the warmer (or yellower/redder) the light.

On the T1i/500D, setting the white balance tells the camera the general range of the light temperature so that it can render white as white, or neutral, in the final image. The more faithful you are in setting the correct white balance or in setting a custom white balance, the less color correction you have to do on the computer.

The colors of light

The color temperature of natural light changes throughout the day. By knowing the predominant color temperature shifts throughout the day, you can adjust settings to ensure accurate color, to enhance the predominant color, and, of course, to use color creatively to create striking photos. Studio and flash light have specific color temperatures, and they can be adjusted for on the camera as well.

Here is a brief overview of different types of light and their characteristics.

Sunrise

In predawn hours, the cobalt and purple hues of the night sky dominate but they change to warm gold and red hues as the sun rises over the horizon. During this time of day, the green color of grass, tree leaves, and other foliage is enhanced, while earth tones take on a cool hue. Although you can use the AWB (Automatic White Balance) setting, you get better color if you set a custom white balance. The preset white balance settings and setting a custom white balance are detailed later in this chapter.

Midday

During midday hours, the warm and cool hues of light equalize to create a light the human eye sees as white or neutral. On a cloudless day, midday light often is considered too harsh and contrasty for many types of photography, such as portraiture. However, midday light is effective for photographing images of graphic shadow patterns, flower petals and plant leaves made translucent against the sun, and images of natural and man-made structures. For midday pictures, the Daylight White Balance setting on the Rebel T1i/500D is a reliable choice.

Sunset

During the time just before, during, and just after sunset, the warmest and most intense color hues of natural light occur. The predominantly red, yellow, and gold hues create vibrant colors, while the low angle of the sun creates soft contrasts that define and enhance textures and shapes. Sunset colors create rich landscape, cityscape, and wildlife photographs. For sunset pictures, the Cloudy or AWB settings are good choices.

Diffused light

On overcast or foggy days, the light is diffused and tends toward cool color hues. Diffusion spreads light over a larger area, making it softer and usually reducing or eliminating shadows. Light can be diffused by clouds; an overcast sky; atmospheric conditions including fog, mist, dust, pollution, and haze; or objects such as awnings or shade from trees or vegetation. Diffused light renders colors as rich and saturated, and it creates subdued highlights and soft-edged shadows. Because overcast and cloudy conditions commonly are between 6000K and 8000K, the Cloudy White Balance setting on the T1i/500D provides accurate color in overcast and cloudy conditions.

3.2 Dense fog diffuses light and creates a tranquil mood in this image of flooded farmland. Exposure: ISO 200, f/2.8, 1/100 second.

Electronic flash

Most on-camera electronic flashes are balanced for the neutral color of midday light, or 5500K to 6000K. Because the light from an electronic flash is neutral, it reproduces colors accurately. Flash is useful in low-light situations, and it is also handy outdoors to fill or eliminate deep shadow areas caused by strong top lighting. On the T1i/500D, the Flash White Balance setting, is the best option to reproduce colors accurately.

Tungsten light

Tungsten is typically the light provided by household lights and lamps. This light has a warmer hue than daylight and produces a yellow/orange cast in photos. In moderation, the yellow hue is valued for the warm feeling it lends to images. Setting the T1i/500D to the Tungsten White Balance setting retains the warm hue of tungsten light while rendering colors with reasonable

accuracy. If you want neutral colors without the warm hue of tungsten, then set a custom white balance.

Fluorescent and other light

Commonly used in offices and public places, fluorescent light ranges from a yellow to a blue-green hue. Other types of lighting include mercury-vapor and sodium-vapor lights found in public arenas and auditoriums that have a green-yellow cast in unfiltered/ uncorrected photos. You should either use Auto White Balance, or set a custom white balance on the T1i/500D in this type of light. Light from fire and candles creates a red-orange-yellow color hue. In most cases, the color hue is warm and inviting and you can modify it to suit your taste on the computer.

 Note *To learn more about light, visit Canon's Web site at www.canon. com/technology/s_labo/light/ 003/01.html.*

Metering light

Light is the basis for all photographic exposures, and to make a proper exposure, the camera must first measure the amount of light in a scene. Measuring or "metering" light is done by using the Rebel T1i/500D's onboard light meter as detailed in Chapter 2.

In any scene, the light meter sees tones ranging from black to white and all shades of gray between. The meter measures how much light that these shades of gray, plus black and white reflect back to it. Objects that are neutral gray, or an even mix of black and white, reflect 18 percent of the light falling on them and absorb the rest of the light. In the black-and-white world of a camera's light meter, objects that are white reflect 72 to 90 percent of the light and absorb the remainder. Objects that are black absorb virtually all of the light.

Because the camera's light meter sees only monotone, you may wonder how that translates to color. Simply stated, all of the colors that you see translate to a percentage or shade of gray. In color scenes, the light and dark values of color correspond to the swatches of gray on the grayscale. A shade of red, for example, has a corresponding shade of gray on a grayscale. The lighter the color's shade, the more light it reflects. Predictably, intermediate percentages between black and white reflect and absorb different amounts of light.

3.3 A single strobe and a silver reflector lit these red tulips. Exposure: ISO 100, f/22, 1/125 second.

Because light has varying temperatures, you can help ensure accurate color by choosing the white balance setting that matches the type of light in which you're shooting. The following sections detail the options you can choose on the Rebel T1i/500D.

Choosing White Balance Options

White balance settings tell the Rebel what type of light is in the scene so that it can render colors accurately in images. Using white balance settings can help you spend more time shooting and less time color-correcting images. On the Rebel T1i/500D, you can choose one of seven preset white balance options, or you can set a custom white balance.

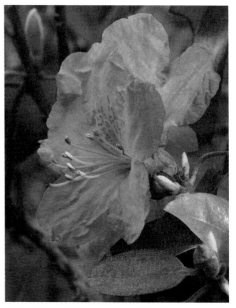

3.5 This image was captured using the Daylight White Balance setting and the Standard Picture Style.

3.4 This image was taken using the Automatic White Balance (AWB) setting. Exposure: ISO 100, f/8, 1/200 second.

3.6 This image was captured using the Shade White Balance setting.

3.7 This image was taken using the Cloudy White Balance setting.

3.9 This image was taken using the Fluorescent White Balance setting.

3.8 This image was taken using the Tungsten White Balance setting.

3.10 This image was taken using the Flash White Balance setting.

Tip *If you shoot RAW images, you can set and adjust the white balance in the RAW conversion program after the image is captured.*

Using white balance options

Because the Rebel T1i/500D offers two basic approaches to setting white balance, you may find that you use different approaches in different situations. For most scenes where there is clearly defined light, the preset white balance options such as Daylight, Cloudy, and so on, provide accurate color. In mixed lighting situations, you'll get the most accurate image color by setting the white balance to Custom. The choice also depends on the amount of time you have. If you don't have time to set a custom white balance, then use the Auto White Balance that's designed to work well in any type of light.

Whatever your approach to white balance options, the time you spend using and understanding them and how they can enhance your images is time that you'll save color-correcting images on the computer.

To change to a preset white balance option such as Daylight, Tungsten, Shade, and so on, follow these steps:

1. **Set the Mode dial to P, Av, Tv, M, or A-DEP, and then press the WB button on the back of the camera.** The WB button is the up cross key. The White balance screen appears.

Getting Accurate Color with RAW Images

If you are shooting RAW capture, a great way to ensure accurate color is to photograph a white or gray card that is in the same light as the subject, and then use the card as a color-balancing point when you convert RAW images on the computer.

For example, if you're taking a portrait, ask the subject to hold the gray card under or beside his or her face for the first shot only. Then continue shooting without the card in the scene. When you begin converting the RAW images on the computer, open the picture that you took with the card. Click the card with the white balance tool to correct the color, and then click Done to save the corrected white balance settings. If you're using a RAW conversion program such as Adobe Camera Raw or Canon's Digital Photo Professional, you can copy the white balance settings from the image you just color balanced. Just select all of the images shot under the same light, and then paste the white balance settings to them. In a few seconds, you can color balance 10, 20, 50, or more images.

There are a number of white and gray card products you can use such as the WhiBal cards from RawWorkflow.com (www.rawworkflow.com/products/whibal) or ExpoDisc from expoimaging (www.expodisc.com/index.php) to get a neutral reference point. There are also small reflectors that do double duty by having one side in 18 percent gray and the other side in white or silver. The least expensive option, and one that works nicely, is a plain white unlined index card.

2. **Press the left or right cross key to select a white balance setting, and then press the Set button.** Because the white balance option you set remains in effect until you change it, remember to reset it when you start shooting in different light.

Set a custom white balance

Mixed-light scenes, such as tungsten and daylight, can wreak havoc on getting accurate or visually pleasing image color. In mixed-lighting scenes, setting a custom white balance balances colors for the specific light or combination of light types in the scene. A custom white balance is relatively easy to set, and it's an excellent way to ensure accurate color.

 Note *You can learn more about setting custom white balance at www. cambridgeincolour.com/tutorials/ white-balance.htm.*

Another advantage to custom white balance is that it works whether you're shooting JPEG or RAW capture in P, Tv, Av, M, or A-DEP mode. Just remember that if light changes, you need to set a new custom white balance to get accurate color.

To set a custom white balance, follow these steps:

1. **Set the camera to P, Av, Tv, M, or A-DEP shooting mode, and ensure that the Picture Style is not set to Monochrome.** To check the Picture Style, press the Picture Style button (the down cross key) on the back of the camera. The Picture Style screen is displayed. To change from Monochrome, which

is denoted on the Picture Style screen with an "M," press the left or right cross key to select another style, and then press the Set button. Also have the white balance set to any setting except Custom.

2. **With the subject in the light you'll be shooting in, position a piece of unlined white paper so that it fills the center of the viewfinder (the Spot metering circle), and take a picture.** If the camera cannot focus, switch the lens to MF (manual focus) and focus on the paper. Also ensure that the exposure is neither underexposed nor overexposed such as by having Exposure Compensation set.

3. **Press the Menu button, and then turn the Main dial to select the Shooting 2 (red) menu.**

4. **Press the up or down cross key to highlight Custom WB, and then press the Set button.** The camera displays the last image captured (the white piece of paper) with a Custom White Balance icon in the upper left of the display. If the image of the white paper is not displayed, press the left cross key until it is.

5. **Press the Set button again.** The T1i/500D displays a confirmation screen asking if you want to use the white balance data from this image for the custom white balance.

6. **Press the right cross key to highlight OK, and then press the Set button.** A second confirmation screen appears.

7. **Press the Set button to select OK, and then press the Shutter button to dismiss the menu.** The camera imports the white balance data from the selected image.

8. **Press the WB button on the back of the camera, and then press the right cross key to select Custom White Balance.** The White balance screen appears. The Custom White Balance setting is identified with text and is denoted by an icon with two triangles on their sides with a black dot between them.

9. **Press the Set button.** You can begin shooting now and get custom color in the images as long as the light doesn't change. The Custom White Balance remains in effect until you change it by setting another white balance.

When you finish shooting in the light for which you set Custom White Balance and move to a different area or subject, remember to reset the white balance option.

Use White Balance Auto Bracketing

Given the range of indoor tungsten, fluorescent, and other types of lights that are available, the preset white balance options may or may not be spot-on accurate for the type of light in the scene. Alternately, you may prefer a bit more of a green or blue bias to the overall image color. With the Rebel T1i/500D, you can use White Balance Auto Bracketing to get a set of three images, each a slightly different color bias up to plus/minus three levels in one-step increments.

White Balance Auto Bracketing is handy when you don't know which color bias will give the most pleasing color or when you don't have time to set a manual white balance correction. The white balance bracketed sequence gives you three images from which you can choose the most visually pleasing color.

 Note *White Balance Auto Bracketing reduces the maximum burst rate of the Rebel T1i/500D by one-third because each press of the Shutter button records three images.*

To set White Balance Auto Bracketing, follow these steps:

1. **With the camera set to P, Tv, Av, M, or A-DEP shooting mode, press the Menu button, and then turn the Main dial until the Shooting 2 (red) menu appears.**

2. **Press the down cross key to highlight WB SHIFT/BKT, and then press the Set button.** The WB Correction/WB Bracketing screen appears.

3. **Turn the Main dial clockwise to set Blue/Amber bias, or counterclockwise to set a Magenta/Green bias.** As you turn the Main dial, three squares appear and the distance between them increases as you continue to turn the dial. The distance between the squares sets the amount of bias. On the right side of the screen, the camera indicates the bracketing direction and level under BKT. You can set up to plus/minus three levels of bias. If you change your mind and want to start again, press the Display (DISP.) button on the back of the camera.

4. **Press the Set button.** The Shooting 2 (red) menu appears with the amount of bracketing displayed next to the menu item.

5. **Lightly press the Shutter button to dismiss the menu.**

6. **If you're in One-shot drive mode, press the Shutter button three times to capture the three bracketed images, or if you're in Continuous drive mode, press and hold the Shutter button to capture the three bracketed images.** With a blue/amber bias, the standard white balance is captured first, and then the bluer and more amber bias shots are captured. If magenta/green bias is set, then the image-capture sequence is the standard, then more magenta, then more green bias. White Balance Bracketing continues in effect until you remove it or the camera is turned off.

Note — You can combine White Balance Bracketing with Auto Exposure Bracketing. If you do this, a total of nine images are taken for each shot. Bracketing also slows the process of writing images to the SD/SDHC card.

Set White Balance Correction

Similar to White Balance Auto Bracketing, you can also manually set the color bias of images to a single bias by using White Balance Correction. The color can be biased toward blue (B), amber (A), magenta (M), or green (G) in plus/minus nine levels measured as mireds, or densities. Each level of color correction that you set is equivalent to five mireds of a color-temperature conversion filter. When you set a color correction or bias, it is used for all images until you change the setting.

Note — On the Rebel T1i/500D, color compensation is measured in mireds, a measure of the density of a color-temperature conversion filter, which is similar to densities of color-correction filters used in film photography that range from 0.025 to 0.5. Shifting one level of blue/amber correction is equivalent to five mireds of a color-temperature conversion filter.

To set White Balance Correction, follow these steps:

1. **Press the Menu button, and then turn the Main dial to select the Shooting 2 (red) menu.**

2. **Press the down cross key to highlight WB SHIFT/BKT, and then press the Set button.** The WB Correction/WB Bracketing screen appears.

3. **Press a cross key to set the color bias and amount that you want — toward blue, amber, magenta, or green.** On the right of the screen, the SHIFT panel shows the bias and correction amount. For example, A2, G1 shows a two-level amber correction with a one-level green correction. If you change your mind and want to start again, press the Display button on the back of the camera.

4. **Press the Set button.** The Shooting 2 menu appears. The color shift you set remains in effect until you change it. To turn off White Balance Correction, repeat Steps 1 and 2, and in Step 3, press the Display button to return the setting to zero.

Choosing and Customizing a Picture Style

The first step to good color is choosing the correct White Balance option. The second step is to set the color tone, saturation, and image contrast by choosing a Picture Style. A Picture Style is the foundation for how images are rendered, and regardless of the shooting mode you choose, a Picture Style is applied. Individual styles offer different "looks," just as different films do. For example, the Landscape Picture Style has vivid color saturation similar to Fuji Velvia film, while the Portrait Picture Style, similar to Kodak Portra film, renders portraits with warm, soft skin tones and sub-dued color saturation.

The Rebel T1i/500D offers six Picture Styles, which are detailed in Table 3.2. The camera uses the Standard Picture Style as the default style for P, Tv, Av, M, and A-DEP shooting modes, and for all Basic Zone modes except Portrait and Landscape shooting modes. Each Picture Style has settings for sharpness, contrast, color saturation, and color tone that you can use as is or you can modify them to suit your preferences. In addition, you can create up to three User Defined Styles that are based on one of Canon's Picture Styles.

Figures 3.11 through 3.17 show how Picture Styles change image renderings. The differences may not be as apparent in this book due to commercial printing, but they give you a starting point for evaluating differences in Picture Styles. The collection of objects in each image is designed to help you evaluate how each style affects a range of colors and skin tones. The images were shot using a custom white balance.

3.11 Standard Picture Style

3.12 Portrait Picture Style

3.13 Landscape Picture Style

3.14 Neutral Picture Style

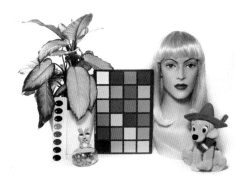

3.15 Faithful Picture Style

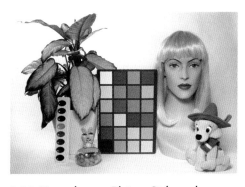

3.16 Monochrome Picture Style and no filter effect

Besides forming the basis of image rendering, Picture Styles are designed to give you good prints with little or no post-processing so that you can print JPEG images directly from the SD/SDHC card. If you shoot RAW capture, you can't print directly from the SD/SDHC card, and the Picture Style is noted for the file, but it's not applied unless you use Canon's Digital Photo Professional program. You can also apply a Picture Style during RAW-image conversion using Canon's Digital Photo Professional conversion program.

> **Tip** Be sure to test Picture Styles first, and then choose the ones that provide the best prints for your JPEG images.

In addition, you can modify a Picture Style on the computer using Canon's Picture Style Editor detailed later in this chapter.

Choosing and customizing Picture Styles helps you get the kind of color results out of the camera that you want. If you find that you want to adjust a Picture Style, here are the adjustments that you can modify when you're shooting in P, Tv, Av, M, and A-DEP shooting modes.

✦ **Sharpness: 0 to 7.** Level zero applies no sharpening and renders a very soft look, whereas level 7 is the highest sharpening setting. If you print images directly from the SD/SDHC card, a moderate amount of sharpening, such as level 3, produces sharp images. But if your workflow includes sharpening images after editing and sizing them in an editing program, then you may want to set a lower sharpening level for the Picture Style in the camera to avoid oversharpening.

✦ **Contrast.** This setting affects the image contrast as well as the vividness of the color. For images printed directly from the SD/SDHC card, a 0 (zero) to level 1 setting produces snappy contrast in prints. A negative adjustment produces a flatter look and a positive setting increases the contrast.

✦ **Saturation.** This setting affects the strength or intensity of the color with a negative setting producing low saturation and vice versa. A zero or +1 setting is adequate for snappy JPEG images destined for direct printing.

✦ **Color Tone.** This control primarily affects skin tone colors. Negative adjustments to color tone settings produce redder skin tones while positive settings produce yellower skin tones.

With the Monochrome Picture Style, only the sharpness and contrast parameters are adjustable, but you can add toning effects, as detailed in Table 3.1. Default settings are listed in order of sharpness, contrast, color saturation, and color tone.

Table 3.1
EOS T1i/500D Picture Styles

Picture Style	Description	Sharpness	Color Saturation	Default Settings
Standard	Vivid, sharp, crisp images that are suitable for direct printing from the SD/SDHC card	Moderate	High	3,0,0,0
Portrait	Enhanced skin tones, soft texture rendering	Low	Low	2,0,0,0
Landscape	Vivid blues and greens, high sharpness	High	High saturation for greens and blues	4,0,0,0
Neutral	Allows latitude for image editing and has low saturation and contrast	None	Low	0,0,0,0
Faithful	True rendition of colors with no increase in specific colors. No sharpness applied.	None	Low	0,0,0,0
Monochrome	Black-and-white or toned images with slightly high sharpness	Moderate	Yellow, orange, red, and green filter effects available	3,0, NA, NA

You can choose a Picture Style by following these steps:

1. **Press the Picture Style button on the back of the camera.** The Picture Style button is the down cross key. The Picture Style screen appears with the current Picture Style highlighted. The screen also shows the default setting for the style.

2. **Press the left or right cross key to highlight the Picture Style you want, and then press the Set button.**

After using, evaluating, and printing with different Picture Styles, you may want to change the default parameters to get the rendition that you want. Alternately, you may want to create a custom style. You can create up to three Picture Styles that are based on an existing style.

After much experimentation, I settled on a modified Neutral Picture Style that provides pleasing results for any images that I shoot in JPEG format. Here is how I've modified the Neutral Picture Style settings.

✦ **Sharpness.** +2

✦ **Contrast.** +1

✦ **Saturation.** +1

✦ **Color tone.** 0

These settings provide excellent skin tones provided that the image isn't underexposed and the lighting isn't flat. You can try this variation and modify it to suit your work.

To modify a Picture Style, follow these steps:

1. **With the camera set to P, Tv, Av, M, or A-DEP shooting mode, press the Menu button, and then turn the Main dial to select the Shooting 2 (red) menu.**

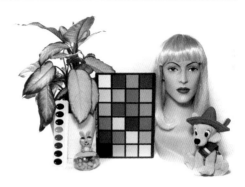

3.17 This is shot using my modified settings that are based on the Neutral Picture Style.

2. **Press the up or down cross key to highlight Picture Style, and then press the Set button.** The Picture Style screen appears with a list of the preset Picture Styles.

3. **Press the down cross key to highlight the Picture Style you want to modify, and then press the Display button.** The Detail set. screen for the selected Picture Style appears.

4. **To change the Sharpness parameter, which is selected by default, press the Set button.** The Sharpness control is activated.

5. **Press the left or right cross key to change the parameter, and then press the Set button.** For all the parameter adjustments, negative settings decrease sharpness, contrast, and saturation, and positive settings provide higher sharpness, contrast, and saturation. Negative color tone settings provide reddish tones, and positive settings provide yellowish skin tones.

6. **Press the down cross key to move to the Contrast parameter, and then press the Set button.** The camera activates the control.

Using Monochrome Filter and Toning Effects

While you can customize the Monochrome Picture Style, only the Sharpness and Contrast parameters can be changed. But, you have the additional option of applying a variety of Filter and/or Toning effects.

✦ **Monochrome Filter effects.** Filter effects mimic the same types of color filters that photographers use when shooting black-and-white film. The Yellow filter makes skies look natural with clear white clouds. The Orange filter darkens the sky and adds brilliance to sunsets. The Red filter further darkens a blue sky, and makes fall leaves look bright and crisp. The Green filter makes tree leaves look crisp and bright and renders skin tones realistically. You can increase the effect of the filter by increasing the Contrast setting.

✦ **Monochrome Toning effects.** You can choose to apply a creative toning effect when shooting with the Monochrome Picture Style. The Toning effect options are None, S: Sepia, B: Blue, P: Purple, and G: Green.

7. **Press the left or right cross key to adjust the parameter, and then press the Set button.**

8. **Repeat Steps 5 through 7 to change additional parameters.**

9. **Press the Menu button. The Picture Style screen appears where you can modify other Picture Styles.** The Picture Style changes are saved, changes are shown in blue, and the changes remain in effect until you change them. Press the Set button to return to the Shooting 2 (red) menu, or lightly press the Shutter button to dismiss the menu.

Registering a User Defined Picture Style

With an understanding of the settings that you can change with Picture Styles, you can create a Picture Style to suit your preferences.

Each style that you create is based on one of Canon's existing styles, which you can choose as a base style.

And because you can create three User Defined Styles, there is latitude to set up styles for different types of shooting situations. For example, you might want to create your own Picture Style for everyday photography that is less contrasty than the Standard Picture Style. While you could modify the existing Standard style, you may want to use it when you know that you're going to print images directly from the SD card and use the User Defined Picture Style for images you want to edit on the computer before printing.

To create and register a User Defined Picture Style, follow these steps:

1. **With the camera set to P, Tv, Av, M, or A-DEP shooting mode, press the Menu button, and then turn the Main dial to select the Shooting 2 (red) menu.**

2. **Press the down cross key to select Picture Style, and then press the Set button.** The Picture Style screen appears.

3. **Press the down cross key to highlight User Def. 1, and then press the Display button.** The Detail set. User Def. 1 screen appears with the currently selected Picture Style listed.

4. **Press the Set button.** The Standard Picture Style control is activated so that you can choose a different base Picture Style if you want.

5. **Press the up or down cross key to select a base Picture Style, and then press the Set button.**

6. **Press the down cross key to highlight the parameter you want to change, and then press the Set button.** The camera activates the parameter's control.

7. **Press the left or right cross key to set the parameter and then press the Set button.**

8. **Repeat Steps 6 and 7 to change the remaining settings.** The remaining parameters are Contrast, Saturation, and Color tone.

9. **Press the Menu button to register the style.** The Picture Style changes are saved, the Picture Style name is displayed in blue, and the changes remain in effect until you change them. Press the Set button to return to the Shooting 2 (red) menu, or lightly press the Shutter button to dismiss the menu.

You can repeat these steps to set up User Def. 2 and 3 styles.

Using the Picture Style Editor

One approach to getting Picture Styles that are to your liking is to set or modify one of the styles provided in the camera. But that approach is experimental: You set the style, capture the image, and then check the results on the camera and in prints until you get the results you want.

If you're an experienced photographer who likes precise results, then Canon provides the Picture Style Editor on the disc that comes with the camera. With it, you can make precise custom changes to Picture Styles. This is a more efficient approach than using trial and error. The process is to open a RAW image that you've already captured in the Picture Style Editor program, apply a Picture Style, and then make changes to the style while watching the effect of the changes as you work. Then you save the changes as a Picture Style file (.PF2), and use the EOS Utility, also provided on the disc, to register the file in the camera and apply it to images.

The Picture Style Editor looks deceptively simple, but it offers powerful and exact control over the style. Because the goal of working with the Picture Style Editor is to create a Picture Style file that you can register in the camera, the adjustments that you make to the sample RAW image are not applied to the image. Rather, the adjustments are saved as a file with a .PF2 extension. However, you can apply the style in Digital Photo Professional after saving the settings as a PF2 file.

While the full details of using the Picture Style Editor are beyond the scope of this book, I encourage you to read the Picture Style Editor descriptions on the Canon Web site at http://web.canon.jp/imaging/pictur-estyle/editor/index.html.

Be sure you install the EOS Digital Solution Disk programs before you begin. To start the Picture Style Editor, follow these steps:

1. **On your computer, start the Picture Style Editor. On a PC, the Picture Style Editor application is located in the Canon Utilities folder. On the Mac, look in the Applications folder for the Canon Utilities folder.** The Picture Style Editor main window appears.

2. **Click and drag a RAW CR2 image onto the main window**. You can also choose File ➪ Open Image, and navigate to a folder that contains RAW images, double-click a RAW file, and then click Open. When the file opens, the Picture Style Editor displays the Tool palette.

3. **To choose a style other than the default Standard style, click the arrow next to Base Picture Style on the Tools Palette.**

4. **At the bottom left of the main window, click one of the split screen icons to show the original image and the image with the changes you make side by side.** You can choose to split the screen horizontally or vertically. Or if you want to switch back to a single image display, click the icon at the far-left bottom of the window.

5. **Click Advanced in the Tool palette to display the parameters for Sharpness, Contrast, Color saturation, and Color tone.** These are the same settings that you can change on the camera. But with the Picture Style Editor, you can watch the effect of the changes as you apply them to the RAW image.

6. **Make the changes you want, and then click OK.**

7. **Adjust the color, tonal range, and curve using the palette tools.** If you are familiar with image-editing programs, or with Digital Photo Professional, most of the tools will be familiar. Additionally, you can go to the Canon Web site at http://web.canon.jp/imaging/picturestyle/editor/functions.html for a detailed description of the functions.

When you modify the style to your liking, you can save it and register it to use in the T1i/500D. However, when you save the PF2 file, I recommend saving two versions of it. During the process of saving the file, you can select the Disable subsequent editing option, which prevents disclosing the adjustments that have been made in the Picture Style Editor as well as captions and copyright information. This is the option to turn on when you save a style for use in the T1i/500D and in the Digital Photo Professional program. But by selecting that option, the style file no longer can be used in the Picture Style Editor.

For that reason, you'll likely want to save a second copy of the PF2 file without selecting the Disable subsequent editing option in

the Save Picture Style File dialog box. That way, if you later decide to modify the style, you can use the Picture Style Editor to make adjustments to this copy of the PF2 file.

Before you begin, ensure that you've installed the EOS Digital Solution Disk programs on your computer.

To save a custom Picture Style, follow these steps:

1. **Click the Save Picture Style File icon at the top far right of the Picture Style Editor Tool palette or choose it from the menu.** The Save Picture Style File dialog box appears.

2. **Navigate to the folder where you want to save the file.**

3. **To save a file to use in the T1i/500D, select the Disable subsequent editing option at the bottom of the dialog box.** To save a file that you can edit again in the Picture Style Editor, do not select this option.

4. **Type a name for the file, and then click Save.** The file is saved in the location you specified with a .PF2 file extension.

To install the custom Picture Style on the Rebel T1i/500D, follow these steps. Before you begin, be sure that you have the USB cable that came with the camera available.

1. **Connect the camera to the computer using the USB cable supplied in the T1i/500D box.**

2. **On your computer, start the Canon EOS Utility program.** The EOS Utility program is located in the Canon Utilities folder on your computer. The EOS Utility screen appears.

3. **Click Camera settings/Remote shooting under the Connect Camera tab in the EOS Utility.** The capture window appears.

4. **Click the camera icon in the red toolbar, and then click Picture Style.** The Picture Style window appears.

5. **Click Detail set at the bottom of the Picture Style list.** The Picture Style settings screen appears.

6. **Click the arrow next to Picture Style, and then click User Defined 1, 2, or 3 from the drop-down menu that appears.** If a Picture Style file was previously registered to this option, the new style overwrites the previous style. When you select User Defined, additional options appear.

7. **Click Open.** The Open dialog box appears.

8. **Navigate to the folder where you saved the Picture Style file that you modified in the Picture Style Editor, and click Open.** The Picture Style settings dialog box appears with the User Defined Picture Style displaying the modified style you opened. If necessary, you can make further adjustments to the file before applying it.

9. **Click Apply.** The modified style is registered in the T1i/500D. It's a good idea to verify that the style was copied by pressing the Picture Style button on the back of the T1i/500D, and then selecting the User Defined Style you registered to see if the settings are as you adjusted them.

In addition to creating your own styles, you can download additional Picture Styles from Canon's Web site at http://web.canon.jp/imaging/picturestyle/index.html.

About Color Spaces

A *color space* defines the range of colors that can be reproduced and the way that a device such as a digital camera, a monitor, or a printer reproduces color. Of the two color space options offered on the Rebel T1i/500D,

the Adobe RGB (Red, Green, Blue) color space is richer because it supports a wider gamut, or range, of colors than the sRGB (standard RGB) color space option. And in digital photography, the more data captured, or, in this case, the more colors the camera captures, the richer and more robust the file. It follows that the richer the file, the more bits that you have to work with whether you're capturing RAW or JPEG images. And with the T1i/500D's 14-bit analog/digital conversion, you get a rich 16,384 colors per channel when you shoot in RAW capture.

Comparing color spaces

The following histograms show the difference between a large and small color space in terms of image data. Spikes on the left and right of the histogram indicate colors that will be clipped, or discarded, from the image.

The High Bit-Depth Advantage

A digital picture is made up of many pixels that are each made up of a group of bits. A bit is the smallest unit of information that a computer can handle. In digital images, each bit stores information that, when aggregated with other pixels and color information, provides an accurate representation of the picture.

Digital images are based on the RGB color space. That means that an 8-bit JPEG image has 8 bits of color information for Red, 8 bits for Green, and 8 bits for Blue. This gives a total of 24 bits of data per pixel (8 bits × 3 color channels). Because each bit can be one of two values, either 0 or 1, the total number of possible values is 2 to the 8th power, or 256 values per color channel.

On the other hand, a 14-bit file, which is offered on the T1i/500D, provides 16,384 colors per channel.

High bit-depth images offer not only more colors but they also offer more subtle tonal gradations and a higher dynamic range than low bit-depth images. If you're shooting JPEG images, this high bit-depth means that when the camera automatically processes and converts the images to 8-bit JPEGs, it uses the much richer 14-bit color file to do so. You get better tonal range and gradations as a result. And if you're shooting RAW files, then you get the full advantage of the 14-bit color, and you can save the images to 16-bit in an editing program such as Adobe Photoshop.

Cross-Reference *For details on evaluating histograms, see Chapter 2.*

Much more image data is retained by using the wider Adobe RGB color space. Richer files can withstand editing, which is by nature destructive, much better than smaller files with less color data and resolution. So if you routinely edit images on the computer, rather than printing directly from the SD/SDHC card, then Adobe RGB is a good choice to provide richer files. But if you don't edit images on the computer, and if you want to print and display images straight from the camera on the Web or in e-mail, then sRGB is the color space to choose.

For printing images, Adobe RGB is the color space of choice for printing on inkjet printers and for printing by some commercial printers, although other commercial printing services use sRGB. If you print at a commercial lab, check with them to see which color space they use.

For images destined for online use in e-mail or Web display, sRGB provides the best image color display. While this may sound like a conflict in choosing color spaces, for most photographers it translates into using Adobe RGB for capture in the camera, and for editing and printing. Then when an image is needed for the Web or e-mail, you can make a copy of the image and convert it to sRGB in an image-editing program such as Photoshop.

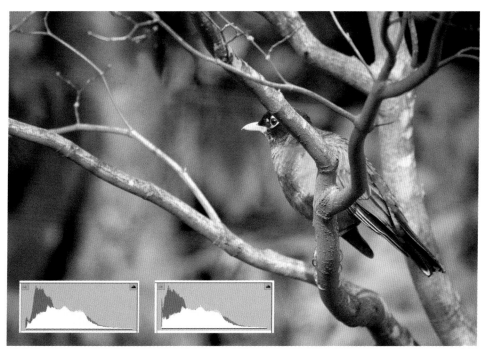

3.18 This RAW image was converted in Adobe Camera Raw and edited in Photoshop CS3. The inset histograms show the image in the Adobe RGB color space on the left and in sRGB color space on the right. Notice that the shadows block up much more in the sRGB color space than in Adobe RGB. Exposure: ISO 200, f/5.6, 1/320 second with -1/3-stop Exposure Compensation.

Choosing a color space

On the T1i/500D, you can select one of two color spaces for shooting in the P, Tv, Av, M, and A-DEP shooting modes. The options are Adobe RGB or sRGB. The color space you choose applies to both JPEG and RAW files shot in Creative Zone modes. In all Basic Zone modes, the camera automatically selects sRGB.

If you choose Adobe RGB, image filenames are appended with _MG_.

Note *The Rebel T1i/500D does not append an ICC (International Color Consortium) profile with the image so you will need to embed it when you're editing the file in an editing program. An ICC profile identifies the color space so that it is read by other devices, such as monitors and printers that support ICC profiles.*

To set the color space on the T1i/500D for Creative Zone modes, follow these steps:

1. **Set the Mode dial to a Creative Zone mode: P, Tv, Av, M, or A-DEP.**

2. **Press the Menu button, and then turn the Main dial to select the Shooting 2 (red) menu.**

3. **Press the up or down cross key to highlight Color space, and then press the Set button.** The camera displays two color space options.

4. **Press the up or down cross key to highlight the color space you want, either sRGB or Adobe RGB, and then press the Set button.** The color space remains in effect until you change it or switch to a Basic Zone mode.

Using Live View

The Live View feature on the Rebel T1i/500D offers a variety of advantages. It offers flexibility in framing images, particularly when crouching down to examine the shot through the viewfinder requires unnatural body contortions; it offers a large LCD view that can be magnified up to 10x to ensure tack-sharp automatic or manual focus; and it can be used with the camera connected to a computer with control of the camera offered on the computer using the EOS Utility program.

The Live View shooting function is useful in specific shooting situations, including macro work, when the camera is connected by a cable to a computer, and for still-life shooting. In short, it is most useful in controlled and close-up shooting scenarios. And with the supplied AV cable or accessory HDMI cable, you can display the Live View image on a TV.

About Live View

The concept of the camera being able to hold the shutter open to provide a real-time view of the scene and yet pause long enough to focus is impressive in terms of technology for digital single lens reflex (dSLR) cameras. And even more impressive is the quality of the live view that the T1i/500D provides, which is smooth and detailed.

Although Live View shooting has an admittedly high "coolness" factor, it comes with cautionary notes. With continual use of Live View shooting, the sensor heats up quickly, and the battery life diminishes markedly.

More specifically, here is what you can expect with Live View shooting:

✦ **Temperature affects the number of shots you can get using Live View.** With a fully charged LP-E5 battery, you can expect 190 shots without flash use and approximately 170 shots with 50 percent flash use in 73-degree temperatures. In freezing temperatures, you can expect 180 shots without flash use and 160 shots with 50 percent flash use per charge. With a fully charged battery and shooting in 73-degree conditions, you'll get approximately one hour of continuous Live View shooting before the battery is exhausted.

✦ **High ambient temperatures, high ISO speeds, or long exposures can cause digital noise or irregular color in images taken using Live View.** If the camera's internal temperature increases too much, a warning icon appears and Live View shooting is automatically stopped until the temperature decreases. Stop using Live View when you're not shooting images to help avoid high internal camera temperatures.

 When you're using Live View, never point the lens toward the sun to avoid damaging the camera.

Live View Features and Functions

Just as real-time shooting is unusual for dSLR photography, so are some of the functions and techniques for Live View shooting as compared to non-Live View shooting.

Canon implemented some helpful features, but it's important to understand what changes when you shoot in Live View.

In addition, Live View shooting in general involves a slower pace of shooting. For example, if you quickly move the camera from one subject to another, it takes a moment for the camera to adjust to any differences in brightness, and you should wait for the camera to catch up before shooting. And if the scene brightness differs, it can cause screen flickering. If this happens, stop and restart Live View shooting. In low-light scenes, you may see visible digital noise, unwanted multicolored flecks particularly in shadow areas, on the LCD. This noise will not appear in the final image.

The following topics give you an overview of the focusing options you can use, and other settings you can specify for Live View shooting.

Live View focusing options

With Live View shooting, you have four focusing options: Live mode, which is a contrast-based autofocus system that reads the sharpness of subjects directly from the image sensor; Live (Face Detection) mode, which is the same as Live mode except that the camera automatically looks for and focuses on a face in the scene; and Quick mode, which uses the camera's nine-point autofocus system. Or you can use manual focusing. Of the focusing options, manual focusing with the image magnified provides the most precise focusing.

Here is a summary of the Live View focusing options.

✦ **Live mode.** With this focusing option, the camera's image sensor is used and detects subject contrast to establish focus. In this mode, the live view is not interrupted because the reflex mirror does not have to move down to focus. However, focusing takes longer with this mode. To set the point of sharpest focus, a focusing point appears on the screen, and you can move it using the cross keys. Then you press the AE/FE Lock button to focus.

✦ **Live (Face Detection) mode.** This is the same as Live mode except that the camera automatically looks for a face in the scene. When a face is detected, corner marks indicating a rectangle appear over the face. For multiple faces, the rectangle has arrow icons on the left and right indicating that you can press the left or right cross key to move the focusing frame to the face you want. If the camera can't detect a face, then the AF point indicated by a solid rectangle is fixed at the center of the frame. Again, you use the AE/FE Lock button to establish focus. With this mode, there may be brightness changes during and after focusing, and it may be more difficult to focus when the view is magnified.

✦ **Quick mode.** This focusing mode uses the camera's autofocus system to focus. For the camera to give you a live view of the scene, it has to keep the reflex mirror locked up, and then to focus, the camera flips down the mirror to focus in this mode, and that action temporarily suspends the live view display on the LCD. To focus in Quick mode, you press the Set button, and the Quick Control screen appears where you can activate and select one of the nine AF points. Then you set focus using the AE/FE Lock button. You can't use this method if you are using the accessory Remote Switch RS-60E3.

✦ **Manual focusing.** This focusing option is most accurate, and you get the best results when you magnify the image to focus. Live View is also not interrupted during focusing. To focus manually, you set the lens switch to MF (Manual Focus), and then turn the lens's focusing ring to focus.

Live View function settings

The Live View Information Display provides the camera settings and the options you've chosen as you shoot in Live View. As you move the camera in Live View, the Rebel T1i/500D updates the LCD to show the scene as it simultaneously meters the changing scene light. To show you whether the LCD view is close to what the final picture will be, the T1i/500D displays an Exp.SIM icon on the LCD. If the icon is blinking, it means that the image simulation is not displayed at the suitable brightness level because of low or bright ambient light. But the final image will have the correct exposure.

Also, if Custom Function (C.Fn) 7 is enabled, which it is by default on the T1i/500D, then Auto Lighting Optimizer automatically corrects underexposed and low-contrast images. As a result, images may appear brighter than they would without using Auto Lighting Optimizer.

> **Note** *Auto Lighting Optimizer also corrects image brightness if you have set exposure modifications such as negative Exposure Compensation. To see the effect of exposure modifications, disable C.Fn-7, Auto Lighting Optimizer. Custom Functions are detailed in Chapter 6.*

As you move the camera around a scene, or as the light changes, the exposure must be updated accordingly. You can choose the amount of time that the exposure is retained, and the options are from 4 seconds to 30 minutes. A longer time speeds up Live View shooting operation overall, and this option works well when the scene light is controlled or constant.

You can also use the Depth of Field Preview button on the front of the camera. And if you are connected to the computer using the supplied USB cable, the EOS Utility Remote Live View window also enables you to preview the depth of field using the program's controls.

Also by setting the Live View function settings on the Setup 2 (yellow) menu, you can choose to display a handy 3 × 3 or 6 × 4 grid on the LCD to help align vertical and horizontal lines in the image.

Using a flash with Live View

You can also use the built-in or an accessory EX-series Speedlite with Live View shooting.

When the built-in flash or an accessory EX-series Speedlite is used, the shooting sequence after fully pressing the Shutter button is for the reflex mirror to drop to allow the camera to gather the preflash data, and then the mirror to move up out of the optical path for the actual exposure. As a result, you hear two shutter clicks, but only one image is taken. Here are some things you should know about using Live View shooting with a flash unit.

✦ **With an EX-series Speedlite, FE (flash exposure) Lock, modeling flash, and test firing cannot be used, and the Speedlite's Custom Functions cannot be set on the flash unit.**

✦ **Non-Canon flash units will not fire.**

Setting Up for Live View

Before you begin using Live View shooting, decide on the focusing method that you want to use and whether you want to turn off Auto Lighting Optimizer, which automatically adjusts underexposed and low-contrast images. The next step is to enable Live View shooting and set your preferences, including whether to display a grid on the LCD and how long the T1i/500D retains the current exposure settings.

> **Note** *To turn off Auto Lighting Optimizer, see Chapter 6 which details Custom Functions and how to change them.*

The Live View function settings include the following:

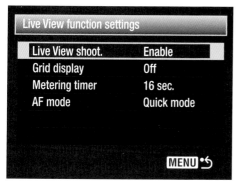

4.1 These are the options that you can set for Live View shooting.

✦ **Live View shoot.** These options determine whether Live View shooting begins when you press the Live View button on the back of the camera. To use Live View shooting, choose Enable.

✦ **Grid display.** You can choose Grid 1 for a 3 × 3 superimposed grid display, or you can choose Grid 2 for a 6 × 4 grid.

✦ **Metering timer.** Choosing a time sets the length of time that the camera maintains the most recent exposure settings. If you change between different lighting often, choose a short amount of time. If you are shooting in unchanging light, choose a longer time interval. The options are 4, 16, and 30 seconds, and 1, 10, and 30 minutes.

✦ **AF mode.** This enables you to choose the type of focusing mode, described earlier, that you want to use.

To set up the Rebel T1i/500D for Live View shooting and to set your preferences, follow these steps:

1. **Set the Mode dial to P, Tv, Av, M, or A-DEP.** You cannot shoot in Live View in the Basic Zone modes such as CA, Full Auto, Portrait, and so on.

2. **Press the Menu button, and then turn the Main dial to select the Setup 2 (yellow) menu.**

3. **Press the down cross key to highlight Live View function settings, and then press the Set button.** The Live View function settings screen appears with the Live View shoot. option selected.

4. **With the Live View shoot. option highlighted, press the Set button.** The camera activates the Live View shooting options.

5. **Press the down cross key to highlight Enable, and then press the Set button.** The Live View function settings screen appears.

6. **Press the down cross key to select Grid display, and then press the Set button.** The Grid display options appear. Selecting the Grid 1 option displays a 3 × 3 grid on the LCD and selecting Grid 2 option displays a 6 × 4 grid either of which help you square up horizontal and vertical lines during Live View shooting.

7. **Press the down cross key to highlight on the grid you want, and then press the Set button.** The Live View function settings screen appears.

8. **Press the down cross key to highlight Metering timer, and then press the Set button.** The Metering timer options appear.

9. **Press the down or up cross key to highlight the timer option you want, and then press the Set button.** The Live View function settings screen appears.

10. **Press the down cross key to highlight AF mode, and then press the Set button.** The options, detailed earlier in this chapter, are Live, Live Face Detection, and Quick mode. You can also focus manually.

11. **Press the up or down cross key to select the AF mode you want, and then press the Set button.** The Live View function settings screen appears. Lightly press the Shutter button to dismiss the menu.

Shooting in Live View

Once you have the options and functions set up for Live View, you can begin shooting. In fact, you can set many functions as you're shooting in Live View by pressing the Set button. Then you can change the AF mode, Picture Style, white balance, drive mode, and image-recording quality. Live View is well suited for macro or still-life shooting. With this type of shooting, you most likely want to use either manual focusing or Quick mode autofocusing with manual tweaking. During focusing, you can enlarge the view up to 10x to ensure tack-sharp focus.

Note — *When shooting in Live View, the camera automatically uses Evaluative metering mode, and if you are shooting in Continuous drive mode, the exposure of the first shot is used for subsequent shots.*

Another good option is to use Remote Live View with the camera connected, or tethered, to a computer. With the Remote Live View option, you connect the camera to the computer using the supplied USB cable and then control the camera on the computer. You can view the scene on the computer monitor in real time.

Either way, just a few minutes of watching the real-time view convinces you that a tripod is necessary for Live View shooting. With any focal length approaching telephoto, Live View provides a real-time gauge of just how steady or unsteady your hands are.

Tip — *You can choose from four display modes when shooting in Live View by pressing the Display (DISP.) button. Each mode adds progressively more shooting and settings information. Just press the Display button one or more times to toggle to different display modes.*

Shooting and focusing in Live View

The following steps detail how to begin shooting in Live View mode with specifics for each of the different shooting modes. Ensure that you've set the AF mode you want, as discussed previously, before you begin.

1. **Set the Mode dial to P, Tv, Av, M, or A-DEP, and then set the ISO, aperture, and/or shutter speed.** Your settings depend on the shooting mode you chose. You can also use Auto Exposure Bracketing (AEB), choose a Picture Style, and set the white balance for Live View shooting.

2. **Press the Live View shooting/ Movie shooting/Print/Share button (located above and to the right of the WB button) to begin shooting in Live View.** The LCD displays a live view of the scene.

3. **To focus, follow these steps based on the focusing mode you're using:**

 • **Live mode.** Press any of the cross keys to move the AF point so that it is over the part of the subject where you want to focus, and then press the AE Lock button on the top-right back of the camera. The AE Lock button has an asterisk above it. You can also press the AF-Point Selection/Magnify button on the top far-right corner of the camera to magnify the view to 5x, and press it again to magnify to 10x. When focus is achieved, the AF-point rectangle turns green and the beeper sounds. If focus isn't achieved, the AF-point rectangle turns orange.

 • **Live (Face Detection) mode.** The camera looks for a face or faces in the scene, and displays corner marks or corner marks with left and right arrows, respectively, over the face(s) it selects. To focus, press the AE Lock button on the top-right back of the camera. When focus is obtained, the corner marks appear in green and the beeper sounds. If the camera can't find a face in the scene, it displays a solid rectangle and uses the center AF point for focusing.

 • **Quick mode.** The LCD displays the nine AF points and a larger magnifying frame around one of the AF points. Press the Set button. The Quick Control screen appears. Press the left or right cross key to activate the AF points, and then turn the Main dial to select one of the AF points. Point the AF point over the part of the subject where you want to focus, and then hold down the AE Lock button on the top-right back of the camera. The reflex mirror flips down to focus and Live View is suspended temporarily. When focus is achieved, the live view resumes with the selected AF point displayed in red. If you have the camera set to A-DEP mode, the camera automatically selects the AF points, and you cannot change them.

 • **Manual focusing.** Set the switch on the side of the lens to MF (Manual Focusing). Press a cross key to move the magnifying frame, and then press the AF-Point Selection/Magnify button on the top-right back of the camera once or twice to magnify the view. Turn the focusing ring on the lens to focus, and then press the AF-Point Selection/Magnify button again to return to nonmagnified view.

4. **Press the Shutter button completely to make the picture.**

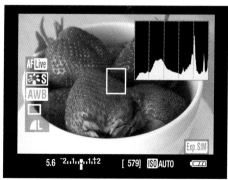

4.2 This shows the shooting display with full camera and exposure information displayed.

Using Live View with tethered shooting

One of the most useful ways to use Live View shooting is for shooting still-life subjects such as products, food, stock shots, and so on with the camera connected to a computer. You can set up with the T1i/500D connected to a computer using the USB cable supplied with the camera.

Before you begin, ensure that you have installed the EOS Digital Solution Disk on the computer to which you are connecting the camera.

To shoot in Live View with the T1i/500D tethered to the computer, follow these steps:

1. **Turn off the camera, and attach the USB cord to the Digital terminal located under the terminal covers on the side of the camera.** Be sure that the icon on the cable connector faces the front side of the camera.

2. **Connect the other end of the USB cable to a USB terminal on the computer.**

3. **Turn on the power switch on the camera and set the Mode dial to P, Tv, Av, or M, and then choose EOS Utility on the screen that appears.**

4. **Click Camera settings/Remote shooting in the EOS Utility window.** The T1i/500D control panel appears. You can use the panel to control exposure settings, set the white balance, Picture Style, and White Balance Shift in this panel. To set exposure, double-click the aperture, ISO, and so on, and use the controls to adjust the settings.

4.3 The EOS Utility Remote Shooting control panel

5. **Click Remote Live View shooting (near the bottom of the control panel).** The Remote Live View window appears. In this window, you can set the white point by clicking a white area or neutral gray area in the scene, preview the depth of field by clicking the On button, and switch between the Brightness and RGB histograms, and you can monitor the histogram as the camera moves or as lighting changes.

6. **When the exposure and composition is set, you can magnify the view, and then focus using either Quick or Live mode focusing techniques detailed earlier in this chapter, or you can focus manually.**

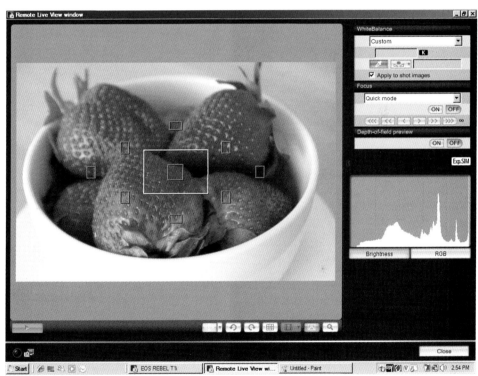

4.4 The Remote Live View window is shown here with color corrected by clicking the white bowl with the eye-dropper tool.

7. Press the Shutter button at the top right of the EOS Utility control panel to make the picture. The Digital Photo Professional main window opens with the image selected.

8. When you finish, turn off the camera, and then disconnect the USB cable from the camera.

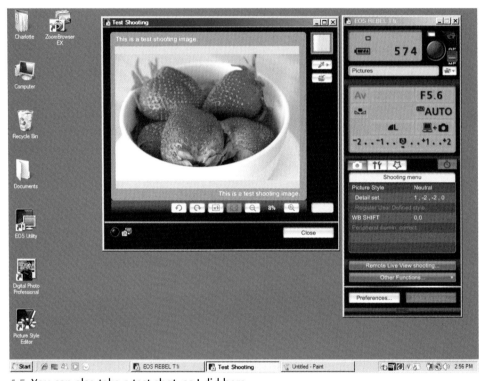

4.5 You can also take a test shot, as I did here.

4.6 The final image taken in Live View shooting using Quick mode autofocusing. Exposure: ISO 100, f/5.6, 1/4 second, using an EF 24-105mm f/4L IS USM lens.

Using Movie Mode

With the addition of Movie mode on the Rebel T1i/500D, a new avenue of creative expression is open to you. Now the visual stories that you capture with the Rebel can be enriched with high-definition movies. The creative possibilities are virtually endless. In short, you have all the tools you need to create compelling visual stories of any subject you choose. Of course, it's also really nice that the Rebel's movie quality is some of the best available. And it's packaged for you in a lightweight camera that accepts more than 60 lenses to enhance your videos in ways that traditional video cameras cannot.

This chapter is by no means exhaustive, but it is written to be a starting point for you as you explore the world of digital video with the Rebel T1i/500D.

About Video

For still photographers, videography seems like learning a new language. And while the language is different, it's a subset of the creative communication that's part and parcel of traditional still photography. So now is a good time to think beyond still shooting and envision ways to create rich multimedia stories with the Rebel T1i/500D.

To appreciate the Rebel's high-definition video capability, it is good to have a basic understanding of digital video and how it relates to the Rebel T1i/500D.

Video standards

In the world of video, there are several industry standards including 720p, 1080i, and 1080p. The numbers relate to the resolution of the video, while the letters relate to the way in which the video is displayed.

The numbers 720 and 1080 represent vertical resolution. The 720 standard has a resolution of 921,600 pixels, or 720 (vertical pixels) × 1280 (horizontal pixels). The 1080 standard has a resolution of 2,073,600 pixels, or 1080 × 1920. It seems obvious that the 1080 standard provides the highest resolution, and, therefore, you'd think that it would be preferable. But that's not the entire story.

The rest of the story is contained in the "i" and "p" designations. The "i" stands for interlaced. Interlaced is a method of displaying video where each frame is displayed on the screen in two passes — first, a pass that displays odd-numbered lines, and then a second pass that displays even-numbered lines. Each pass is referred to as a field, and two fields comprise a single video frame. This double-pass approach was engineered to keep the transmission bandwidth for televisions manageable. And the interlaced transmission works only because our minds automatically merge the two fields, so that the motion seems smooth with no flickering. Interlacing, however, is the old way of transmitting moving pictures.

The newer way of transmitting video is referred to as progressive scan, hence, the "p" designation. Progressive scan quickly displays a line at a time until the entire frame is displayed. And it happens so quickly that we see it as if it were being displayed all at once. The advantage of progressive scanning is most apparent in scenes where either the camera or the subject is moving fast. With interlaced transmission, fast camera action or a moving subject tends to blur between fields. That's not the case with 720p, which provides a smoother appearance. So while 1080i offers higher resolution, 720p provides a better video experience.

Another piece of the digital video story is the frame rate. In the world of film, the frame rate was 24 frames per second (fps), and this frame rate is responsible for the classic cinematic look of old movies. In the world of digital video, the standard is 30 fps. Anything less than 24 fps, however, provides a jerky look to the video. The TV and movie industries use standard frame rates including 60i that produces 29.97 fps that's used for NTSC (National Television System Committee); 50i that produces 25 fps and is standard for PAL (Phase Alternating Line) that's used in some parts of the world, and 30p that produces 30 fps that produces smooth rendition for fast-moving subjects.

With this very brief background, let's look at the digital video options on the Rebel T1i/500D.

Video on the Rebel T1i/500D

By now, you're probably asking how the Rebel T1i/500D stacks up to industry standards, and other questions including how long you can record on your SD/SDHC card, and how big the files are? Following is a rundown of the digital video recording options that you can choose on the T1i/500D.

✦ **Full HD (Full High-Definition) at 1920 × 1080p at 20 fps.** You get about 12 minutes of recording time with a 4GB card, and about 49 minutes with a 16GB card. The file size is 330MB per minute. Full HD enables you to use HDMI output for HD viewing of stills and video.

✦ **HD (High-Definition) at 1280 × 720p at 30 fps.** You get about 18 minutes of recording time with a 4GB card, and 1 hour and 13 minutes with a 16GB card. The file size is 222MB per minute.

✦ **SD (Standard recording) at 640 × 480 at 30 fps.** You get 24 minutes of recording time with a 4GB card, and 1 hour and 39 minutes with a 16GB card. The file size is 165MB per minute.

So you have two high-quality video options albeit at different frame rates. While the Full HD resolution is a tempting option for its high resolution, 20 fps creates a less than smooth rendition. While the Full HD video option may be an option for still or slow-moving subjects – perhaps an interview with a person who doesn't move around the set – my recommendation is to use the 720p/30 fps HD movie option.

The Rebel produces QuickTime MOV files. This means that videos can be viewed in Apple's QuickTime Player. The QuickTime Player is free, although Apple offers a professional version that supports full-screen video as well as other features.

Here are other important aspects to consider when shooting video.

✦ **Audio.** You can use the Rebel T1i/500D's built-in monaural microphone that is adequate and better than nothing if you don't want to invest in a separate audio recorder and microphone. The audio is 16-bit at a sampling rate of 44.1 kHz and is output in mono. If you use the built-in mic, be aware that all of the mechanical camera functions are recorded including the sound of the Image Stabilization function, the focusing motor, wind,

background noise, and so on. You also have no control over the recording volume.

✦ **Exposure and camera settings.** Video exposure is fully automatic, although you can use AE Lock and set Exposure Compensation of +/- 2 stops. You can see what aperture and shutter speed the camera is using by pressing the Display (DISP.) button during recording. You cannot, however, maintain the same exposure through a series of movie sessions. But you can change the focus mode, Picture Style, white balance, recording quality, and still image quality before you begin shooting in Movie mode.

✦ **Battery life.** At normal temperatures, you can expect to shoot for slightly more than 1 hour, with the time diminishing in colder temperatures. Movie playback with a fully charged battery is approximately 2.5 hours.

✦ **Video capacities and cards.** The upper limit is 4GB of video. When the movie reaches the 4GB point, the recording automatically stops. You can start recording again provided that you have space on the card, but the camera creates a new file. As the card reaches capacity, the Rebel warns you by displaying the movie size and time remaining in red. Also, Canon recommends a Class 6 SD/SDHC card or faster. Slower cards may not provide the best video recording and playback. If you have a slow card, a five-level meter appears on the left of the LCD to show you how much data is buffered, waiting to be written to the card. If the buffer fills up, recording stops. If you're going to record movies, buy fast cards.

Note *The Rebel T1i/500D does not support the newer SDXC memory card.*

✦ **Focusing.** You have the same options for focusing as you have in Live View shooting with one caveat: If you choose Quick mode, the camera automatically switches to Live focusing mode, for good reason. In Quick mode, the reflex mirror has to flip down to establish focus, and that blackout would create a lousy video experience. I recommend using Live mode or manual focusing and focusing before you shoot.

Cross-Reference *For more details on Live View focusing options, see Chapter 4.*

✦ **Still-image shots during recording.** You can capture a still image at any time during video recording by pressing the Shutter button completely. This results in a 1-second pause in the video. The still image is recorded to the card as a file separate from the video. The still image is captured at the image-quality setting you've previously set for still-image shooting, and the camera automatically sets the aperture and shutter speed, defaults to Single-shot drive mode, and doesn't use the built-in flash. The white balance, Picture Style, and quality settings that you've set for shooting in P, Tv, Av, M, and A-DEP shooting modes are used for still images.

✦ **Flash.** You can't use the built-in flash in Movie mode.

Recording and Playing Back Videos

Some of the setup options for Movie shooting are the same as or similar to those offered in Live View shooting. In particular, the focusing modes are the same in both modes except that Quick focusing isn't used in movie recording.

Before you begin shooting, set up the options you want. When the video is recorded, you have several options for playback described in the following sections.

Recording videos

Choosing Movie mode setup options is the first step to shooting video with the Rebel T1i/500D. You can choose the movie recording size, whether to record mono audio, focusing mode, and, as with Live View shooting, you can also display a grid to line up vertical and horizontal lines, set the amount of time the camera retains the last metering for exposure, and whether to use a remote control.

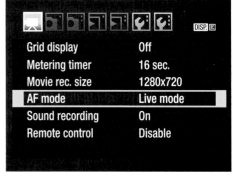

5.1 The Movie shooting mode menu

To set movie options, follow these steps:

1. **Set the Mode dial to Movie shooting mode, and then press the Shutter button halfway.** The reflex mirror flips up and a live view of the scene appears on the LCD.

2. **Press the Menu button.** The Movie mode (red) menu appears. The only time this menu appears is when the Mode dial is set to Movie shooting mode. You'll also notice that the number of menu tabs is decreased in Movie mode.

3. **Select each menu item by pressing the up or down cross key, press the Set button, and then press the appropriate cross key to choose the option you want.** You can choose the following options:

 • **Grid display.** Selecting the Grid 1 option displays a 3 × 3 grid on the LCD and selecting the Grid 2 option displays a 6 × 4 grid either of which helps you square up horizontal and vertical lines during Live View shooting.

 • **Metering time.** Choose the length of time for the camera to maintain the most recent exposure settings. The options are 4, 16, and 30 seconds, and 1, 10, and 30 minutes. If you change between different lighting often, choose a short amount of time. If you are shooting in unchanging light, choose a longer time interval.

 • **Movie rec. size.** Full HD at 1920 × 1080p at 20 fps, HD at 1280 × 720p at 30 fps, or SD at 640 × 480 at 30 fps.

• **AF mode.** The options are Live mode, Live mode with Face Detection, and Quick mode. Even if you choose Quick mode, the camera automatically uses Live mode. You can also focus manually, although the action of changing the focus is distracting and intrusive during the movie.

• **Sound recording.** The options are On or Off. If you are using a separate audio recorder and a mic, then choose Off. Because there is no terminal on the camera for another mic, you will have to buy a separate stand-alone or shoe-mountable unit.

• **Remote control.** The options are Enable or Disable. Choose Enable if you're using the accessory Remote Controller RC-1/RC-5. With RC-1, you can set a 2-second delay, and then press the transmit button. If the switch is set to immediate shooting, then still images will be taken.

4. **Press the Shutter button halfway.** The live view of the scene appears on the LCD with a ribbon of camera settings displayed on the left side of the screen. The settings are: focus mode, Picture Style, white balance, movie recording quality, and still-image recording quality.

5. **Press the Set button.** The first setting at the left of the screen is selected and displayed in blue.

6. **Turn the Main dial to cycle through to the setting you want.**

7. **Press the down cross key to select the next setting you want to change, and then turn the Main dial to make changes.**

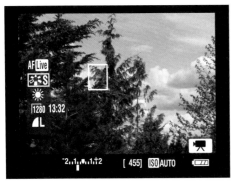

5.2 The Movie shooting ready screen

To record a movie, follow these steps:

1. **Set the Mode dial to Movie shooting mode.**

2. **Focus on the subject using the focusing mode you've chosen.** Here is how to use the focusing options.

 • **Live mode.** Press a cross key to move the white magnifying rectangle so that it is over the part of the subject that you want in focus, and then press the AE Lock button on the top right back of the camera. When focus is achieved, the AF-point rectangle turns green. In Live mode, it can take up to 5 seconds to establish and lock focus.

 • **Live (Face Detection) mode.** The camera looks for a face or faces in the scene, and displays corner marks or corner marks with left and right arrows, respectively, over the face(s) it selects. You can press the left or right cross key to move the focusing frame to another face. To focus, press the AE Lock button. When focus is obtained, the corner marks appear in green.

If the camera can't find a face in the scene, it displays a solid rectangle and the camera uses the center AF point for focusing.

• **Manual focusing.** You can manually focus by turning the focusing ring on the lens. If you have to change focus during shooting, manual focusing avoids the noise of the AF motor being recorded, but the focusing adjustment can be intrusive to the video.

3. **Press the Live View shooting/ Movie shooting/Print/Share button on the back of the camera.** A red dot appears in the upper right of the screen indicating recording is in progress. The recording quality and video length are displayed on the left side of the screen.

4. **If you want to set Exposure Compensation, press and hold the Av button on the back of the camera as you turn the Main dial.** The amount of compensation is displayed on the Exposure Level Indicator displayed at the bottom of the LCD.

5. **Alternately, you can use Auto Exposure Lock by pressing the ISO button.** To cancel AE Lock, press the AF-Point Selection/ Magnify button.

6. **Press the Live View shooting/ Movie shooting/Print/Share button to stop recording the movie.**

Video recording tips

As you work with video recording with the T1i/500D, you'll doubtless begin to want more exposure control. Here are a few tips that you can use to get slightly more control and to create better videos.

✦ **Exposure.** While the Rebel automatically sets the exposure, you can use workarounds. It's beyond the scope of this book to explain advanced metering techniques, but for those who are familiar with metering off a gray card, you can meter off a gray card for video shooting, and then press the ISO button (which becomes the AE Lock button in Movie mode) to retain the meter reading for the video recording.

✦ **Depth of field.** Without the ability to change the aperture, your creative options for changes in depth of field lie in using the inherent characteristics of your lenses creatively. For example, use a telephoto lens to create a shallow depth of field, and a wide-angle lens for extensive depth of field.

✦ **White balance.** If you're shooting under mixed light or indoors, you can set a custom white balance for the light you're shooting in before you begin recording the movie. Then when you have the camera ready to shoot, simply switch to the Custom white balance setting (described previously), and it will be used for the video recording.

✦ **Smooth recording.** Just as with Live View shooting, video recording quickly reveals just how unsteady your hands are and what a challenge it is to create smooth pans and zooms. You can use a tripod with a sturdy ball head or pan and tilt head, but there are other options. The pricey Steadicam Merlin frees you from the tripod and allows you steady handheld shooting because the apparatus absorbs your body movements. Alternately, Manfrotto and other companies produce more affordable camera stabilizers and support systems.

Playing back videos

For a quick preview of your movies, you can play them back on the camera LCD. Of course, with the high-definition quality, you'll enjoy the movies much more by playing them back on a television or computer.

To play back a movie on the camera LCD, follow these steps:

1. **Press the Playback button, and then press the left or right cross key until you get to a Movie file.** Movies are denoted with a movie icon and the word Set in the upper left of the LCD display.

2. **Press the Set button.** A progress bar appears at the top of the screen, and a ribbon of controls appears at the bottom of the display.

3. **Press the Set button to begin playing back the movie, or press the left or right cross key to select a playback function, and then press the Set button.** You can choose from the following:

5.3 These controls enable you to control movie playback.

• **Exit.** Select to return to single-image playback.

• **Play.** Press the Set button to start or stop the movie playback.

• **Slow motion.** Press the left or right cross key to change the slow-motion speed.

• **First frame.** Select to move to the first frame of the movie.

• **Previous frame.** Press the Set button once to move to the previous frame, or press and hold the Set button to rewind the movie.

• **Next frame.** Press the Set button once to move to the next frame, or press and hold the Set button to fast forward through the movie.

• **Last frame.** Select to move to the last frame or the end of the movie.

• **Volume.** Denoted as ascending gray or green bars, just turn the Main dial to adjust the audio volume.

4. **Press the Set button to stop playing the movie.**

Tip *You can choose to play back only movies. Just go to the Playback 2 (blue) menu, choose Slide show, and then press the Set button. On the Slide show screen, press the up or down cross key to select All images, and then press the Set button. Press the up or down cross key until Movies is displayed, and then press the Set button. Press the down cross key to select Start, and then press the Set button to begin playing all movies. Press the Set button to stop playing the movies.*

To play back movies on a TV, follow these steps. To connect the camera to an HD TV, you must have an accessory HDMI Cable HTC-100.

1. **With the camera turned off, connect the supplied AV cable to the camera's A/V Out/Digital terminal.** For an HD TV, connect the HDMI cable to the HDMI terminal on the camera's HDMI Out terminal.

2. **Connect the other end of the AV cable to the Video In terminal and Audio In terminals of the TV.** For an HD TV, connect the HDMI cable to the HDMI In port.

3. **Turn on the TV and select the video input to the connected terminal.**

4. **Turn on the camera, and then press the Playback button.**

Editing Movies

Unless you're an accomplished videographer, your movies will almost certainly benefit from judicious editing. And editing is the way to join multiple video clips, add titles, and add background music to present a polished and complete story.

Basic editing is available using Canon's MovieEdit Task program and is accessible through the Zoom Browser/Image Browser program on the supplied EOS Solution Disk. You can edit movies except 1920 × 1080 MOV files. With this program, you can:

✦ Arrange and order movie clips on a storyboard, and then add effects including text or filters such as sepia, enlarge parts of the movie, and set transitions.

✦ Adjust the audio with Fade In and Fade Out volume changes, add MP3, AIFF, or WAV audio files as background music.

✦ Cut movies to set the start and end points.

✦ Grab a still frame from video footage. Frame grabs range from 2 million pixels for a 1920 × 1080 video, 1 million pixels for a 1280 × 720 video, and about 300,000 pixels for a 640 × 480 video.

Certainly Canon's Image Browser is a good starting point. If you want greater functionality for movie editing, there are many commercial programs that range in price from shocking and sobering to comfortably affordable. Here are some programs that you may want to consider.

✦ **Apple Final Cut Pro.** This advanced video-editing program is part of Apple's Final Cut Studio 2 suite. Final Cut Pro supports all video formats.

✦ **Adobe Premier.** This is also an advanced editing program that enables you to work with multiple videos, add audio tracks, color correct, and make other edits.

✦ **Adobe Premier Elements.** This is the "light" version of Adobe Premier that's designed for nonprofessional videographers. Use it to add audio, narration, text, special effects, transitions, and pictures in pictures, and more.

✦ **Corel VideoStudio Pro X2.** This Windows program enables you to capture, edit, burn, and view HD video as well as create montages, picture-in-picture effects with multiple video, add audio and title tracks, and more.

✦ **iMovie.** This Mac-only program is easy to use and enables you to skim movies, cut and paste video clips together, add music, add themes, titles, and special effects, correct color, and more.

✦ **Windows Movie Maker.** This PC-only program offers the same general capabilities as iMovie.

✦ **Sony Vegas.** This line of programs comes in packages for users of different skill levels. The Platinum version supports HD video editing, and you can alternately move up to the Platinum Pro Pack or Vegas Pro at, of course, increasing cost levels.

Customizing the EOS Rebel T1i/500D

◆ ◆ ◆ ◆

In This Chapter

Setting Custom Functions

Customizing My Menu

Other customization options

◆ ◆ ◆ ◆

One of the first things most photographers do when setting up a new camera is to customize it for their personal shooting preferences. The EOS Rebel T1i/500D offers excellent options for customizing the operation of controls and buttons and the shooting functionality, both for everyday shooting and for shooting specific scenes and subjects.

The T1i/500D offers three helpful features for customizing the use and operation of the camera.

◆ **Custom Functions.** Thirteen Custom Functions enable you to control functions ranging from whether digital noise reduction is applied for long-exposure and high-ISO images to the way the camera controls operate.

◆ **My Menu.** This is a feature where you can place six of your most often used menu items in priority order on a single menu for fast access.

◆ **LCD Screen Colors.** Whether it's a matter of increasing the readability of the LCD shooting information display, or just adding a bit of color and pizzazz to it, you have four options for personalizing the look of the display.

These customization features used separately and in combination provide a great way to spend less time tweaking camera settings and more time shooting.

Setting Custom Functions

Custom Functions enable you to customize camera controls and operations to better suit your shooting style; and, as a result, they can save you significant time. The T1i/500D offers 13 Custom Functions ranging from customizing exposure changes to changing the functions of various buttons. There are a couple of specifics that you should keep in mind regarding Custom Functions:

✦ They can be set only in Creative Zone modes such as P, Tv, Av, M, and A-DEP.

✦ Once you change a Custom Function, the change remains in effect until you change it.

> **Note** *Canon denotes Custom Functions using the abbreviation C.Fn [group Roman numeral]-[function number]; for example, C.Fn II-3. In other cases, the Roman numeral is dropped so that the designation is simply C.Fn-3. The abbreviated designation is used in this chapter.*

Some Custom Functions are useful for specific shooting specialties or scenes while others are more broadly useful for everyday shooting. For example, the Mirror Lockup Custom Function is useful in specific scenarios such as when you're shooting macro and long exposures and when you're using a super-telephoto lens. On the other hand, the Custom Function that enables the Set button to be used during shooting is an example of a function that is broadly useful for everyday shooting.

 Caution *Be sure to remember how you have set the Custom Functions because some options change the behavior of the camera controls.*

Custom Function groupings

Canon organized the 13 Custom Functions into four main groups denoted with Roman numerals, all of which you can access from the Setup 3 (yellow) camera menu.

Table 6.1 delineates the groupings and the Custom Functions within each group. In addition, the function and options that are either enabled or disabled in Live View and Movie mode shooting are noted.

Custom Functions specifics

In this section, I explain each of the Custom Functions and the options that you can set. As you read about each Custom Function, consider how you could use it to make your use of the camera more intuitive and simple. You don't have to set each option, and it is likely you may find only a few that are useful to you in the beginning. But as you continue shooting, you may recognize other functions that you want to use. Over time, I think that you'll grow to appreciate the power that Custom Functions offer.

Keep in mind that the functions are easy to find, so that you can go back and reset them if you don't like the changes that you've made. In addition, you can reset all Custom Functions to the original settings if necessary. The steps to reset all Custom Functions are included at the end of this section.

Table 6.1
Custom Functions

C.Fn Number	Function Name
Group I: Exposure	
1	Exposure level increments. Options work for Live View shooting, but not for Movie mode shooting.
2	ISO Expansion. Options work for Live View shooting, but not for Movie mode shooting.
3	Flash synchronization speed in Av mode. Options work for Live View shooting, but not for Movie mode shooting.
Group II: Image	
4	Long exposure noise reduction. Options work for Live View shooting, but not for Movie mode shooting.
5	High ISO speed noise reduction. Options work for Live View shooting, but not for Movie mode shooting.
6	Highlight tone priority. Options are used for Live View shooting, but not Movie mode shooting.
7	Auto Lighting Optimizer. Options work for Live View shooting, but only Option 1 works for Movie mode.
Group III: Autofocus/Drive	
8	AF-assist beam firing. Options work for Live View shooting, but not for Movie mode shooting.
9	Mirror Lockup. Cannot be used for Live View or Movie mode shooting.
Group IV: Operation/Others	
10	Shutter button/AE lock button. Only Option 1 works for Live View shooting, and none of the options work for Movie mode shooting.
11	Assign SET button. Option 0 (zero) can be used for both Live View and Movie mode shooting.
12	LCD display when power ON. Options work for Live View shooting, but not for Movie mode shooting.
13	Add original decision data. Options work for Live View shooting, but not for Movie mode shooting.

C.Fn I: Exposure

In this group, the three Custom Functions enable you to determine the level of fine control you have over exposure and over flash exposure synchronization speeds when you're shooting in Aperture-priority (Av) mode.

C.Fn-1: Exposure-level increments

The options available for this function enable you to set the exposure increment to use for shutter speed, aperture, exposure compensation, and Auto Exposure Bracketing (AEB). The exposure increment you choose is displayed in the viewfinder and on the LCD as

double marks at the bottom of the expo-sure-level indicator. Your choice depends on the level of control you want. Here are the C.Fn-1 options with a description of each one:

✦ **0: 1/3-stop.** This is the Rebel T1i/500D's default option, and it offers the finest level of exposure control. Using this option, the cam-era displays shutter speeds in finer increments such as 1/60, 1/80, 1/100, 1/125 second, and so on. And it offers apertures as f/4, f/4.5, f/5, f/5.6, f/6.3, f/7.1, and so on.

✦ **1: 1/2-stop.** This is a coarser expo-sure control setting. Using this option, the T1i/500D displays shut-ter speeds in increments such as 1/60, 1/90, 1/125, 1/180 second, and so on. And it offers apertures as f/4, f/4.5, f/5.6, f/6.7, f/8, f/9.5, and so on. You may want to set this option when you want to quickly make larger changes in exposure settings with a minimum of adjustments.

C.Fn-2: ISO Expansion

You can choose to increase the ISO range from the default 100 to 3200 to include ISO 6400 and 12800 by choosing Option 1. Enabling the expansion has no effect on the Auto ISO range that remains 100 to 1600. The expanded settings are available only when you shoot in P, Tv, Av, M, and A-DEP modes. The ISO range for the automatic shooting modes such as Close-up, Landscape, and so on remains ISO 100 to 1600 in most shooting modes. If you enable ISO expan-sion, then two additional ISO settings are available for you to choose. The ISO 12800 setting is denoted as "H" in the viewfinder and on the LCD. Clearly, you should test the high ISO options for digital noise before using them. However, in scenes where you

would otherwise not be able to get the pic-ture, the expanded ISO settings can be use-ful. Here are the options.

✦ **0: Off.** With this option set, the ISO range is 100 to 1600 in most shooting modes. This is the default setting on the Rebel T1i/500D.

✦ **1: On.** With this option set, you can choose ISO 6400 and "H" that is equivalent to ISO 12800.

C.Fn-3: Flash sync. speed in Av (Aperture-priority AE) mode

This function enables you to set the Flash Sync speed range, have the Rebel set it automatically, or set it to a fixed 1/200 sec-ond when you're using Av shooting mode. Here are the options and a description of each one:

✦ **0: Auto.** When you're shooting in Av mode, choosing this option means that the T1i/500D will choose a shutter speed of 1/200 second to 30 seconds depending on the existing light. Slower Flash Sync speeds allow the scene to be illuminated by both the flash and the existing light in the scene. However, you must watch the shut-ter speed because at slow shutter speeds, any subject or camera movement appears as a blur. As long as the shutter speed is reasonably fast, this option is nice because the combination of ambient light and flash creates a natural-looking image.

✦ **1: 1/200-1/60 sec. auto.** This option limits the Flash Synch speed from going slower than 1/60 sec-ond automatically when you're using Av shooting mode. The advantage is that it prevents slow

shutter speeds that can cause blur from handholding the camera or from subject movement. The downside is that the background will be dark because less existing light and more flash light may be factored into the exposure.

✦ **2: 1/200 sec. (fixed).** With this option, the Flash Sync speed is always set to 1/200 second and the flash provides the main illumination with less existing light being included in the exposure. While this option prevents blur from subject or camera movement that you may get using Option 1, the image will have flash shadows and a dark background that are characteristic of flash images with this option.

C.Fn II: Image

The Image Custom Function group concentrates primarily on avoiding and reducing digital noise that can cause a grainy appearance with flecks of color particularly in the shadows, allowing you greater latitude in avoiding blown highlights, or highlights that are completely white with no detail, and improving the appearance of dark and low-contrast images.

Cross-Reference *For details on digital noise, see Chapter 6.*

C.Fn-4: Long-exposure noise reduction

With this function, you can turn noise reduction on, off, or set it to automatic for exposures of 1 second and longer. If you turn on noise reduction, the reduction process takes the same amount of time as the original exposure. In other words, if the original image exposure is 1 second, then noise reduction takes an additional 1 second. This means that you cannot take another picture until the noise reduction process finishes,

and, of course, this greatly reduces the maximum shooting rate in Continuous drive mode. I keep the T1i/500D set to Option 1 to automatically perform noise reduction if it is detected in long exposures. Here are the options and a description of each one:

✦ **0: Off.** This is the default setting where no noise reduction is performed on long exposures. This maximizes fine detail in the image, but it also increases the chances of noise in images of 1 second and longer. With this option, there is no reduction in the maximum burst rate when you're using Continuous drive mode.

✦ **1: Auto.** The camera automatically applies noise reduction on 1 second and longer exposures if it finds noise present. If the Rebel T1i/500D detects noise that is typically found in long exposures, then it takes a second picture at the same exposure time as the original image, and it uses the second image, called a "dark frame," to subtract noise from the first image. Although technically two images are taken, only one image — the original exposure with noise subtracted — is stored on the Secure Digital (SD/SDHC) card.

✦ **2: On.** The Rebel automatically performs noise reduction on all exposures of 1 second and longer. This option slows shooting down considerably because the Rebel T1i/500D always makes the dark frame to subtract noise from the original image, and the dark frame is exposed at the same amount of time as the first image. If you're shooting in Live View mode, then "Busy" is displayed during the noise reduction process. Weigh the

option you choose based on the shooting situation. If you need to shoot without delay, then Option 0 or 1 is preferable. But if you want to save time at the computer apply-ing noise reduction during image editing, then Option 2 is the ticket.

C.Fn-5: High ISO speed noise reduction

This option applies noise reduction when you shoot at high ISO speed settings. (The camera applies some noise reduction to all images.) If you turn this option on, noise in low-ISO images is further reduced. Because Canon has a good noise-reduction algo-rithm, this setting maintains a good level of fine detail in images, and reducing shadow noise is advantageous. You may want to set this function for specific shooting situations, or you may want to set a level and leave it to be applied to all of your images. Here are the options, and the level names are self-explanatory:

✦ **0: Standard**

✦ **1: Low**

✦ **2: Strong**

✦ **3: Disable**

Note *If you have C.Fn-5 set to Option 2, the burst rate in Continuous drive mode is decreased.*

C.Fn-6: Highlight tone priority

One of the most interesting and useful func-tions is Highlight tone priority, which helps ensure good image detail in bright areas of the image such as those on a bride's gown. With the function turned on, the high range of the camera's dynamic range (the range between deep shadows and highlights in a scene as measured in f-stops) is extended from 18 percent gray (middle gray) to the brightest highlights. Also, the gradation from middle gray tones to highlights is smoother

with this option turned on. The downside of enabling this option is increased digital noise in shadow areas. But if you shoot weddings or any other scene where it's criti-cal to retain highlight detail, then the tradeoff is worthwhile. If noise in the shadow areas is objectionable, you can apply noise reduc-tion in an image-editing program.

If you turn on Highlight Tone Priority, ISO speed settings are reduced to 200 to 3200 (rather than 100 to 3200). The ISO display in the viewfinder, on the LCD, and in the Shooting information display uses a D+ to indicate that this Custom Function is in effect. Here are the options and a descrip-tion of each one:

✦ **0: Disable.** Highlight tone priority is not used and the full range of ISO settings is available.

✦ **1: Enable.** The T1i/500D empha-sizes preserving the highlight tonal values in the image and improving the gradation of tones from middle gray to the brightest highlight. Shadows go dark quicker and tend to show more digital noise. Also the ISO range is 200 to 3200 rather than 100 to 3200. When you press the ISO button to change the ISO, the ISO speed screen notes Highlight tone priority at the bot-tom to remind you that this func-tion is set.

C.Fn-7: Auto Lighting Optimizer

This function is an automatic exposure adjustment that corrects overly dark, or underexposed, images and boosts the con-trast in low-contrast scenes such as those in hazy or overcast light. However, just as when you brighten underexposed images in an image-editing program, any digital noise that is present is revealed. The same effect may result from using Auto Lighting Optimizer

depending on the level you choose. While you can turn off this function for shooting in Creative Zone modes, you cannot turn it off for images shot in Basic Zone shooting modes such as CA, Full Auto, Portrait, Landscape, and so on. In Basic Zone shooting modes the optimization is set to Standard level. Also, if you're shooting in P, Tv, Av, or A-DEP modes, automatic lightening is not applied to RAW or RAW+Large JPEG images. And the function is not applied if you're shooting in Manual shooting mode or when you're making a Bulb exposure.

Because Auto Lighting Optimizer is on by default, if you use AEB to shoot three images — one at standard exposure, one with more exposure, and one with less exposure — you may not see much or any difference among the three images because the darker image will be automatically optimized for brightness. If you want to see the effects of AEB, then set the option to 3: Disable. In addition, if you shoot in Live View mode with Auto Lighting Optimizer enabled, and if you set negative Exposure Compensation, then images may appear brighter than they would without Auto Lighting Optimizer.

So should you turn off Auto Lighting Optimizer? The answer is that it depends. If you print images directly from the SD/SDHC card, or if you do not routinely edit your images on the computer, then you may find that the optimization provides better prints. However, if you routinely edit images on the computer, then disabling this function allows you to control brightening and contrast adjustments to your personal tastes while controlling the appearance of digital noise in the shadow areas. In addition, disabling this function gives you a true representation of images shot with Auto Exposure Lock, AEB, and Exposure Compensation. Because I edit images on the computer and

prefer to control brightening myself, I turn off Auto Lighting Optimizer. Here are the options and notes for some of the options:

✦ **0: Standard.** This is the default setting.

✦ **1: Low**

✦ **2: Strong**

✦ **3: Disable.** Turns off Auto Lighting Optimizer when shooting JPEG images in P, Tv, Av, and A-DEP shooting modes.

C.Fn III: Autofocus/Drive

This group of functions concentrates on autofocus speed and on enabling Mirror Lockup to prevent blur from the action of the reflex mirror in macro and long exposures.

C.Fn-8: AF-assist beam firing

This function enables you to control whether the Rebel T1i/500D's built-in flash or an accessory EX Speedlite's autofocus-assist light is used to help the camera's autofocus system establish focus. The AF-assist beam speeds up focusing and ensures sharp focus in low-light or low-contrast scenes. Here are the options and a description of each one:

✦ **0: Enable.** This option allows the AF-assist beam from either the built-in flash or a Canon Speedlite mounted on the camera to help the camera focus. Enable is the default setting for the Rebel T1i/500D.

✦ **1: Disable.** If you choose this option, neither the built-in flash or the Speedlite AF-assist beam lights to help establish focus. While this option is useful in shooting situations where the AF-assist light may be annoying or intrusive, it will be difficult to establish accurate focus in low-light scenes.

✦ **2: Only external flash emits.** If you choose this option, the AF-assist beam emits only when a Canon Speedlite is mounted on the camera's hot shoe. The Speedlite's AF-assist beam is more powerful than the beam of the built-in flash, and that makes this option good for low-light and low-contrast subjects that are farther away from the camera. However, be aware that if you have set the Custom Function on the Speedlite so that the AF-assist beam does not fire, then the Speedlite's Custom Function option overrides the camera's Custom Function option.

C.Fn-9: Mirror Lockup

Option 1 for this function prevents blur that can be caused in close-up and super-telephoto shots by the camera's reflex mirror flipping up at the beginning of an exposure. While the effect of motion from the mirror is negligible during normal shooting, it can make a difference in the extreme magnification levels for macro shooting and when using super-telephoto lenses. If you turn on Mirror Lockup, the first time that you press the Shutter button, it flips up the reflex mirror. You then have to press the Shutter button again to make the exposure. Also be sure to use a tripod in conjunction with Mirror Lockup. You cannot use C.Fn-9 with Live View shooting. Here are the options and a description of each one:

✦ **0: Disable.** This is the default setting where the reflex mirror does not lock up before making an exposure.

✦ **1: Enable.** Choosing this option locks up the reflex mirror when you first press the Shutter button. With the second press of the Shutter button, the exposure is made and the reflex mirror drops back down.

Tip *If you often use Mirror Lockup, you can add this Custom Function to My Menu for easy access. Customizing My Menu is detailed later in this chapter. Also, if you use Mirror Lockup with bright subjects such as snow, bright sand, the sun, and so on, be sure to take the picture right away to prevent the camera curtains from being scorched by the bright light.*

C.Fn IV: Operation/Others

This group of Custom Functions enables you to change the functionality of camera buttons for ease of use to suit your shooting preferences, to control the LCD display, and to add data that verifies that the images are original and unchanged.

C.Fn-10: Shutter button/AE Lock button

This function changes the function of the Shutter button and the AE Lock button (the button located at the top-right back of the camera with an asterisk above it) for focusing and exposure metering. To understand this function, it's important to know that the Rebel T1i/500D biases the light metering in Evaluative metering mode to the active AF point.

However, there are many times when you want to bias the exposure somewhere other than where you want to focus. For example, if you're shooting a portrait, you may want to meter the light (on which the exposure will be calculated) and have it biased toward an area of the subject's face. This area isn't where you want to set the focus; rather, you want to focus on the subject's eyes. To bias the metering on one area and focus on another area, you can use AE Lock.

The options of this function enable you to switch or change the functionality of the Shutter button and the AE Lock button, or to

disable AE Lock entirely when you use continuous focusing via AI Servo AF mode. Note that only Option 1 can be used in Live View shooting, and none of the options works in Movie mode shooting.

Here are the options and a description of each one:

✦ **0: AF/AE lock.** This is the default setting where you set the focus using the Shutter button and you can set and lock the exposure by pressing and holding the AE Lock button.

✦ **1: AE lock/AF.** Choosing this option switches the function of the Shutter button and the AE Lock button. Pressing the AE Lock button sets focus while pressing and holding the Shutter button halfway sets and locks the exposure. Then you press the Shutter button completely to make the picture.

✦ **2: AF/AF lock, no AE lock.** If you're shooting in AI Servo AF mode where the camera automatically tracks the motion of a moving subject, this function enables you to press the AE Lock button to suspend focus tracking. This is useful, for example, when an object moves in front of the subject so that subject focus can be thrown off. For sports, action, and wildlife shooting, this option is useful in ensuring sharp subject focus. The downside, of course, is that you do not have the ability to use AE Lock at all.

✦ **3: AE/AF, no AE lock.** This option extends Option 2 by allowing you to suspend AI Servo AF focus tracking by pressing the AE Lock button. For example, if you are photographing an athlete who starts and stops

moving erratically, you can press the AE Lock button to start and stop continuous autofocus tracking (AI Servo AF). In AI Servo AF mode, the exposure and focusing are set when you press the Shutter button.

C.Fn-11: Assign SET button

This Custom Function enables you to take advantage of using the Set button while you're shooting rather than only when you're using camera menus. The Set button continues to function normally when you're accessing camera menus. Here are the options and a description of each one:

✦ **0: Quick Control screen.** With this option selected, you can press the Set button to display the Quick Control screen that enables you to change exposure and camera settings directly from the Quick Control screen.

✦ **1: Image quality.** With this option, you can press the Set button as you shoot to display the Image-recording quality screen on the LCD so that you can make changes.

✦ **2: Flash Exposure Compensation.** With this option, you can press the Set button to display and change Flash Exposure Compensation setting screen to set or change flash exposure compensation.

✦ **3: LCD monitor On/Off.** With this option, pressing the Set button toggles the LCD monitor display on or off, replicating the functionality of the Display (DISP.) button.

✦ **4: Menu display.** With this option, pressing the Set button displays the last camera menu that you accessed with the last menu item highlighted.

✦ **5: Disabled.** This is the default set-ting where the Set button has no functionality during shooting.

C.Fn-12: LCD display when power ON

This function enables you to save a bit of bat-tery power by choosing whether the shoot-ing information is displayed on the LCD when you turn on the Rebel T1i/500D. Sounds simple enough, but Option 1 isn't quite as straightforward as it seems. Here are the options and a description of each one:

✦ **0: Display.** This is the default set-ting where the T1i/500D displays shooting information on the LCD when you turn on the camera. To turn off the display, you must press the Display button on the back of the camera.

✦ **1: Retain power OFF status.** With this option, the shooting informa-tion is not displayed on the LCD when you turn on the camera only if you pressed the Display button to turn off the LCD display the last time you used the camera. To dis-play shooting information, press the Display button. Now, you might assume that setting this option, and turning off the display before shutting down the camera would be sufficient, but such is not the case. If you had the shooting infor-mation displayed on the LCD the last time the camera was turned off, the shooting information is dis-played when you power up the camera. So to keep the display from turning on, you have to remember to turn off the display by pressing the Display button before powering down the camera every time you use the camera. Annoying, but true.

It's tempting to choose Option 1 simply to save battery power. But if you keep the display off, then you have to manually turn on the dis-play by pressing the Display button before you can display the ISO set-tings screen, for example.

For the sake of convenience and to avoid having to press the Display button before using the ISO and Av buttons, I recommend using Option 0: Display.

C.Fn-13: Add original decision data

When this option is turned on, data is appended to verify that the image is original and hasn't been changed. This is useful when images are part of legal or court pro-ceedings. The optional Original Data Security Kit OSK-E3 is required. Here are the options and a description of each one:

✦ **0: Off**

✦ **1: On.** With this option and when used with the Original Data Security Kit OSK-E3, data is auto-matically appended to the image to verify that it is original. When you display shooting information for the image, a distinctive locked icon appears.

Setting Custom Functions

Depending on your shooting preferences and needs, you may immediately recognize functions and options that would make your shooting faster or more efficient. You may also find that combinations of functions are useful for specific shooting situations. Whether used separately or together, Custom Functions can significantly enhance your use of the T1i/500D.

To set a Custom Function, follow these steps:

1. **Set the Mode dial to P, Tv, Av, M, or A-DEP.**

2. **Press the Menu button, and then turn the Main dial until the Setup 3 (yellow) menu is displayed.**

3. **If necessary, press the up or down cross key to highlight Custom Functions (C.Fn), and then press the Set button.** The most recently accessed Custom Function screen appears.

4. **Press the right or left cross key to move through the Custom Function numbers displayed in the box at the top right of the screen, and when you get to the number you want, press the Set button.** The Custom Function option control is activated and the option that is currently in effect is highlighted.

5. **Press the up or down cross key to highlight the option you want, and then press the Set button.** You can refer to the previous descriptions in this section of the chapter to select the function option that you want. Repeat Steps 4 and 5 to select other Custom Functions and options. Lightly press the Shutter button to return to shooting.

If you want to reset one of the Custom Functions, repeat these steps to change it.

If you want to restore all Custom Function options to the camera's default settings, follow Steps 1 through 3, but in Step 3 press the down cross key to highlight Clear Settings, and then press the Set button. On the Clear Settings screen, select Clear all Custom Func. (C.Fn). Press the right cross key to select OK, and then press the Set button.

Customizing My Menu

Given the number of menus and menu options on the T1i/500D, and given that in an average day of shooting you may use only a few menus and options consistently, customizing the My Menu option makes good sense. My Menu lets you select and register six of your most frequently used menu items and Custom Functions for easy access.

You can add and delete items to My Menu easily and quickly, and you can change the order of items by sorting the items you register. You can also set the T1i/500D to display My Menu first when you press the Menu button.

Before you begin registering items to My Menu, look through the camera menus and Custom Functions carefully and choose your six most frequently changed items.

To register camera Menu items and Custom Functions to My Menu, follow these steps:

1. **Set the Mode dial to P, Av, Tv, M, or A-DEP.**

2. **Press the Menu button, and then turn the Main dial until My Menu (green) is displayed.**

3. **Press a cross key to highlight My Menu settings, if necessary, and then press the Set button.** The My Menu settings screen appears.

4. **Press a cross key to highlight Register, and then press the Set button.** The My Menu registered item screen appears. This screen contains a scrolling list of all the camera's menu items, options, and Custom Functions.

5. **Press the down cross key until you get to a menu item or Custom Function that you want to register, and then press the Set button.** As you press the down cross key to scroll, a scroll bar on the right of the screen shows your relative progress through the list. When you select an item and press the Set button, a confirmation screen appears.

6. **Press the right cross key to highlight OK, and then press the Set button.** The My Menu registered item screen reappears.

7. **Repeat Steps 5 and 6 until you've selected and registered six menu items.**

8. **When you finish registering menu items, press the Menu button.** The My Menu settings screen appears. If you want to sort your newly added items, from here go to Step 4 in the next set of steps.

To arrange your My Menu items in the order you want, follow these steps:

1. **In P, Av, Tv, M, or A-DEP mode, press the Menu button, and then press the right cross key until My Menu (green) is displayed.**

2. **Press the down cross key to highlight My Menu settings, and then press the Set button.** The My Menu settings screen appears.

3. **Press the down cross key to highlight Sort, and then press the Set button.** The Sort My Menu screen appears.

4. **Press the down cross key to select the item that you want to move, and then press the Set button.** The sort control for the selected item is activated and is

displayed with up and down arrow icons.

5. **Press the up cross key to move the item up in the list, or press the down cross key to move it down in the list, and then press the Set button.**

6. **Repeat Steps 4 and 5 to move other menu items in the order that you want.** Lightly press the Shutter button to return to shooting.

Note *The My Menu settings item always appears at the bottom of the My Menu list. Selecting it gives you access to the My Menu settings screen where you can Register, Sort, Delete, Delete all items, and disable or enable the display of My Menu as the first menu displayed.*

You can delete either one or all items from My Menu. And you can choose to have My Menu displayed first every time you press the Menu button. To delete one or more items from My Menu, follow these steps:

1. **In P, Av, Tv, M, or A-DEP mode, press the Menu button, and then press the right cross key until My Menu (green) is displayed.**

2. **Press the down cross key to highlight My Menu settings, and then press the Set button.** The My Menu settings screen appears.

3. **Press the down cross key to highlight Delete to delete a single item, or highlight Delete all items to delete all registered items, and then press the Set button.** The Delete My Menu or the Delete all My Menu items screen appears depending on the option you chose.

4. **If you chose to delete a single menu item, press the down cross key to highlight the menu item you want to delete, and then press the Set button.** The Delete My Menu confirmation screen appears. If you chose to Delete all items, the Delete all My Menu items screen appears.

5. **Press the right cross key to select OK, and then press the Set button.** Lightly press the Shutter button to return to shooting.

If you want the My Menu tab to be the first menu displayed when you press the Menu button, follow these steps:

1. **On the My Menu menu, press the down cross key to highlight My Menu settings, and then press the Set button.** The My Menu settings screen appears.

2. **Press the down cross key to highlight Display from My Menu, and then press the Set button.** Two options appear.

3. **Press the down cross key to select Enable, and then press the Set button.** Lightly press the Shutter button to return to shooting.

Other Customization Options

In addition to setting Custom Functions and setting up My Menu, you can also display a handy Quick Control screen from which you can quickly change key camera and exposure settings in P, Tv, Av, M, and A-DEP shooting modes, and you can change the color of the LCD monitor.

Displaying the Quick Control screen

The Quick Control screen is a very convenient way to not only see what settings the Rebel T1i/500D is currently set to, but also to quickly change settings on the fly with a minimum of changing among camera controls and menus.

Here is how to display and use the Quick Control screen:

1. **In any camera mode, press the Display button.** The shooting settings screen appears on the LCD showing the current exposure and camera settings.

2. **Press the Set button.** The Quick Control screen is activated. In Basic Zone modes such as Portrait, Landscape, and so on, the only option you can change is the image recording quality. In CA mode, you can change the shooting and exposure options displayed on the screen. And in P, Tv, Av, M, and A-DEP shooting modes, you can change the options displayed on the screen including ISO, shutter speed, or aperture, depending on the shooting mode, Exposure Compensation, Picture Style, white balance, Metering mode, and so on.

3. **Press a cross key to select the option or setting that you want to change, and then turn the Main dial to change the setting.** As you turn the Main dial, the camera cycles through the available options. To change another setting, repeat this step.

Changing the shooting settings screen color

Another customization option on the Rebel T1i/500D is choosing the screen color you want for the LCD shooting information display. You can choose from four options:

✦ Black text on a light gray background, which is the default setting

✦ White text on a black background

✦ White text on a brown background

✦ Green text on a black background

To set the screen color, follow these steps.

1. **In any camera mode, press the Menu button, and then turn the Main dial to select the Setup 1 (yellow) menu.**

2. **Press the down cross key to highlight Screen Color, and then press the Set button.** The Screen color screen appears.

3. **Press a cross key to select the color scheme that you want, and then press the Set button.** The option you choose remains in effect until you change it.

The T1i/500D offers you a high level of customizability. While the full complement of choices may initially seem overwhelming, I recommend taking each one in turn and building on it to set more custom settings until you get the camera set up for your shooting style.

Doing More with the EOS Rebel T1i/500D

Using Flash

Whether you use the Rebel T1i/500D's onboard flash unit or an accessory Canon EX-series Speedlite, flash photography extends the creative opportunities of the Rebel in many different scenes. And with the continued improvements in flash settings and options, you can get natural-looking results whether you're shooting indoors or outdoors, particularly when you're using P, Tv, Av, and M shooting modes.

This chapter explores flash technology, details the use of the T1i/500D's onboard flash, and covers the menu options for both the built-in flash and for accessory EX-series Speedlites. This is not an exhaustive look at all the ways in which you can use the onboard or accessory flash units. Rather, the focus is on fundamental flash techniques and ideas for using flash for both practical situations and creative effect.

Exploring Flash Technology

Both the onboard flash and Canon's EX-series Speedlites employ E-TTL II technology. E-TTL stands for Evaluative Through-the-Lens flash exposure control. E-TTL II is a flash technology that receives information from the camera, including the focal length of the lens, distance from the subject, and exposure settings including aperture, and then the camera's built-in Evaluative metering system balances subject exposure with the existing light in the scene.

In more technical terms, with E-TTL II, the camera's meter reads through the lens, but not off the focal plane. After the Shutter button is fully pressed but before the reflex mirror goes up, the flash fires a preflash beam. Information from this preflash is combined with data from the Evaluative metering system to analyze and compare existing light exposure values with the amount of light needed to make a good exposure. Then the camera calculates and stores the flash output needed to illuminate the subject while maintaining a natural-looking balance with the ambient light in the background.

In addition, the flash automatically figures in the angle of view for the T1i/500D given its cropped image sensor size. Thus, regardless of the lens being used, the built-in flash and EX-series Speedlites automatically adjust the flash zoom mechanism for the best flash angle and to illuminate only key areas of the scene, which conserves power. Altogether, this technology makes the flash very handy for a variety of subjects.

Whether you use the built-in flash or an accessory EX Speedlite, you can use flash in Tv, Av, and M shooting modes knowing that the exposure settings are taken into account during exposure given the maximum sync speed for the flash. When you use the flash in P shooting mode, you cannot shift, or change, the exposure. Instead, the camera automatically sets the aperture, and it sets the shutter speed between 1/250 and 1/60 second. The same is true for using the flash in A-DEP mode.

7.1 For this image, I used the built-in flash, which provided a nice fill light to supplement the window light above the scene. Exposure: ISO 100, f/8, 1/200 second.

 Note *In Basic Zone modes except Landscape, Sports, and Flash Off, the camera automatically fires the flash. The only way to turn off flash use in automatic modes is by switching to Flash Off shooting mode, or to Landscape or Sports shooting modes provided that the subject is appropriate for the exposure settings made in these two modes. Also if you use the flash in A-DEP mode, the maximum depth of field will not be obtained, and the results will be more like shooting in P shooting mode.*

When shooting with accessory Speedlites, Canon's flash technology allows wireless, multiple flash photography where you can simulate studio lighting in both placement of lights and light ratios (the relative intensity of each flash unit).

Using the onboard flash

Without question, the T1i/500D's onboard flash unit is a handy complement to existing-light shooting. You can use it to add just a pop of flash for subjects that are backlit, to balance the exposure for combined outdoor and indoor scenes, and in low-light scenes to ensure that there is no blur from hand-holding the camera at slow shutter speeds. Once you understand both the flexibility and the limitations of the flash, you'll have another tool that helps ensure tack-sharp, well-lit images in scenes where you might not have gotten these results without using the flash. And, most important, there is enough control that you can also avoid the sterile, overly bright, deer-in-the-headlights images that are commonly associated with flash use.

Why Flash Sync Speed Matters

Flash Sync speed matters because if it isn't set correctly, only part of the image sensor has enough time to receive light while the shutter is open. The result is an unevenly exposed image. The T1i/500D doesn't allow you to set a shutter speed faster than 1/200 second, but in some modes you can set a slower Flash Sync speed, as shown in Table 7.1. Using Custom Function C.Fn-3, you can set whether the T1i/500D sets the Flash Sync speed automatically (Option 0), from 1/200 to 1/60 second (Option 1), or always uses 1/200 second (option 2) when you shoot in Av mode. If you choose to always use 1/200 second, then the flash becomes the main light source rendering a bright subject with a dark background. If you use Auto, then the existing light contributes more to the exposure providing proper subject and background exposure. If you choose Option 1 of 1/200 to 1/60 second, then the background will be dark but you can avoid blur from handholding the camera at the slower shutter speed that Auto may use.

First, though, it's important to understand a few aspects of the built-in flash that help you know when to use it and what to expect from it.

✦ The built-in flash unit offers coverage for lenses as wide as 17mm (equivalent to 27mm in full 35mm frame shooting).

✦ After firing the flash, it takes approximately 3 seconds for the flash to recycle or repower itself depending on the number of firings. When the flash is fully recycled, the Flash-ready light that resembles a lightning bolt illuminates in the viewfinder.

✦ To provide adequate light, be sure the subject is no closer than 3.3 feet (1 meter) and no farther than 16.4 feet (5 meters) from the camera.

✦ Don't use a lens hood when you're using the flash, as it will obstruct part of the light from the flash.

✦ In both Tv and Av shooting modes, if you use autoflash, the flash output is set based on the aperture (f-stop). But if you're shooting in Tv mode where the shutter speed is the primary concern, know that you can set the Flash Sync speed from 1/200 to 30 seconds.

✦ In the Basic Zone modes of Portrait, Close-up, and Night Portrait, the Rebel T1i/500D automatically fires the flash when it detects lower light or backlit subjects. In Landscape, Sports, and, of course, in Flash Off modes, the flash doesn't fire. In Landscape mode, the range of the flash isn't sufficient to illuminate distant scenes. In Sports mode, the shutter speed often exceeds the Flash Sync speed or the subject distance exceeds the range of the flash.

The built-in flash also offers good versatility and features overrides, including Flash Exposure Compensation (FEC) and Flash Exposure Lock (FE Lock) covered later in this

chapter. In addition, many flash options can be set on the camera's Flash Control menu when you shoot in P, Tv, Av, M, and A-DEP modes.

Flash Control menu options include the ability to turn off firing of the built-in flash and an accessory flash, shutter sync with first or second curtain, and Evaluative or Average metering. The T1i/500D also allows you to set Custom Functions for an accessory EX-series Speedlite through the Shooting 1 (red) camera menu — a handy feature that enables you to use the camera's larger size LCD to set up external flash functions. Control of Red-eye reduction is also provided on the Shooting 1 (red) menu.

In the following images, you can see how the different flash options for the built-in flash change the exposure and look of the images. My personal preference is to have the most natural-looking result but with the pop of a little flash light that brings the subject visually forward in the frame.

Tip *As the subject distance increases, the light from the flash falls off. If you double the distance, the light is one quarter as much as before. This is called the Inverse Square Law.*

7.2 For this image, I used the built-in flash with the default Evaluative flash metering option that's adjustable under the Built-in flash control options on the Shooting 1 (red) menu. I shot in Av shooting mode with C.Fn-3 set to Option 0: Auto. Exposure: ISO 200, f/5.6, 1/125 second.

7.3 For this image, I used the built-in flash but changed to the Average flash metering option on the Built-in flash control menu. The flash output increased significantly and the mannequin is overexposed. Exposure: ISO 100, f/5.6, 1/125 second.

Using Guide Numbers

A guide number indicates the amount of light that the flash emits so that you can determine the best aperture to use at a particular distance and at a given ISO, usually ISO 100. The guide number for the built-in flash is 43 (feet)/13 (meters) at ISO 100. Knowing that guide number, you can then divide the guide number by the flash-to-subject distance to determine what aperture to set. So the relationship between the aperture and the flash-to-subject distance is Guide Number ÷ Aperture = Distance for optimal exposure and Guide Number ÷ Distance = Aperture for optimal exposure.

For example, with a guide number of 43, and shooting 8 feet from the subject, the optimal aperture is determined thusly: 43 ÷ 8 feet is 5.375, or rounded up to f/5.6. If that aperture isn't what you want, then you can change the camera-to-subject distance, or you can increase the ISO sensitivity setting. By increasing the ISO, the camera needs less light to make the exposure, and it simultaneously increases the range of the flash. When you increase the ISO from 100 to 200, the guide number increases by a factor of 1.4x, while increasing from 100 to 400 doubles the guide number.

Table 7.1 shows the behavior of the flash in each of the Rebel T1i/500D's Creative Zone shooting modes. Table 7.2 shows the approximate effective range of the flash with the Canon EF 18-55mm lenses.

Tip *If you're using a non-Canon flash unit, the sync speed is 1/200 second or slower. Non-Canon flash units do not fire in Live View shooting mode. Canon advises against using a hot-shoe mount high-voltage flash unit.*

Table 7.1
Using the Built-in Flash in Creative Zone Modes

Mode	Shutter Speed	Automatic Exposure (AE) Setting
Tv (Shutter-priority AE)	1/200 sec. to 30 sec.	You can set the shutter speed up to 1/200 second, and the camera automatically sets the appropriate aperture.
Av (Aperture-priority AE)	1/200 sec. to 30 sec.	You set the aperture, and the camera automatically sets the shutter speed up to 1/200 second. In this mode, the camera may set long shutter speeds that can result in blur if the subject moves or if you handhold the camera. To avoid this, you can set C.Fn -3 to Option 1: 1/200-1/60 second, or to Option 2: 1/200 second (fixed).
M (Manual)	1/200 to 30 sec.	You set both the aperture and the shutter speed. Flash exposure is set automatically.
A-DEP (Automatic depth-of field), and P (Program)	1/60 sec. to 1/200 sec.	Both the aperture and the shutter speed are set automatically by the camera. In A-DEP shooting mode, using the flash sacrifices the maximum depth of field.

Table 7.2

T1i/500D Built-in Flash Range with the EF-S 18-55mm Lens

ISO	18mm	55mm
100	1 to 3.7m (3.3 to 12.1 ft.)	1 to 2.3m (3.3 to 7.5 ft.)
200	1 to 5.3m (3.3 to 17.4 ft.)	1 to 3.3m (3.3 to 10.8 ft.)
400	1 to 7.4m (3.3 to 24.3 ft.)	1 to 4.6m (3.3 to 15.1 ft.)
800	1 to 10.5m (3.3 to 34.4 ft.)	1 to 6.6m (3.3 to 21.7 ft.)
1600	1 to 14.9m (3.3 to 47.9 ft.)	1 to 9.3m (3.3 to 30.5 ft.)

Using the flash's autofocus-assist beam without firing the flash

In some low-light scenes, you may want to shoot without the flash, but the camera often cannot focus due to the low light, or it takes the camera a long time to focus. In these situations, you can set up the Rebel to use the flash's autofocus-assist (AF-assist) beam. Then you pop up the flash, half-press the Shutter button, and the autofocus-assist beam fires to help the camera establish focus. In these scenes, you can keep the flash from firing but still use the flash's AF-assist beam to help the camera to establish focus.

Before you begin, ensure that the autofocus-assist beam firing is turned on in C.Fn-8. If you're using an accessory Canon Speedlite, you can alternately choose Option 2: Only external flash emits to use only the Speedlite's AF-assist beam.

To use the flash's AF-assist beam for focusing but not use the flash, follow these steps:

1. **Press the Menu button, and then turn the Main dial until the Shooting 1 (red) menu is displayed.**

2. **Press the down cross key to highlight Flash control, and then press the Set button.** The Flash control screen appears.

3. **Press a cross key to highlight Flash firing, and then press the Set button.** Two options appear.

4. **Press a cross key to highlight either Enable or Disable, and then press the Set button.** If you choose Disable, neither the built-in flash nor an accessory Speedlite will fire. However, the camera will use the flash's AF-assist beam to establish focus in low-light scenes where the camera has difficulty focusing.

5. **Pop up the built-in flash by pressing the Flash button on the front of the camera, or mount an accessory EX-series Speedlite, press the Shutter button halfway to focus, and then press the Shutter button completely to make the picture.** When you press the Shutter button halfway, the flash's AF-assist beam fires to help the camera establish focus.

Red-eye reduction

A disadvantage of flash exposure in portraits of people and pets is unattractive red in the subject's eyes. There is no sure fix that prevents red eye, but a few steps help reduce it. First, be sure to turn on Red-Eye Reduction on the T1i/500D. This option is set to Off by default. Before making the picture, have the subject look at the Red-Eye Reduction lamp on the front of the camera when it fires at the beginning of a flash exposure. Also have the room well lit.

To turn on Red-Eye Reduction, follow these steps:

1. **Press the Menu button, and then turn the Main dial to select the Shooting 1 (red) menu if it isn't already displayed.**

2. **Press the down cross key to highlight Red-eye On/Off, and then press the Set button.** Two options are displayed.

3. **Press the down cross key to highlight On, and then press the Set button.** The setting you choose applies to both Basic and Creative Zone modes.

4. **If you're shooting in P, Tv, Av, M, or A-DEP, press the Flash button on the camera to pop up the built-in flash.** In Basic Zone modes such as Full Auto, Portrait, and so on, the built-in flash pops up and fires automatically depending on the amount of light in the scene.

5. **Focus on the subject by pressing the Shutter button halfway, and then watch the timer display at the bottom center of the viewfinder.** When the timer display in the viewfinder disappears, press the Shutter button completely to make the picture.

Modifying Flash Exposure

There are doubtless times when the output of the flash will not be what you envisioned. Most often, the output is stronger than desired, creating an unnaturally bright illumination on the subject. The Rebel T1i/500D offers two options for modifying the flash output: Flash Exposure Compensation (FEC) and Flash Exposure Lock (FE Lock) for both the built-in flash and one or more accessory Speedlites.

Flash exposure modification controls are available only when you're shooting in P, Tv, Av, M, and A-DEP shooting modes. In the automatic modes such as Portrait, Landscape, and Full Auto, the T1i/500D fires the flash and controls the flash output automatically.

Flash Exposure Lock

One way to modify flash output is by using Flash Exposure Lock (FE Lock). Much like Auto Exposure Lock (AE Lock), FE Lock allows you to meter and set the flash output on any part of the scene.

With FE Lock, you lock the flash exposure on a midtone area in the scene or any area where exposure is critical. The camera calculates a suitable flash output, and locks or remembers the exposure, and then you can recompose, focus, and make the picture.

FE Lock is also effective when there are reflective surfaces such as a mirror, chrome, or glass in the scene. Without using FE Lock, the camera takes the reflective surface into account and reduces the flash, causing underexposure. Instead, set FE Lock for a midtone area in the scene that does not include the reflective surface, and then make the exposure.

To set FE Lock, follow these steps:

1. **Set the camera to P, Tv, Av, or M, and then press the Flash button to raise the built-in flash or mount the accessory Speedlite.** The flash icon appears in the viewfinder.

2. **Point the lens at the area of the subject or scene where you want to lock the flash exposure such as a midtone area in the scene, press the Shutter button halfway, and then press the AE/FE Lock button on the back-right side of the camera.** This button has an asterisk above it. The flash exposure is biased toward the active AF point. The camera fires a preflash. FEL is displayed momentarily in the viewfinder, and the flash icon in the viewfinder displays an asterisk beside it to indicate that flash exposure is locked. The camera retains the flash output in memory.

 If the flash icon in the viewfinder blinks, you are too far from the subject for the flash range. Move closer to the subject and repeat Step 2.

3. **Move the camera to compose the image, press the Shutter button halfway to focus on the subject, wait for the flash timer display to disappear, and then completely press the Shutter button to make the image.** You can take additional pictures at this flash output as long as the asterisk is displayed in the viewfinder.

FE Lock is a practical technique to use when shooting individual images. But if you're shooting a series of images under unchanging light, then FEC is more efficient and practical.

Flash Exposure Compensation

Flash Exposure Compensation (FEC) is much like Auto Exposure Compensation in that you can increase or decrease flash exposure up to +/-2 stops in 1/3-stop increments. A positive compensation increases the flash output and a negative compensation decreases the flash output. The compensation is applied to all flash exposures until you reset the compensation back to 0.

As with non-flash exposure, the camera is calibrated for an "average" scene of 18 percent gray, and flash exposures can be thrown off by very light and very dark subjects or scenes. As a result, very light subjects may need increased flash exposure ranging from +0.3 to +1 stop. Dark-toned subjects may need a flash reduction of approximately -1 to -1.3 stops. Some experimentation is required because subject and scene tonality varies.

If you use flash compensation to create a more natural-looking portrait in daylight, try setting negative compensation between -1 and -2 stops. Also be aware that in bright light, the camera assumes that you're using fill flash to reduce dark shadows and automatically provides flash reduction. Experiment with the Rebel T1i/500D in a variety of lighting to know what to expect.

7.4 This image was made using no flash in overcast, late-afternoon light. Exposure: ISO 200, f/5.6, 1/125 second.

7.5 For this image, FEC was set to -1 Exposure Value (EV). The lowered flash exposure provides a more natural appearance than full flash would provide (compare to Figure 7.2). I used Av shooting mode and set C.Fn I-3 to Auto so the camera would balance existing light with the flash light. Exposure: ISO 200, f/5.6, 1/125 second, Av mode.

It's important to note that if you use FEC, you may not see much if any difference with negative compensation because the T1i/500D has Auto Lighting Optimizer turned on by default for all JPEG images. This feature automatically corrects images that are underexposed or have low contrast. So if you set FEC to a negative setting to reduce flash output, the camera may detect the image as being underexposed (too dark) and automatically brighten the picture. The next series of images shows the advantage of fill flash with FEC over using no flash.

If you're using FEC, it's best to turn off Auto Lighting Optimizer by choosing Option 3: Disable for C.Fn-7. Auto Lighting Optimizer remains disabled in P, Tv, Av, M, and A-DEP shooting modes until you enable it again.

If you use an accessory Speedlite, you can set FEC either on the camera or on the Speedlite. However, the compensation that you set on the Speedlite overrides any compensation that you set on the T1i/500D's Shooting 1 (red) camera menu. If you set compensation on both the Speedlite and the camera, the Speedlite setting overrides what you set on the camera. In short, you can set the compensation either on the Speedlite or on the camera, but not on both.

7.6 For this image, FEC was set to -2 Exposure Value (EV). This image provides the most natural-looking image to my eye because it adds a little light to the face while balancing the existing light in the background. Exposure: ISO 100, f/5.6, 1/125 second.

FEC can be combined with Exposure Compensation. If you're shooting a scene where one part of the scene is brightly lit and another part of the scene is much darker — for example, an interior room with a view to the outdoors — then you can set Exposure Compensation to -1 and set the FEC to -1 to make the transition between the two differently lit areas more natural.

To set FEC for the built-in flash, follow these steps:

1. **Set the Mode dial to P, Tv, Av, M, or A-DEP.**

2. **Press the Menu button, and turn the Main dial to select the Shooting 1 (red) menu.**

3. **Press the down cross key to highlight Flash control, and then press the Set button.** The Flash control screen appears.

4. **Press the down cross key to highlight Built-in flash func. setting, and then press the Set button.** The Built-in flash func. setting screen appears.

5. **Press the down cross key to highlight Flash exp. Comp, and then press the Set button.** The Flash Exposure Compensation control is activated.

6. **Press the left cross key to set negative compensation (lower the flash output for a darker image) or press the right cross key to set positive flash output (increase the flash output for a brighter image).** As you make changes, a tick mark under the exposure level meter moves to indicate the amount of FEC in 1/3-stop increments. The FEC is displayed in the viewfinder when you press the Shutter button halfway. The FEC you set on the camera remains in effect until you change it.

To remove FEC, repeat these steps, but in Step 2, press the left or right cross key to move the tick mark on the exposure level meter back to the center point.

Using flash control options

With the T1i/500D, many of the onboard and accessory flash settings are available on the camera menus. The Shooting 1 (red) menu offers onboard flash settings including the first or second curtain shutter sync, Flash Exposure Compensation, and E-TTL II or Average exposure metering.

7.7 For this image, I used the built-in flash at a -2 FEC to light the center of these cherry blossoms. Exposure: ISO 200, f/8, 1/125 second.

When an accessory Speedlite is mounted, you can use the Setup 2 (yellow) menu to set FEC and to set Evaluative or Average flash metering. In addition, you can change or clear the Custom Function (C.Fn) settings for compatible Speedlites such as the 580 EX II. If the Speedlite functions cannot be set with the camera, these options display a message notifying you that the flash is incompatible with this option. In that case, set the options you want on the Speedlite itself.

To change settings for the onboard or compatible accessory EX-series Speedlites, follow these steps:

1. **Set the camera to a P, Tv, Av, M, or A-DEP.** If you're using an accessory Speedlite, mount it on the hot shoe and turn on the power.

2. **Press the Menu button, and then press the right cross key until the Shooting 1 (red) menu is displayed.**

3. **Press the down cross key to highlight Flash Control, and then press the Set button.** The Flash Control screen appears with options for the built-in and external flash.

4. **Press a cross key to highlight the option you want, and then press the Set button.** Choose a control option from the Flash Control menu and press the Set button. Table 7.3 lists the menu settings, options, and suboptions that you can choose to control the flash.

Table 7.3
Flash Control Menu Options

Setting	Option(s)	Suboptions/Notes
Built-in flash func. setting	Flash mode	E-TTL II (Cannot be changed from E-TTL II)
	Shutter Sync	**1st curtain:** Flash fires at the beginning of the exposure. Can be used with a slow-sync speed to create light trails in front of the subject. **2nd curtain:** Flash fires just before the exposure ends. Can be used with a slow-sync speed to create light trails behind the subject.
	Flash exp. Comp	Press the Set button to activate the exposure level meter, and then turn the Quick Control dial to set +/-2 stops.
	E-TTL II	**Evaluative:** This default setting sets the exposure based on an evaluation of the entire scene. **Average:** Flash exposure is metered and averaged for the entire scene. Results in brighter output on the subject and less balancing of ambient background light.
External flash func. setting	External flash function setting	Available only with a compatible EX-series Speedlite attached. The available options depend on the EX-series Speedlite. With some Speedlites, only Flash Exposure Compensation and E-TTL II can be set using the External flash func. options.
	External flash C.Fn setting	Available only with a compatible Speedlite attached. Enables you to set the Speedlite's Custom Functions.
	Clear external flash C.Fn setting	Available only with a compatible Speedlite attached. Resets Speedlite Custom Functions to the default settings.

 Cross-Reference

For more details on using Flash Sync options when you're using Av shooting mode, see Chapter 6.

Using Accessory Speedlites

With one or more accessory flash units, a new level of lighting options opens up, ranging from simple techniques such as bounce

flash and fill flash to controlled lighting ratios with up to three groups of accessory flash units. With E-TTL II metering, you have the option of using one or more flash units as either the main or an auxiliary light source to balance ambient light with flash to provide even and natural illumination and balance among light sources.

One or more Speedlites provide an excellent portable studio for portraits and still-life shooting. And you can add light stands and light modifiers such as umbrellas and softboxes, and use a variety of reflectors to produce images that either replicate studio lighting results or enhance existing light.

Using multiple Speedlites

The Rebel T1i/500D is compatible with all EX-series Speedlites. With EX-series Speedlites, you get Flash Exposure Bracketing and flash modeling (to preview the flash pattern before the image is made).

When I travel to shoot portraits on location, I take three Speedlites with stands and silver umbrellas. This setup is a lightweight mobile studio that can either provide the primary lighting for subjects or supplement ambient light. Like most photographers, I also use a variety of reflectors.

In addition to the Speedlites, I use Canon's Speedlite Transmitter ST-E2. This transmitter wirelessly communicates with multiple Speedlites set up as groups or individually so that they fire at the same flash output. Alternately, you can set up slave units and vary the flash ratio from 1:8 – 1:1 – 1:8.

7.8 This is the back of the Canon Speedlite Transmitter ST-E2. It enables you to set up groups of flash units, control the channel in case other photographers are shooting wirelessly nearby, and to set up the lighting ratio.

In addition, if you have a studio lighting system, you can use the T1i/500D for studio shooting. Just buy a relatively inexpensive hot shoe-to-PC adapter to connect the studio lighting sync cord, or a wireless hot-shoe trigger can be used as well. Then set the Rebel to 1/200 second or slower, the sync speed for flash use. I recommend the Wein Safe-sync hot-shoe adapter to regulate the sync voltage of studio strobes to a safe level of 6 volts to protect the camera.

Exploring flash techniques

While it's beyond the scope of this book to detail all the lighting options that you can use with one or multiple Speedlites, I'll cover some common flash techniques that provide better flash images than using straight-on flash.

7.9 The Canon Speedlite 580EX II accessory flash. The T1i/500D includes a waterproof jacket around the hot shoe that matches up to the 580EX II seal to keep water from getting into the electrical connection in wet weather.

Bounce flash

One frequently used flash technique is bounce flash, which softens hard flash shadows by diffusing the light from the flash. To bounce the light, turn the flash head so that it points diagonally toward the ceiling or a nearby wall so that the light hits the ceiling or wall and then bounces back to the subject. This technique spreads and softens the flash illumination.

If the ceiling is high, then it may underexpose the image. As an alternative, I often hold a silver or white reflector above the

flash to act as a "ceiling." This technique offers the advantage of providing a clean light with no colorcast.

Adding catchlights to the eyes

Another frequently used technique is to create a catchlight in the subject's eyes by using the panel that is tucked into the flash head of some Speedlites. Just pull out the translucent flash panel on the Speedlite. At the same time, a white panel comes out, and that is the panel you use to create catchlights. The translucent panel is called the "wide" panel and it's used with wide-angle lenses to spread the light. Push the translucent panel back in while leaving the white panel out. Point the flash head up, and then take the image. The panel throws light into the eyes, creating catchlights that add a sense of vitality to the eyes. For best results be within 5 feet of the subject.

If your Speedlite doesn't have a panel, you can tape an index card to the top of the flash to create catchlights.

Balancing lighting extremes

With a little creativity in thinking about the flash and exposure modifications that are available on the T1i/500D and Speedlites, you can balance the extremes in lighting differences between two areas. For example, if you're shooting an interior space that has a view to the outdoors and you want good detail and exposure in both areas, then combine Auto Exposure Compensation on the camera with Flash Exposure Compensation to balance the two areas.

Tip *For detailed information on using Canon Speedlites, be sure to check out the* Canon Speedlite System Digital Field Guide *by J. Dennis Thomas (Wiley).*

Exploring Canon Lenses and Accessories

One of the first questions that photographers ask after using the Rebel T1i/500D for a while is, "What lens should I buy next?" Because there are so many factors that must be considered with a lens purchase, the best way to answer that question is to evaluate your shooting preferences and needs, know what lenses are available, know your budget, and then study lens reports published online and in photography magazines. This chapter helps you with the evaluation process.

It's important to remember that your images are as good as the lens that you use. With a high-quality lens, pictures have stunning detail, high resolution, and snappy contrast. Conversely, low-quality optics produce marginal picture quality. Thus, it's a good strategy to invest in the best lens that you can afford. Over time your investment in lenses will far exceed the purchase price of the camera. If you make careful decisions on lens purchases, the lenses will pay off for years to come in getting great image sharpness and quality and in building a solid, long-lasting photography system.

This chapter looks at the lenses available to help you make decisions about lenses you can add to your system to enhance the type of photography you most enjoy.

Understanding the Focal Length Multiplication Factor

One of the first things to know about the Rebel T1i/500D is that the image sensor is 1.6 times smaller than a traditional 35mm film frame. The Rebel's cropped sensor size affects the angle of view of all lenses you use. The angle of view is how much of the scene, side to side and top to bottom, that the lens includes in the image. For example, a 15mm fisheye lens has a 180-degree angle of view. By contrast, a 200mm lens has a scant 12-degree angle of view.

In short, the angle of view for all lenses you use on the T1i/500D is reduced by a factor of 1.6 times at any given focal length, producing an image that is equal to that of a lens with 1.6 times the focal length. That means that a 100mm lens on a 35mm film camera becomes the equivalent of a 160mm on the T1i/500D. Likewise, a 50mm lens becomes the equivalent of an 80mm lens, which is equivalent to a short telephoto lens on a full-frame 35mm size. A 24mm lens on a 35mm camera is roughly equivalent to a 38mm lens on the Rebel.

This focal length multiplication factor works to your advantage with a telephoto lens because it effectively increases the lens's focal length (although technically the focal length doesn't change). And because telephoto lenses tend to be more expensive than other lenses, you can buy a shorter and less expensive telephoto lens and get 1.6 times more magnification at no extra cost.

The focal length multiplication factor works to your disadvantage with a wide-angle lens because the sensor sees less of the scene when the focal length is magnified by 1.6x.

But, because wide-angle lenses tend to be less expensive than telephoto lenses, you can buy an ultrawide 14mm lens to get the equivalent of an angle of view of 22mm.

You may be wondering if the change in angle of view also affects the depth of field. Given that telephoto lenses provide a shallow depth of field, it seems reasonable to assume that the focal length multiplication factor would produce the same depth-of-field results on the T1i/500D that a longer lens gives. That isn't the case, however. Although an 85mm lens on a full-frame 35mm camera is equivalent to a 136mm lens on the T1i/500D, the depth of field on the T1i/500D matches the 85mm lens, not the 136mm lens. This depth-of-field principle also holds true for enlargements. The depth of field in the print is shallower for the longer lens on a full-frame camera than it is for the T1i/500D.

 Depth of field is discussed in detail in Chapter 9.

Buying Lenses for the Long Term

In the Canon lens lineup, there are two types of lenses: EF, and EF-S lenses. The T1i/500D is compatible with all EF- and EF-S-mount lenses, but the EF-S lenses are not compatible with full-frame Canon EOS dSLRs such as the EOS 5D Mark II and the EOS 1Ds Mark III. The EF-S lens mount is specially designed to have a smaller image circle, or the area covered by the image on the sensor plane. EF-S lenses can be used only on cameras with a cropped frame such as the T1i/500D, the 50D, and 40D among others because of a rear element that protrudes back into the camera body.

8.1 This image shows the approximate difference in image size between a 35mm film frame and the T1i/500D. The smaller image size represents the T1i/500D's image size.

On the other hand, the EF lens mount is compatible across all Canon EOS cameras regardless of image sensor size, and regardless of camera type, whether digital or film.

This distinction becomes important as you consider your long-term strategy for building a lens system. As you consider buying lenses, think about whether you want lenses that are compatible with both a full-frame camera and a cropped sensor. Consider also that as your photography career continues, you'll most likely buy a second camera body or move to another Canon EOS camera body. And if your next EOS camera body has a full-frame sensor, then you'll want the lenses that you've already acquired to be compatible with it. Both of these considerations point to buying EF-mount lenses. Certainly the EF-S lenses are often more affordable, but their use is limited only to cropped-sensor cameras.

Lens Choices

The best starting point for considering new lenses is to gain a solid understanding of the different types of lenses and their characteristics. Only then can you evaluate which types of lenses best fit your needs. The following sections provide a foundation for evaluating lenses by category and by characteristics.

Lenses are categorized by whether they zoom to different focal lengths or have a fixed focal length — known as prime lenses. Within those two categories, lenses are grouped by focal length (the amount of the scene included in the frame) in three main categories: wide angle, normal, and telephoto. And within those categories are macro lenses that serve double-duty as either normal or telephoto lenses with macro capability. Here is a brief overview of lens categories.

Note *Lenses are categorized according to their focal length on a full-frame 35mm size sensor rather than on the smaller sensor size of the Rebel.*

✦ **Wide-angle lenses.** These lenses offer a wide view of a scene. Lenses shorter than 50mm are considered wide angle on full-frame 35mm image sensors. With the 1.6 multiplication factor on the Rebel, a wide-angle focal length begins at approximately 30mm and runs through the 15mm fisheye lens. A wide-angle lens offers extensive depth of field, particularly at narrow apertures such as f/8, f/11, and so on. Depth of field is the range in front of and behind the subject that is in acceptably sharp focus.

✦ **Normal lenses.** A normal lens offers an angle of view and perspective very much as your eyes see the scene. On full-frame 35mm cameras, a 50mm lens is considered a normal lens. However, with the focal length conversion factor of 1.6x on the T1i/500D, a 35mm lens is closer to the normal focal length. Normal lenses provide extensive depth of field (particularly at narrow apertures of f/8, f/11, and so on) and are compact in size and versatile.

✦ **Telephoto lenses.** These lenses offer a narrow angle of view, enabling close-ups of distant scenes. On full-frame 35mm cameras, lenses with focal lengths longer than 50mm are considered telephoto lenses. On the Rebel T1i/500D, telephoto is anything longer than 35mm. Telephoto lenses offer shallow depth of field, providing a softly blurred background, particularly at wide apertures such as

f/5.6. And, of course, they offer a closer view of distant scenes and subjects.

✦ **Macro lenses.** These lenses are designed to provide a closer lens-to-subject focusing distance than non-macro lenses. Depending on the lens, the magnification ranges from half-life-size (0.5x) to 5x magnification. Thus, objects as small as a penny or a postage stamp can fill the frame, while nature macro shots can reveal breathtaking details that are commonly overlooked or are not visible to the human eye. By contrast, nonmacro lenses typically allow maximum magnifications of about one-tenth life-size (0.1x). Macro lenses are single focal-length lenses that come in normal and telephoto focal lengths.

Zoom Versus Prime Lenses

Within the basic focal-length lens categories, you can choose between zoom and prime (also called single focal-length) lenses. The most basic difference between zoom and prime lenses is that zoom lenses offer a range of focal lengths in a single lens while prime lenses offer a fixed, or single, focal length. There are additional distinctions that come into play as you evaluate which type of lens is best for your shooting needs.

About zoom lenses

Zoom lenses, with their variable focal length, are versatile because they offer multiple and variable focal lengths in a single lens. Available in wide-angle and telephoto ranges, zoom lenses can maintain focus during zooming. To keep the lens size compact,

and to compensate for aberrations with fewer lens elements, most zoom lenses use a multigroup zoom with three or more movable lens groups.

Some zoom lenses are slower than single focal-length lenses, and getting a fast zoom lens usually comes at a higher price. In addition, some zoom lenses have a variable aperture, which means that the minimum aperture changes at different zoom settings (discussed in the following sections).

Zoom lens advantages

The obvious advantage of a zoom lens is the ability to quickly change focal lengths and image composition without changing lenses. In addition, only two or three zoom lenses are needed to encompass the focal range you use most often for everyday shooting. For example, carrying a Canon EF-S 17-55mm f/2.8 IS USM lens and a Canon EF 55-200mm f/4.5-5.6 II USM lens, or a similar combination, provides the focal range needed for everything from landscape to portrait to some wildlife photography.

A zoom lens also offers the creative freedom of changing image composition with the turn of the zoom ring — all without changing your shooting position or changing lenses. Most midpriced and more expensive zoom lenses offer high-quality optics that produce sharp images with excellent contrast. As with all Canon lenses, full-time manual focusing is available by switching the button on the side of the lens to MF (Manual Focus).

Zoom lens disadvantages

Although zoom lenses allow you to carry around fewer lenses, they tend to be heavier than their single focal-length counterparts. Midpriced, fixed-aperture zoom lenses also tend to be "slow," meaning that with maximum apertures of only f/4.5 or f/5.6, they call

for slower shutter speeds that, in turn, limit your ability to get sharp images when hand-holding the camera, provided that the lens does not have image stabilization (IS), a technology that is detailed later in this chapter.

Some zoom lenses have variable apertures. A variable-aperture lens of f/4.5 to f/5.6 means that at the widest focal length, the maximum aperture is f/4.5 and at the telephoto end of the focal range, the maximum aperture is f/5.6. In practical terms, this limits the versatility of the lens at the longest focal length for shooting in all but bright light unless you set a high ISO. And unless you use a tripod and your subject is stone still, your ability to get a tack-sharp picture in lower light at f/5.6 will be questionable.

Cross-Reference *For a complete discussion on aperture, see Chapter 9.*

8.2 Wide-angle zoom lenses such as the Canon EF 16-35mm f/2.8L USM lens are ideal for the smaller sensor size of the T1i/500D.

More expensive zoom lenses offer a fixed and fast maximum aperture, meaning that with maximum apertures of f/2.8, they allow faster shutter speeds that enhance your ability to get sharp images when handholding the camera in low light. But the lens speed comes at a price: the faster the lens, the higher the price.

About prime lenses

While you hear much less about prime or single focal-length lenses, they are worth careful evaluation. With a prime lens, the focal length is fixed, so you must move closer to or farther from your subject, or change lenses to change image composition. Canon's venerable EF 50mm f/1.4 USM lens and EF 100mm f/2.8 Macro USM are only two of a full lineup of Canon prime lenses.

8.3 Single focal-length lenses such as the EF 50mm f/1.4 USM lens are smaller and lighter and provide excellent sharpness, contrast, and resolution when used on the T1i/500D.

Prime lens advantages

Unlike zoom lenses, prime lenses tend to be fast with maximum apertures of f/2.8 or wider on nontelephoto lenses and on some telephoto lenses. Wide apertures allow fast shutter speeds that enable you to handhold the camera in lower light and still get a sharp image. Compared to zoom lenses, single focal-length lenses are lighter and smaller. In addition, many photographers believe that single focal-length lenses are sharper and provide better image quality overall than zoom lenses.

Prime lens disadvantages

Most prime lenses are lightweight, but you need more of them to have lenses that run the full focal-length range. Prime lenses also limit the options for some on-the-fly composition changes that are possible with zoom lenses.

Working with Different Types of Lenses

Within the categories of zoom and prime lenses, lenses are grouped by their focal length. While some lenses cross group lines, the groupings are still useful for talking about lenses in general. Each type of lens has specific characteristics that you can use creatively to render images as you envision them. So as you read about the characteristics, consider how you can use each lens creatively and perhaps out of the traditional context.

Working with wide-angle lenses

A wide-angle lens is a versatile lens for capturing subjects ranging from large groups of people to sweeping landscapes, as well as for taking pictures in places where space is cramped. The distinguishing characteristic of wide-angle lenses is the range of the angle of view. Within the Canon lens lineup, you can choose angles of view from the 15mm fisheye lens, which offers a 180-degree angle of view, to the 35mm lens, which offers a 63-degree angle of view, not counting the 1.6x focal-length multiplication factor.

With wide-angle lenses, the Rebel's 1.6x focal-length multiplier works to your disadvantage. For example, with the EF 28-135mm f/3.5-5.6 IS lens, the lens translates to only 44mm on the wide end and 216mm on the telephoto end of the lens. The telephoto range is excellent, but you don't get a wide angle of view with this lens. Thus, if you often shoot landscapes, cityscapes, architecture, and interiors, a priority will be to get a lens that offers a true wide-angle view. Good choices include the EF 16-35mm f/2.8L II USM (approximately 26 to 56mm with the 1.6x multiplier), the EF-S 10-22mm f/3.5-4.5 USM lens (approximately 16 to 35mm with the multiplier), or the EF 17-40mm f/4L USM lens (approximately 27 to 64mm with the multiplier).

Evaluating Bokeh Characteristics

The quality of the out-of-focus area in a wide-aperture image is called *bokeh*, originally from the Japanese word *boke*, pronounced bo-keh, which means fuzzy. In photography, bokeh reflects the shape and number of diaphragm blades in the lens, and that determines, in part, the way that out-of-focus points of light are rendered in the image. Bokeh is also a result of spherical aberration that affects how the light is collected.

Although subject to controversy, photographers often judge bokeh as being either good or bad. Good bokeh renders the out-of-focus areas as smooth, uniform, and generally circular shapes with nicely blurred edges. Bad bokeh, on the other hand, renders out-of-focus areas with polygonal shapes, hard edges, and with illumination that creates a brighter area at the outside of the disc shape. Also, if the disc has sharper edges, then either points of light or lines in the background become more distinct when, in fact, they are better rendered blurred. Bokeh is also affected by the number of blades used in the lens's diaphragm. Generally lens diaphragms are comprised of five, eight, or nine blades. A five-blade design renders the point of light as a pentagon while an eight-blade diaphragm renders it as an octagon. You can check the specifications for the lens you're considering to find out how many blades are used, but generally, the more blades, the more visually appealing the bokeh.

Ken Rockwell provides an article on bokeh with examples at www.kenrockwell.com/tech/bokeh.htm.

8.4 This old wagon is always a draw for photographers, and the Canon EF 24-70mm f/2.8L USM lens provided excellent sharpness in this image. Exposure: ISO 100, f/2.8, 1/1000 second.

When you shoot with a wide-angle lens, keep these lens characteristics in mind:

✦ **Extensive depth of field.** Particularly at small apertures from f/8 to f/32, the entire scene, front to back, will be in acceptably sharp focus. This characteristic gives you slightly more latitude for less-than-perfectly focused pictures.

✦ **Narrow, fast apertures.** Wide-angle lenses tend to be faster (meaning they have wider apertures) than telephoto lenses. As a result, these lenses are good choices for shooting in lower light scenes.

✦ **Distortion.** Wide-angle lenses can distort lines and objects in a scene, especially if you tilt the camera up or down when shooting. For example, if you tilt the camera up to photograph skyscrapers with a wide-angle lens mounted, the lines of the buildings tend to converge toward the center of the frame and the buildings appear to lean backward (also called *keystoning*). You can use this wide-angle lens characteristic to creatively enhance some compositions, or you can move back from the subject and keep the camera parallel to the main subject to help avoid the distortion.

✦ **Perspective.** Wide-angle lenses make objects close to the camera appear disproportionately large. You can use this characteristic to move the closest object visually forward in the image, or you can move back from the closest object to reduce the effect. Moderate wide-angle lenses are popular for portraits, but if you use a wide-angle lens for close-up portraiture, keep in mind that the lens exaggerates the size of facial features closest to the lens, which can be unflattering.

Using telephoto lenses

Telephoto lenses offer a narrow angle of view, enabling close-ups of distant scenes. On the T1i/500D, the focal-length multiplier works to your advantage with telephoto lenses. Factoring in the 1.6x multiplier, a 50mm lens is equivalent to 80mm, or a short telephoto lens. And because telephoto lenses are more expensive overall than wide-angle lenses, you get more focal length for your money when you buy telephoto lenses for the T1i/500D.

Telephoto lenses offer an inherently shallow depth of field that is heightened by shooting at wide apertures. Choose a telephoto lens to take portraits and to capture distant subjects such as birds, buildings, wildlife, and landscapes. Short telephoto lenses such as 85mm and 100mm are ideal for portraits, while long lenses (200mm to 800mm) allow you to photograph distant birds, wildlife, and athletes. When photographing wildlife, long lenses also allow you to keep a safe distance from the subject.

8.5 Telephoto lenses are larger and heavier than wide-angle and normal lenses, but having a sharp and versatile telephoto zoom lens is indispensable. This 70-200mm lens also features image stabilization, which helps counteract camera shake when handholding the camera.

Answering the Inevitable Question

I don't make it a habit to recommend specific lenses particularly because the lenses that suit my shooting assignments and budget may not match your needs and budget. But I'll say that my general approach to adding lenses to my system is to buy the highest-quality lens available in the focal length that I need. If I can't afford the highest-quality lens, then I wait and save money until I can buy it. For example, my last lens purchase was an EF 100-400 f/4.5-5.6L IS USM lens, and it took me a year to save enough money to buy it.

But for inquiring minds, the workhorse lenses in my gear bag are the first two Canon lenses I bought: the EF 70-200mm f/2.8L IS USM and the EF 24-70mm f/2.8L USM lens. Both lenses have outstanding optics, superb sharpness, and excellent resolution and contrast on *any* EOS camera body. I also frequently use the EF 100mm f/2.8 Macro USM lens, the EF 50mm f/1.4 USM, and the EF 100-400 f/4.5-5.6L IS USM. I've used these and other lenses on the T1i/500D with great image results.

When you shoot with a telephoto lens, keep these lens characteristics in mind:

✦ **Shallow depth of field.** Telephoto lenses magnify subjects and provide a limited range of sharp focus. At wide apertures, such as f/4, you can reduce the background to a soft blur. Because of the shallow depth of field, there is no latitude for anything except tack-sharp focus. All Canon lenses include full-time manual focusing that you can use to fine-tune the camera's autofocus.

✦ **Narrow coverage of a scene.** Because the angle of view is narrow with a telephoto lens, much less of the scene is included in the image. You can use this characteristic to exclude distracting scene elements from the image.

✦ **Slow speed.** Midpriced telephoto lenses tend to be slow; the widest aperture is often f/4.5 or f/5.6, which limits the ability to get sharp images without a tripod in all but bright light unless the lens has image stabilization. And because of the magnification, even the slight movement when handholding the camera and lens or in subject movement is exaggerated.

✦ **Perspective.** Telephoto lenses tend to compress perspective, making objects in the scene appear stacked together.

Using normal lenses

Normal lenses offer an angle of view and perspective very much as your eyes see the scene. On full-frame 35mm cameras, 50mm lenses are considered normal lenses. However, on the T1i/500D, a normal lens is 28mm to 35mm when you take into account the focal-length multiplier. And, likewise, the 50mm lens is equivalent to an 80mm lens on the T1i/500D.

When you shoot with a normal lens, keep these lens characteristics in mind:

✦ **Natural angle of view.** On the T1i/500D, a 28 or 35mm lens closely replicates the sense of distance and perspective of the human eye. This means the final image will look much as you remember seeing it when you made the picture.

✦ **Little distortion.** Given the natural angle of view, the 50mm lens retains a normal sense of distance, especially when you balance the subject distance, perspective, and aperture.

Using macro lenses

Macro lenses are designed to provide a closer lens-to-subject focusing distance than nonmacro lenses. Depending on the lens, the magnification ranges from half life-size (0.5x) to 5x magnification. Thus, objects as small as a penny or a postage stamp can fill the frame, while nature macro shots can reveal breathtaking details that are commonly overlooked or are not visible to the human eye. Macro lenses are single focal-length lenses that come in normal and telephoto focal lengths.

Normal and telephoto lenses offer macro capability. Because these lenses can be used at their normal focal length as well as for macro photography, they do double-duty. Macro lenses offer one-half or life-size magnification or up to 5x magnificaion with the MP-E 65mm f/2.8 1-5 Macro Photo lens.

Based on focal length and magnification, choose the lens that best suits the kinds of subjects you most often photograph. I often use the 100mm, f/2.8 Macro USM lens as a walk-around lens because much of my work lends itself to a short telephoto focal length and macro work.

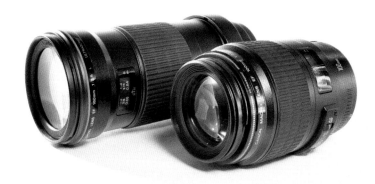

8.6 Canon offers several macro lenses, including the EF 180mm f/3.5L Macro USM (left), which offers 1x (life-size) magnification and a minimum focusing distance of 0.48m/1.6 ft. Also shown here is the Canon EF 100mm f/2.8 Macro USM lens.

8.7 The EF 100mm is one of my standard walk-around lenses, and I used it to capture this lily. Exposure: ISO 100, f/11, 2 seconds.

Using tilt-and-shift lenses

Referred to as TS-E, tilt-and-shift lenses allow you to alter the angle of the plane of focus between the lens and sensor plane to provide a broad depth of field even at wide apertures and to correct or alter perspective at almost any angle. This allows you to correct perspective distortion and control focusing range.

Tilt movements allow you to bring an entire scene into focus, even at maximum apertures. By tilting the lens barrel, you can adjust the lens so that the plane of focus is uniform on the focal plane, thus changing the normally perpendicular relationship between the lens's optical axis and the

camera's focal plane. Alternately, reversing the tilt has the opposite effect of greatly reducing the range of focusing.

Shift movements avoid the trapezoidal effect that results from using wide-angle lenses pointed up — to take a picture of a building, for example. Keeping the camera so that the focal plane is parallel to the surface of a wall and then shifting the TS-E lens to raise the lens results in an image with the perpendicular lines of the structure being rendered perpendicular and with the structure being rendered with a rectangular appearance.

TS-E lenses revolve within a range of plus/minus 90 degrees making horizontal shift possible, which is useful in shooting a series of panoramic images. You can also use shifting to prevent having reflections of the camera or yourself in images that include reflective surfaces, such as windows, car surfaces, and other similar surfaces.

All of Canon's TS-E lenses are manual focus only. These lenses, depending on the focal length, are excellent for architectural, interior, merchandise, nature, and food photography.

Using image-stabilized lenses

For anyone who's thrown away a stack of images blurred from handholding the camera at slow shutter speeds, Image Stabilization is a welcome addition to lenses. Image Stabilization (IS) is a technology that counteracts some or all of the motion blur that can happen when you handhold the camera. If you've shopped for lenses lately, then you know that IS comes at a premium price. IS lenses are pricey because they give you from 1 to 4 f-stops of additional stability

over non-image-stabilized lenses — and that means that you may be able to leave the tripod at home.

With an IS lens, miniature sensors and a high-speed microcomputer built into the lens analyze vibrations and apply correction via a stabilizing lens group that shifts the image parallel to the focal plane to cancel camera shake. The lens detects camera motion via two gyro sensors — one for yaw and one for pitch. The sensors detect the angle and speed of shake. Then the lens shifts the IS lens group to suit the degree of shake to steady the light rays reaching the focal plane.

But what about when you want to pan or move the camera with the motion of a subject? Predictably, IS detects panning as camera shake and the stabilization then interferes with framing the subject. To correct this, Canon offers two modes on IS lenses. Mode 1 is designed for stationary subjects. Mode 2 shuts off IS in the direction of movement when the lens detects large movements for a preset amount of time. So when panning horizontally, horizontal IS stops but vertical IS continues to correct any vertical shake during the panning movement.

Stabilization is particularly important with long lenses, where the effect of shake increases as the focal length increases. As a result, the correction needed to cancel camera shake increases proportionately.

To see how the increased stability pays off, consider that the rule of thumb for hand-holding the camera and a non-IS lens is 1/ [focal length]. For example, the slowest shutter speed at which you can handhold a 200mm lens and avoid motion blur is 1/200 second. If the handholding limit is pushed, then shake from handholding the camera bends light rays coming from the subject

into the lens relative to the optical axis, and the result is a blurry image. But when you factor in IS, then you can handhold the camera and lens at 1/100 or 1/60 second or even a slower shutter speed and get a sharp image.

IS lenses come at a higher price, but they are very effective for low-light scenes and telephoto shooting.

Fine-Tuning Lens Performance

Depending on the lens you're using, there may be some light falloff within the lens that causes the corners of the image to be darker than the center area of the frame. The corner darkening is referred to as vignetting. Vignetting is most likely to appear in images shot with wide-angle lenses, at a lens's maximum aperture, or when an obstruction such as the lens barrel rim or a filter reduces light that reaches the frame corners.

You can correct for lens light falloff in the camera if you shoot JPEG images. If you shoot RAW images, you can make the correction in Canon's Digital Photo Professional program during RAW image conversion. For JPEG images, the correction is applied by enabling the Peripheral Illumination Correction option. Once the Peripheral Illumination Correction option is enabled, the camera automatically applies correction for any of the lenses that have correction data registered in the camera. The Rebel ships with lens correction data for 25 Canon lenses. If the lens you're using isn't among the 25, you can register correction data for your lens using the EOS Utility, a program included on the EOS Digital Solution Disk.

Note: *If you're using a non-Canon lens, be sure to turn off Peripheral Illumination Correction. On the Rebel T1i/500D, Peripheral Lens Illumination Correction is turned on by default.*

If you use Peripheral Illumination Correction for JPEG images, the amount of correction applied is just shy of the maximum amount. If you shoot RAW images, you can, however, apply the maximum correction in Digital Photo Professional. Also, the amount of correction for JPEG images decreases as the ISO sensitivity setting increases. If the lens does not communicate distance information to the camera, then less correction is applied.

Here's how to turn on or turn off Peripheral Illumination Correction. Because Peripheral Illumination Correction is turned on by default, do these steps only if you are using a non-Canon lens, or if you do not want the correction for some other reason.

1. **Set the camera to the JPEG image quality setting that you want.**

2. **Press the Menu button, and then turn the Main dial to highlight the Shooting 1 (red) menu.**

3. **Press the down cross key to highlight Peripheral illumin. correct., and then press the Set button.** The Peripheral illumin. Correct. screen appears with the attached lens listed, and whether correction data is available. If correction data is unavailable, then you can register correction data using the Canon EOS Utility program.

4. **By default, Peripheral Illumination Correction is turned on. If you're using a non-Canon** lens, then press the down cross key to select Disable, and then press the Set button.

Exploring Lens Accessories

There are a variety of ways to increase the focal range and decrease the focusing distance to provide flexibility for the lenses you already own. These accessories are not only economical, but they also extend the range and creative options of existing and new lenses. Lens accessories can be as simple as using a lens hood to avoid flare; adding a tripod mount to quickly change between vertical and horizontal positions without changing the optical axis or the geometrical center of the lens; or adding a drop-in or adapter-type gelatin filter holder. Other options include using lens extenders, extension tubes, and close-up lenses.

Lens extenders

For relatively little cost, you can increase the focal length of any lens by using an extender. An extender is a lens set in a small ring mounted between the camera body and a regular lens. Canon offers two extenders, a 1.4x and 2x, that are compatible only with L-series Canon lenses. Extenders can also be combined to get even greater magnification.

For example, using the Canon EF 2x II extender with a 200mm lens doubles the lens's focal length to 400mm, and then you can apply the 1.6x focal length conversion factor to get the equivalent of a 640mm lens. Using the Canon EF 1.4x II extender increases a 200mm lens to 280mm or 448mm with the 1.6x conversion factor.

Extenders reduce the amount of light reaching the sensor. The EF 1.4x II extender decreases the light by 1 f-stop, and the EF 2x II extender decreases the light by 2 f-stops. In addition to being fairly lightweight, the obvious advantage of extenders is that they can reduce the number of telephoto lenses you carry.

The 1.4x extender can be used with fixed focal-length lenses 135mm and longer (except the 135mm f/2.8 Softfocus lens) and with zoom lenses including the 70-200mm f/2.8L, 70-200mm f/2.8L IS, 70-200mm f/4L, 70-200mm f/4L IS USM, and 100-400mm f/4.5-5.6L IS zoom lenses. With the EF 2x II, autofocus is possible if the lens has an f/2.8 or faster maximum aperture and compatible IS lenses continue to provide stabilization for two shutter speeds less than 1/focal length in seconds.

Extension tubes and close-up lenses

Extension tubes are close-up accessories that provide magnification increases from approximately 0.3 to 0.7, and can be used on many EF lenses, though there are exceptions. Extension tubes are placed between the camera body and lens and connect to the camera via eight electronic contact points. The function of the camera and lens is unchanged, and you can combine extension tubes for greater magnification.

Canon offers two extension tubes, the EF 12 II and the EF 25 II. Magnification differs by lens, but with the EF12 II and standard zoom lenses, it is approximately 0.3 to 0.5. With the EF 25 II, magnification is 0.7. When combining tubes, you may need to focus manually.

8.8 Extenders, such as this Canon EF 1.4x II mounted between the camera body and the lens, extend the range of L-series lenses. They increase the focal length by a factor of 1.4x in addition to the 1.6x focal length multiplication factor inherent in the camera.

Extension tube EF 25 II is not compatible with the EF 15mm f/2.8 Fisheye, EF 14mm f/2.8L USM, EF 20mm f/2.8 USM, EF 24mm f/1.4L USM, EF 16-35mm f/2.8L USM, EF 17-40mm f/4L USM, EF 20-35mm f/3.5-4.5 USM, EF 24-70mm f/2.8L USM, MP-E 65mm f/2.8 1-5x Macro Photo, TS-E 45mm f/2.8, and EF-S 18-55mm f/3.5-5.6 (at wide angles). Extension tube EF12 II is not compatible with the EF 15mm f/2.8 Fisheye, EF 14mm, f/2.8L USM, and MP-E 65mm f/2.8 1-5X Macro Photo lens.

Additionally, you can use screw-in close-up lenses. Canon offers three lenses that provide enhanced close-up photography. The 250D/500D series uses a double-element design for enhanced optical performance. The 500D series features single-element construction for economy. The working distance from the end of the lens is 25cm for the 250D, and 50cm for the 500D.

Learning Lens Lingo

As you shop for lenses and read lens reports, the terms can be very confusing. There is no need to memorize these terms, but when you are considering lenses, come back to this section of the book to look up the terms you're reading about or hearing from a salesperson. In that way, you can make a more informed decision and know what elements are important for the type of lens you're considering.

Here are key terms for lens construction and technology.

✦ **EF/EF-S lens mount.** This designation identifies the type of mount that the lens has and the camera accepts. The EF lens mount provides not only quick mounting

and removal of lenses, but it also provides the communication channel between the lens and the camera body. The EF mount is fully electronic and resists abrasion, shock, and play. The EF system does a self-test using a built-in microcomputer so that you're alerted of possible malfunctions of the lens via the camera's LCD display. In addition, if you use lens extenders, the exposure compensation is automatically calculated. The EF-S lens mount is designed specifically for cropped image-sensor cameras such as the T1i/500D. These lenses tend to be more affordable with good optical resolution. Because EF-S lenses have a shorter back focus than EF lenses, the EF-S lenses won't be compatible should you eventually buy a full-frame EOS camera.

✦ **USM.** When you see USM, it indicates the lens features a built-in ultrasonic motor with a very quiet focusing mechanism. The motor is powered by the camera; however, because the lens has its own focusing motor, you get fast focus. USM lenses use electronic vibrations created by piezoelectric ceramic elements to provide quick and quiet focusing action with near instantaneous starts and stops.

In addition, lenses with a ring-type ultrasonic motor offer full-time manual focusing without the need to first switch the lens to manual focus. This design is offered in the large-aperture and super-telephoto lenses. A second design, the micro-ultrasonic motor, provides the advantages of this technology in the less expensive EF lenses.

✦ **L-series lenses.** Canon's L-series lenses feature a distinctive red ring on the outer barrel, or in the case of telephoto and super-telephoto lenses, are distinguished by Canon's well-known white barrel. The distinguishing characteristics of L-series lenses, in addition to their sobering price tags, are a combination of technologies that provide outstanding optical performance. L-series lenses include one or more of the following technologies and features:

 • **UD/Fluorite elements.** Ultralow Dispersion (UD) glass elements help minimize color fringing or chromatic aberration. This glass also provides improved contrast and sharpness. On the other hand, Fluorite elements, which are used in super-telephoto L-series lenses, reduce chromatic aberration. Lenses with UD or fluorite elements are designated as CaF2, UD, and/or S-UD.

 • **Aspherical elements.** This technology is designed to help counteract blurred images that happen as a result of spherical aberration. Spherical aberration happens when wide-angle and fast normal lenses cannot resolve into a sharp point of focus light rays coming into the lens from the center with those coming from the edge. An aspherical element uses a varying curved surface to ensure that the entire image plane appears focused. These types of optics help correct distortion in ultrawide-angle lenses as well. Lenses with aspherical elements are designated as AL.

 • **Dust, water-resistant construction.** The L-series EF lenses stand up well to inclement weather and heavy use. L-series lenses have rubber seals at the switch panels, exterior seams, drop-in filter compartments, and lens mounts to make them both dust- and water-resistant. Moving parts, including the focusing ring and switches, are also designed to keep out environmental contaminants.

✦ **Image stabilization.** Lenses labeled as IS lenses offer image stabilization, which is detailed earlier in this chapter. IS lenses enable you to handhold the camera at light levels that normally require a tripod.

✦ **Macro.** Macro lenses enable close-up focusing with subject magnification of one-half to life-size and up to 5x with the MP-E 65mm f/2.8 Macro Photo lens.

✦ **Full-time manual focusing.** An advantage of Canon lenses is the ability to use autofocus, and then tweak focus manually using the lens's focusing ring without switching out of autofocus mode or changing the switch on the lens from the AF (Autofocus) to MF (Manual Focusing) setting.

✦ **Inner and rear focusing.** Lenses' focusing groups can be located in front of or behind the lens diaphragm, both of which allow for compact optical systems with fast AF. Lenses with rear optical focusing, such as the EF 85mm f/1.8 USM, focus faster than lenses that move their entire optical system, such as the EF 85mm f/1.2L II USM.

✦ **Floating system.** Canon lenses use a floating system that dynamically varies the gap between key lens elements based on the focusing distance. As a result, optical aberrations are reduced or suppressed through the entire focusing range. In comparison, optical aberrations in nonfloating system lenses are corrected only at commonly used focusing distances. At other focusing distances, particularly at close focusing distances, the aberrations appear and reduce image quality.

✦ **AF Stop.** The AF Stop button, offered on several EF IS super-telephoto lenses, allows you to temporarily suspend autofocusing of the lens if an obstruction comes between the lens and the subject to prevent the focusing from being thrown off.

✦ **Diffractive optics.** Diffractive optics (DO) are created by bonding diffractive coatings to the surfaces of two or more lens elements. The elements are then combined to form a single multilayer DO element designed to cancel chromatic aberrations at various wavelengths when combined with conventional glass optics. Diffractive optics result in smaller and shorter telephoto lenses without compromising image quality.

The Elements of Exposure and Composition

f you're new to photography or if you're returning after some time away from shooting, the information in this chapter serves as a refresher on the elements of exposure and a short guide to traditional photographic composition guidelines. This chapter can also help you build a foundation from which you can expand your skills and creative options in using the Rebel T1i/500D.

The Four Elements of Exposure

The goal of making a picture is to capture the scene or subject as you envision it. Making a picture begins with your creative eye and your personal expression. Your creative tool, the camera, is governed by technical factors collectively referred to as the elements of exposure. While the technical aspects may not seem as exciting as the creative aspects of picture making, the more you understand what goes into making a photographic exposure, the more creative control you'll have over the Rebel. And once you have that understanding, you're better able to find creative ways to work around the technical limitations of the camera when you encounter scenes that require both creative vision and creative use of the Rebel.

Exposure is a precise combination of four elements, all of which are related to light. The four elements of exposure are:

✦ **Light.** The starting point of exposure is the amount of light that's available in the scene to make a picture. With every image, the Rebel T1i/500D measures, or "meters," the amount of light in the scene, and then it bases its suggested exposure settings on the meter reading. Your range of creative control with the Rebel T1i/500D is directly related to the amount of light in the scene, often referred to as "existing light."

✦ **Sensitivity.** Sensitivity refers to the amount of light that the camera's image sensor needs to make an exposure or to the sensor's sensitivity to light. Sensitivity is controlled by the ISO setting.

✦ **Intensity.** Intensity refers to the strength or amount of light that reaches the image sensor. Intensity is controlled by the aperture, or f-stop. The aperture controls the lens diaphragm, an adjustable opening that opens or closes to allow more or less light into the camera.

✦ **Time.** Time refers to the length of time that light is allowed to reach the sensor. Time is controlled by setting the shutter speed, which determines how long the camera's shutter stays open.

The following sections look at each exposure element in more detail. As you read, know that every exposure element is related to the other elements. That means that if one exposure element changes, one or all of the other elements must also change proportionally.

Light

As mentioned earlier, all photographs depend on the amount of light that's available to make a photographic exposure. To determine the exposure settings, the Rebel T1i/500D must first measure the light in the scene using the onboard light meter. Every time that you half-press the Shutter button, the camera measures, or meters, the light that is reflected from the subject back to the camera. The light meter reading is biased toward the autofocus (AF) point that you or the camera selected. The camera takes the meter reading, looks at the current ISO setting, and then calculates how much light (the light intensity that's set by the aperture) is needed and for how long (the time factor that's set by the shutter speed) to make a good exposure.

 Chapter 2 details using Auto Exposure (AE) Lock, a technique that enables you to bias the meter reading on an area of the scene or subject but set the point of sharpest focus on another area of the scene. You will also find information on choosing and using different shooting and metering modes.

With the camera's "ideal" exposure calculated, the camera then automatically applies those exposure settings in the Basic Zone modes such as Portrait, Landscape, Sports, and so on. In semiautomatic modes, the camera sets either the aperture, if you're using Tv mode, or shutter speed, if you're using Av mode, based on the ISO (International Organization for Standardization) setting you've selected. In M (Manual) mode, you set both the aperture and the shutter speed by watching the Exposure Level Indicator shown in the viewfinder. When the tick mark is at the center of the indicator, then you've set the Rebel T1i/500D's suggested exposure.

Note *A "slow" lens is one with a maximum aperture of f/5.6 – the widest aperture you can choose. At f/5.6, the camera needs a good deal of light in the scene for you to be able to handhold the camera and get a sharp image. A "fast" lens is one with a maximum aperture of f/2.8 to f/1.4. A fast lens enables you to handhold the camera in lower light and get a sharp image.*

Sensitivity: The role of ISO

In very general terms, the ISO setting determines how sensitive the image sensor is to light. The higher the ISO number is, the less light that's needed to make a picture. The lower the ISO number, the more light that's needed to make a picture. High ISO numbers or settings such as ISO 800 to 1600 provide faster shutter speeds so that you can handhold the camera and get a sharp image in low-light scenes. Conversely, in bright to moderately bright light, low settings from 100 to 400 work well because there is enough light in the scene to ensure a fast enough shutter speed to get a sharp image.

Each ISO setting is twice as sensitive to light as the previous setting. For example, ISO 800 is twice as sensitive to light as ISO 400. As a result, the sensor needs half as much light to make an exposure at ISO 800 as it does at ISO 400.

In P, Tv, Av, M, and A-DEP shooting modes, the ISO sequence encompasses Auto (ISO 100 to 1600, which is set automatically by the camera) and ISO 100, 200, 400, 800, and 3200. The ISO can also be expanded to include ISO 6400 and 12800 using Custom Function (C.Fn) 2. In the automated Basic Zone modes, the T1i/500D automatically sets the ISO between 100 and 1600, depending on the light. In P, Tv, Av, M, and A-DEP shooting modes, the Auto ISO setting ranges form 100 to 3200.

Note *The International Organization for Standardization (ISO) measures, tests, and sets standards for many photographic products, including the rating or speed for film, which has, in turn, been applied to equivalents for the sensitivity of digital image sensors.*

In addition to setting the relative light sensitivity of the sensor, ISO also factors into the overall image quality in several areas, including sharpness, color saturation, contrast, and digital noise or lack thereof.

On a digital camera, increasing the image sensor's sensitivity to light amplifies the signal. This amplification also can increase digital noise in the image, much like hiss or static in an audio system that becomes more audible as the volume increases. Noise in digital images is roughly analogous to grain in high-ISO film. However, in digital photography, noise is comprised of luminance and chroma noise. Luminance noise is similar to film grain. Chroma noise appears as mottled color variations and as colorful pixels in the shadow areas of the image.

Regardless of the type, digital noise degrades overall image quality by overpowering fine detail in foliage and fabrics, reducing sharpness and color saturation, and giving the image a mottled look. Digital noise increases with high ISO settings, long exposures, and underexposure as well as high ambient temperatures, such as from leaving the camera in a hot car or in the hot sun. This occurs because the hotter the sensor gets, the more digital noise appears.

9.1 This image was taken using ISO 1000, and the digital noise isn't apparent until the image is viewed at 100 percent in an image-editing program. Exposure: ISO 1000, f/2.8, 1/4000 second.

The tolerance for digital noise is subjective and varies by photographer. It's important to shoot images at each of the ISO settings and examine the images for noise. This type of testing helps you know what to expect in terms of digital noise at each ISO setting. Then you can determine how high an ISO you want to use on an average shooting day.

For long exposures, you can also enable a Custom Function (C.Fn-4: Long exp. noise reduction) to reduce digital noise in exposures of 1 second or longer. This option doubles the exposure time duration, but the noise is virtually imperceptible. And you can enable C.Fn-5: High ISO speed noise reduction.

9.2 This detail of figure 9.1 shows the grainy appearance from digital noise in the shadow areas as well as a mottled appearance from using color noise reduction during RAW image processing.

Cross-Reference *See Chapter 6 for details on setting Custom Functions.*

Checking for Digital Noise

If you choose a high ISO setting, be sure to check for digital noise by zooming the image to 100 percent in an image-editing program. Look for flecks of color in the shadow and midtone areas that don't match the other pixels and for areas that resemble the appearance of film grain.

If you detect objectionable levels of digital noise, you can use noise-reduction programs such as Noise Ninja (www.picturecode.com), Neat Image (www.neatimage.com), or NIK Dfine (www.niksoftware.com) to reduce it. Typically, noise reduction softens fine detail in the image, but these programs minimize the softening. If you shoot RAW images, programs including Canon's Digital Photo Professional and Adobe Camera Raw offer noise reduction options that you can apply during RAW conversion.

Intensity: The role of aperture

The lens aperture (the size of the lens diaphragm opening) determines the intensity of light that strikes the image sensor. Aperture is indicated as f-stop numbers, such as f/2.8, f/4.0, f/5.6, f/8, and so on. When you increase or decrease the aperture by a full f-stop, it doubles or halves the exposure, respectively. For example, f/5.6 provides twice as much light as f/8 provides, while f/5.6 provides half as much light as f/4.0.

> **Note** *The apertures that you can choose depend on the lens that you're using. For example, the Canon EF-S 18-55mm f/4.5-5.6 lens has a maximum aperture of f/4.5 at 18mm and f/5.6 at 55mm and a minimum aperture of f/22, while the EF 100-300mm f/4.5-5.6 USM lens has a maximum aperture of f/4.5 at 100mm and f/5.6 at 300mm and a minimum aperture of f/32-38 at the same respective zoom settings.*

Wide aperture

Smaller f-stop numbers, such as f/2.8, set the lens diaphragm to a large opening that lets more light reach the sensor. A large lens opening is referred to as a wide aperture. Based on the ISO and in moderate light, a wide aperture (a large diaphragm opening) such as f/5.6 delivers sufficient light to the sensor so that the amount of time that the shutter has to stay open to make the exposure decreases, thus allowing a relatively faster shutter speed as compared to a narrow aperture of f/8 or f/11. In very general terms, this means that wide apertures of f/5.6 to f/1.4 enable you to shoot in lower-light scenes with a reasonably fast shutter speed (depending on the existing light and ISO setting). And that combination helps you get sharp handheld images in lower light.

9.3 In this image, an aperture of f/2.8 combined with a close shooting distance blurred the background, and renders only the edges of the petals in sharp focus. Exposure: ISO 100, f/2.8, 1/50 second.

9.4 In this image, I used a narrow aperture of f/22 to get as much sharp detail as possible throughout the orchid structures. Exposure: ISO 100, f/20, 1/125 second.

Narrow aperture

Larger f-stop numbers, such as f/8, f/11, f/16, and narrower, set the lens diaphragm to a small opening that allows less light to reach the sensor. A small lens opening is referred to as a narrow aperture. Based on the ISO and in moderate light, a small diaphragm opening such as f/11 delivers less light to the sensor so the amount of time that the shutter has to stay open increases allowing a comparatively slow shutter speed. Thus, because narrow apertures of f/8 to f/32 require longer shutter speeds you need lots of light to shoot with narrow apertures, or you need to use a tripod and have a scene or subject that remains stock still.

Note *Aperture also plays a starring role in the depth of field of images. Depth of field is detailed later in this chapter.*

Choosing an aperture

In everyday shooting, photographers most often select an aperture based on how they want background and foreground to look — either showing acceptably sharp detail or with blurred detail. This is called controlling the depth of field, discussed next. In addition, choosing a specific aperture may involve other factors. For example, if you want to avoid blur from camera shake in lower light, choose a wide aperture (smaller

f-number) so that you get the faster shutter speeds. Or if you want selective focus, where only a small part of the image is in sharp focus, choose a wide aperture. But if you're shooting a group of people or a sweeping scene, then choose a narrow aperture to render sharper detail throughout the frame.

You can control the aperture by switching to Av or M mode. In Av mode, you set the aperture, and the camera automatically sets the correct shutter speed based on the selected ISO. In M mode, you set both the aperture and the shutter speed based on the reading from the camera's light meter. The Exposure Level Indicator is displayed in the viewfinder as a scale and it indicates over-, under-, and correct exposure based on the aperture, shutter speed, and ISO.

Tip	*You can use P mode to make one-time changes to the aperture that the camera initially sets. Unlike Av mode where the aperture you choose remains in effect until you change it, in P mode, changing the aperture is temporary. After you take the picture, the camera reverts to its suggested aperture and shutter speed.*

Cross-Reference	*You can learn more about shooting modes in Chapter 2.*

What is depth of field?

Depth of field is the zone of acceptably sharp focus in front of and behind a subject. In simple terms, depth of field determines if the foreground and background are rendered as a soft blur or with distinct detail. Depth of field generally extends one-third in front of the point, or plane, of sharp focus and two-thirds behind it. Aperture is the main factor that controls depth of field, although camera-to-subject distance and focal length affect it as well.

Depth of field is as much a practical matter — based on the light that's available in the scene to make the picture — as it is a creative choice to enhance the rendering of background and foreground elements in the image. For example, if you are shooting at a music concert and you've set the ISO where you want it, you might creatively prefer a moderate depth of field provided by f/8 to show midstage props in acceptably sharp focus. But to be able to handhold the camera and get a sharp image, practicality dictates using a wide aperture to get as fast a shutter speed as possible.

Shallow depth of field

Images where the background is a soft blur and the subject is in sharp focus have a shallow depth of field. As a creative tool, shallow depth of field is typically preferred for portraits, some still-life images, and food photography. As a practical tool, choosing a wide aperture that creates a shallow depth of field is necessary when shooting in low light. In general terms, to get a shallow depth of field, choose a wide aperture ranging from f/5.6 to f/1.4 depending on the lens. The subject will be sharp, and the background and foreground will be soft and nondistracting. Lenses also factor into depth of field, with a telephoto lens offering a shallower depth of field than a normal or wide-angle lens.

9.5 In this image, a wide aperture of f/1.2 provided a very shallow depth of field. Exposure: ISO 100, f/1.2, 1/100 second.

Extensive depth of field

Pictures with acceptably sharp focus in front of and behind the point of sharpest focus in the image are described as having extensive depth of field. Extensive depth of field is preferred for images of large groups of people, landscapes, architecture, and interiors. To get extensive depth of field, choose a narrow aperture, such as f/8 or f/11, or smaller.

Given the same ISO, choosing a narrow aperture such as f/16 requires a slower shutter speed to ensure that enough light reaches the sensor for a correct exposure. Conversely, choosing a wide aperture provides a faster shutter speed.

While aperture is the most important factor that affects the range of acceptably sharp focus in a picture, other factors also affect depth of field:

9.6 A narrow f/14 aperture provides extensive depth of field of a golf course with Mt. Rainier in the background. Exposure: ISO 100, f/14, 1/250 second.

✦ **Camera-to-subject distance.** At any aperture, the farther you are from a subject, the greater the depth of field is and vice versa. Additionally, the farther the subject is from the background the shallower the depth of field.

✦ **Focal length.** Focal length, or angle of view, is how much of a scene the lens "sees." From the same shooting position, a wide-angle lens produces more extensive depth of field than a telephoto lens.

Lenses with a wide maximum aperture such as f/2.8 are referred to as fast lenses, while lenses with a maximum aperture of f/4 or f/5.6 are referred to as slow lenses. In addition, some lenses have variable apertures, where the maximum aperture changes based on the zoom setting on the lens. For example, the Canon EF 28-300mm f/3.5-f/5.6L IS USM lens allows a maximum aperture of f/3.5 at the 28mm zoom setting and f/5.6 at the 300mm zoom setting.

Cross-Reference *For more information on lenses, see Chapter 8.*

Time: The role of shutter speed

Shutter speed controls how long the shutter stays open to let light from the lens strike the image sensor. The longer the shutter, or curtain, stays open, the more light reaches the sensor (at the aperture and ISO that you've set). When you increase or decrease the shutter speed by one full setting, it doubles or halves the exposure. For example, twice as much light reaches the image sensor at 1/30 second as at 1/60 second.

In daily shooting, shutter speed is also related to:

✦ The ability to handhold the camera and get sharp images, particularly in low light. The general rule for handholding a non-image stabilized lens is the reciprocal of the focal length, or 1 over the focal length. For example, if you're shooting at 200mm, then the slowest shutter speed at which you can handhold the lens and get a sharp image is 1/200 second.

✦ The ability to freeze motion or show it as blurred in a picture. For example, you can set a fast shutter speed to show a basketball player's jump in midair with no blur. As a general rule, set the shutter speed to 1/125 second or faster to stop motion. Or set a slow shutter speed to show the motion of water cascading over a waterfall as a silky blur. To show motion as a blur, use a 1/30 second or slower shutter speed and use a tripod.

You can control the shutter speed in Shutter-priority AE (Tv) or Manual (M) mode. In Shutter-priority AE (Tv) mode, you set the shutter speed, and the camera automatically sets the correct aperture. In Manual (M) mode, you set both the shutter speed and the aperture based on the reading from the camera's light meter and the ISO. The light meter is displayed in the viewfinder as a scale — the Exposure Level Indicator — and it shows over-, under-, and correct exposure based on the shutter speed, aperture, and ISO.

9.7 A fast shutter speed stopped the motion of the dog as it came toward me. Exposure: ISO 200, f/3.2, 1/500 second.

Equivalent Exposures

Cameras require a specific amount of light to make a good exposure. As you have seen, after the camera meters the light and factors in the selected ISO, the two remaining factors determine the exposure — the aperture and the shutter speed.

Many combinations of aperture (f-stop) and shutter speed produce exactly the same exposure at the same ISO setting. For example, f/22 at 1/4 second is equivalent to f/16 at 1/8 second, as is f/11 at 1/15, f/8 at 1/30, and so on. And this is based on the doubling and halving effect discussed earlier. For example, if you are shooting at f/8 and 1/30 second, and you change the aperture (f-stop) to f/5.6, then you have doubled

the amount of light reaching the image sensor, so the time that the shutter stays open must be halved to 1/60 second.

While these exposures are equivalent, the rendering of the image and your shooting options change proportionally. An exposure of f/22 at 1/4 second produces extensive depth of field in the image, but the shutter speed is slow, so your ability to handhold the camera and get a sharp image is dubious. But if you switch to an equivalent exposure of f/5.6 at 1/60 second, you are more likely to be able to handhold the camera, but the depth of field will be shallow.

As with all aspects of photography, evaluate the tradeoffs as you make changes to the exposure. And again, it all comes back to light. Your creative options for changing the exposure setting are ultimately limited by the amount of light in the scene.

Putting It All Together

ISO, aperture, shutter speed, and the amount of light in a scene are the essential elements of photographic exposure. On a bright, sunny day, you can select from many different f-stops and still get fast shutter speeds to prevent image blur. You have little need to switch to a high ISO for fast shutter speeds at small apertures.

As it begins to get dark, your choice of f-stops becomes limited at ISO 100 or 200. You need to use wide apertures, such as f/4 or wider, to get a fast shutter speed. Otherwise, your images will show some blur from camera shake or subject movement. Switch to ISO 400 or 800, however, and your options increase and you can select narrow apertures, such as f/8 or f/11, for greater depth of field. The higher ISO enables you to shoot at faster shutter speeds to reduce the risk of blurred images, but it also increases the chances of digital noise.

Approaches to Composition

The technical aspects of photography are unquestionably important, and until now, that's been the primary concentration of this book. But technical competence alone doesn't create memorable images. Among the qualities that make images memorable are artful composition and compelling content. I will leave the content of images to your imagination, but will discuss some widely used approaches to composition.

While composition guidelines will help you design an image, the challenge and the joy of photography is combining your visual, intellectual, and emotional perceptions of a scene from the objective point of view of the camera. And, while composition guidelines are helpful, your personal aesthetic is the final judge. After all, for every rule of composition, there are galleries filled with pictures that break the rules and succeed famously.

Tip As you think about composition, remember that if you're in doubt about how to compose an image, keep it simple. Simple compositions clearly and unambiguously identify the subject, and they are visually easy to read.

Subdividing the photographic frame

One of the first tasks in making a picture is to decide how to divide the photographic frame. Since antiquity, artists, builders, and engineers have looked to nature and mathematics to find ways to portion spaces that create a harmonious balance of the parts to the whole space.

From the fifth century BCE, builders, sculptors, and mathematicians applied what is now known as the Divine Proportion. Euclid, the Greek mathematician, was the first to express the Divine Proportion in mathematical language. The Divine Proportion is expressed as the Greek symbol Phi where Phi is equal to 1/2(1 + square root of 5) = 1.618033989. This proportion divides a line in such a way that the ratio of the whole to the larger part of the line is the same as the larger part is to the smaller part. This proportion produced such pleasing balance and

symmetry that it was applied in building the pyramids of Egypt; the Parthenon in Athens, Greece; and Europe's Gothic cathedrals. The proportion also made its way into art. For example, some believe that the Divine Proportion provides the underlying structure for Leonardo da Vinci's *The Last Supper* and *Mona Lisa* paintings. Over time, harmonious balance was expressed as the Golden Section, or the Golden Rectangle. The 35mm photographic frame, although being slightly deeper and having a ratio of 3:2, is very similar to the Golden Rectangle. The Golden Rectangle provided a map for artists to balance color, movement, and content within the confines of a canvas.

However, unlike painters, photographers don't begin with a blank canvas but with a scene that often presents itself ready-made. Even with a ready-made scene, photographers have a variety of creative guidelines at their disposal to structure the photographic frame. A popular device is the rule of thirds. This "rule" divides the photographic frame into thirds, much like superimposing a tic-tac-toe grid on the frame. To create visually dynamic compositions, place the subject or the point of interest on one of the points of intersection, or along one of the lines on the grid.

The rule is, of course, approximate because not all scenes conform to the grid placement. But the rule of thirds provides a good starting point for subdividing the frame and for placing the subject within the subdivisions. For example, if you're taking a portrait, you might place a subject's eyes at the upper-left intersection point of the grid. In a landscape scene, you can place the horizon along the top or bottom line of the grid depending on what you want to emphasize.

9.8 This image, with a rule-of-thirds grid superimposed, places the dog's right eye roughly at the top-left point of intersection. Exposure: ISO 100, f/22, 1/125 second.

Balance and symmetry

Balance is a sense of "rightness" or harmony in a photo. A balanced photo appears to be neither too heavy (lopsided) nor too off-center. To create balance in a scene, evaluate the visual "weight" of colors and tones (dark is heavier than light), the shape of objects (larger objects appear heavier than smaller objects), and their placement (objects placed toward an edge appear heavier than objects placed at the center of the frame).

The eye seeks balance in an image. Whether it is in tones, colors, or objects, the human eye seeks equal parts, equal weight, and resolved tension. Static balance begins with a single subject in the center of the frame with other elements emanating from the center point to create equal visual weight. Variations on this balance include two

identical subjects at equal distances from each other, or several subjects arranged at the center of the frame.

Conversely, dynamic balance is created when tones, colors, or weights are asymmetrical, or unequally balanced, creating visual tension.

Because the human eye seeks balance and symmetry, should compositions be perfectly balanced? Perfectly symmetrical compositions create a sense of balance and stability. And while symmetry is a defining characteristic in nature, if all images were perfectly balanced and symmetrical, they would tend to become boring. While the human eye seeks symmetry and balance, once it finds it, the interest in the image quickly diminishes.

9.9 This image shows equal balance between the two vases. Exposure: ISO 100, f/22, 1/125 second using an EF 24-70mm, f/2.8L USM lens.

In real-world shooting, the choice of creating perfect balance or leaving tension in the composition is your choice. If you choose perfect symmetry, then it must be perfect, for the eye will immediately scan the image and light on any deviation in symmetry. In dynamic balance, the viewer must work to find balance, and that work can be part of the satisfaction in viewing the image.

Tone and color

At the most fundamental level, contrast is the difference between light and dark tones in an image. But in a larger context, contrast includes differences in colors, forms, and shapes, and it is at the heart of composition. In photography, contrast not only defines the subject but also renders the shape, depth, and form of the subject and establishes the mood and the subject's relationship to other elements in the image.

Related to tones are colors used in composition. Depending on how colors are used in a photo, they can create a sense of harmony, or visual contrasts. In very basic terms, colors are either complementary or harmonizing. Complementary colors are opposite each other on a color wheel — for example, green and red, and blue and yellow. Harmonizing colors are adjacent to each other on the color wheel, such as green and yellow, yellow and orange, and so on, and offer no visual conflict.

If you want a picture with strong visual punch, use complementary colors of approximately equal intensity in the composition. If you want a picture that conveys peace and tranquility, use harmonizing colors.

The more that the color of an object contrasts with its surroundings, the more likely it is that the object will become the main point of interest. Conversely, the more

uniform the overall color of the image, the more likely that the color will dictate the overall mood of the image.

The type and intensity of light also strongly affect the intensity of colors, and, consequently, the composition. Overcast weather conditions, such as haze, mist, and fog, reduce the vibrancy of colors. These conditions are ideal for creating pictures with harmonizing, subtle colors. Conversely, on a bright, sunny day, color is intensified and is ideal for composing pictures with bold, strong color statements.

While a full discussion of tone and color are beyond the scope of this book, knowing some characteristics of tone and color will help you make decisions about photographic compositions.

✦ The viewer's eye is drawn to the lightest part of an image. If highlights in an image fall somewhere other than on the subject, the highlights will draw the viewer's eye away from the subject.

✦ Overall image brightness sets the mood of the image. In addition, the predominance of tones determines the "key." Images with primarily bright tones are said to be "high key," while images with predominately dark tones are "low key."

✦ Colors, like tones, advance and recede; they have symbolic, cultural meanings; and they elicit emotional responses from viewers. For example, red advances and is associated with energy, vitality, and strength as well as with passion and danger. Conversely, blue recedes and tends to be dark. It is widely associated with nature and water.

Tip	When speaking of color and when working with images in editing programs, keep these definitions in mind. Hue is the color — or the name of the color. For example, blue is a hue. Saturation is the intensity or purity of a hue. Brightness determines if the hue is light or dark.

Lines and direction

Because lines have symbolic significance, you can use them to bolster communication, to direct focus, and to organize visual elements. For example, you can place a subject's arms in ways that direct attention to the face. In an outdoor scene, you can use a gently winding river to guide the viewer's eye through the scene. You can use a strong diagonal beam in an architecture shot to bolster the sense of the building's strength. When planning the composition, keep in mind that images have both real and implied lines. Examples of implied lines include the bend of a leaf or a person's hand. Ideally, lines will also lead the viewer's eye toward the subject, rather than away from it or out of the frame.

Leaving space in the frame can reinforce a sense of direction. For example, leaving space in the direction that the subject is looking or moving provides visual space to look or move into.

Lines traditionally convey these meanings:

✦ Horizontal lines imply stability and peacefulness.

✦ Diagonal lines create strength and dynamic tension.

✦ Vertical lines imply motion and strength.

9.10 This image uses strong vertical lines as well as a limited color palette of three strong colors for a very graphic effect. The subject also fills the frame. Exposure: ISO 100, f/16, 1/125 second.

✦ Curved lines symbolize grace.

✦ Zigzag lines convey a sense of action.

✦ Wavy lines indicate peaceful movement.

✦ Jagged lines create tension.

Fill the frame

Just as an artist would not leave part of a canvas blank or filled with extraneous details, you should try to fill the full image frame with the subject and elements that support the subject and the message of the image. Try to include elements that reveal more about the subject.

Check the background

In any picture, the elements behind and around the subject become as much a part of the photograph as the subject, and occasionally more so because the lens tends to compress visual elements. As you compose the picture, check all areas in the viewfinder or LCD for background and surrounding objects that will, in the final image, seem to merge with the subject, or that compete with or distract from the subject.

A classic example of failing to use this technique is the picture of a person who appears to have a telephone pole or tree growing out of the back of his or her head. To avoid this type of background distraction, you can change your shooting position or, in some cases, move the subject.

Frame the subject

Photographers often borrow techniques from painters — and putting a subject within a naturally occurring frame, such as a window or an archway, is one such technique. The frame may or may not be in focus, but to be most effective, it should add context and visual interest to the image.

Control the focus and depth of field

Sharp focus establishes the relative importance of the elements within the image. And because the human eye is drawn first to the sharpest point in the photo, be sure that the point of sharpest focus is on the part of the subject that you want to emphasize; for example, in a portrait, the point of sharpest focus should be on the subject's eyes.

Differential focusing controls the depth of field, or the zone (or area) of the image that is acceptably sharp. In a nutshell, differential focusing works like this: the longer the focal length (in other words, a telephoto lens or zoom setting) and the wider the aperture (the smaller the f-stop number), the shallower the depth of field is (or the softer the background). Conversely, the shorter the focal length and the narrower the aperture, the greater the depth of field.

You can use this principle to control what the viewer focuses on in a picture. For example, in a picture with a shallow depth of field, the subject stands in sharp focus against a blurred background. The viewer's eyes take in the blurred background, but they return quickly to the much sharper area of the subject.

9.11 For this rose shot, I wanted to maximize the depth of field given the close shooting distance, so I used a narrow f/14 aperture. Exposure: ISO 100, f/14, 1/125 second.

Tip For portraits, experiment with different viewpoints. For example, if you photograph a subject from a position that is lower than eye level, the subject seems powerful, while a position that is higher than eye level creates the opposite effect.

To control depth of field, you can use the techniques in Table 9.1 separately or in combination with each other.

Table 9.1
Depth of Field

To Decrease the Depth of Field (Soften the Background Details)	To Increase the Depth of Field (Sharpen the Background Details)
Choose a telephoto lens or zoom setting	Choose a wide-angle lens or zoom setting
Choose a wide aperture from f/1.4 to f/5.6	Choose a narrow aperture from f/8 to f/22
Move closer to the subject and move the subject farther from the background	Move farther away from the subject

Defining space and perspective

Some ways to control the perception of space in pictures include changing the distance from the camera to the subject, selecting a telephoto or wide-angle lens or zoom setting, changing the position of the light in a studio or changing the subject position in an outdoor setting, and changing the camera position.

For example, camera-to-subject distance creates a sense of perspective and dimension so that when the camera is close to a foreground object, background elements in the image appear smaller and farther apart. A wide-angle lens also makes foreground objects seem proportionally larger than midground and background objects.

While knowing the rules provides a good grounding for well-composed pictures, Henri Cartier-Bresson summed it up best when he said, "Composition must be one of our constant preoccupations, but at the moment of shooting it can stem only from our intuition, for we are out to capture the fugitive moment, and all the interrelationships involved are on the move. In applying the

Golden Rule, the only pair of compasses at the photographer's disposal is his own pair of eyes." (From *The Mind's Eye: Writings on Photography and Photographers* by Henri Cartier-Bresson [Aperture, 2005].)

9.12 Weather conditions and the range of tones create a sense of depth in this snow scene. Exposure: ISO 200, f/8, 1/30 second using +1.33-stop Exposure Compensation.

As you can see from this chapter, a combination of technical exposure considerations combined with your creative vision and composition form the foundation for all the images you make. While it seems like a lot to learn, you can approach learning by choosing one aspect of exposure and composition at a time. Practice until you are comfortable with that aspect, and then move to the next aspect.

And to spark your creativity, become an avid observer of how nature organizes elements, watch movies and music videos to see how videographers approach composition, and study classic art and photography books. Along the way, your study and observation will translate into your personal and unique signature and style.

In the Field with the EOS Rebel T1i/500D

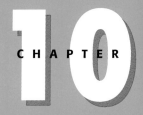

CHAPTER

10

I n this chapter, you move into using the Rebel T1i/500D in the field for everyday photography. The selected photography specialty areas covered in this chapter provide examples that you can use for your shooting, or that you can use as a springboard for your work.

Each section explores using different features and options of the Rebel T1i/500D to not only enhance your images but also to make your shooting more enjoyable and convenient. For example, the action shooting section provides recommendations for lenses, setting up the autofocus and drive modes for action shots, ways to modify exposure in challenging lighting situations, and which custom functions to enable or disable for the best camera performance. While you may choose to use different features and options, the examples provide a starting point for getting the most from the Rebel in different shooting situations, and they show you how to apply various camera features and options to specific shooting scenarios. By the end of this chapter, I hope that you'll have a good appreciation of the versatility that the T1i/500D provides in shooting different scenes and subjects.

And as you move from photographing one type of scene or subject to another, make it a habit to check the camera settings and reset them for the new scene or subject. In fact, you

might want to create a shooting checklist that you carry in your gear bag to remind you to double-check the ISO, white balance, autofocus mode, drive mode, and so on as you move between different shooting situations.

The more you shoot with the Rebel T1i/500D, the more you'll appreciate the creative options you have to make images that match your creative vision.

Action and Sports Photography

Anyone who shoots action and sports events knows that a fast camera is essential for capturing the energy of and the peak moments of the action. With a burst rate of approximately 170 JPEG or 9 RAW frames in Continuous drive mode, the T1i/500D is a solid performer for action shooting. The focal length multiplication factor of 1.6x brings the action in close with telephoto lenses. For example, using the Canon EF 70-300m f/4.5-5.6 IS USM lens effectively provides a 112-480mm equivalent focal length.

And with shutter speeds that range from 1/4000 to 30 seconds, depending on shoot-ing mode, the camera offers ample opportu-nity to freeze action or to pan with the motion of the subject.

/ **Note** *Panning is a technique where you move the camera with the motion of the subject. In the final image, the subject is in sharp focus while the background is shown with blurred streaks. Panning requires relatively slow shutter speeds of 1/30 second or slower. You can occasionally use faster shutter speed such as 1/60 second in some situations.*

You can choose any of the Rebel's three autofocus modes when you shoot in P, Tv, Av, M, or A-DEP shooting modes. Of the three autofocus modes, AI Servo AF mode is designed specifically for action shooting, and tracks focus on the subject motion. Depending on the scene or subject, you might alternately find that AI Focus AF is a good choice. In this autofocus mode, for example, you can focus on one of many runners at the start line using One-shot AF mode. Then when the runner begins mov-ing, the camera detects motion and auto-matically switches to AI Servo AF to track focus on the subject until you press the Shutter button.

If you have a passion for sports and action shooting, one way to hone your skills is by shooting local events. As you shoot, try to capture the decisive moment when a run-ner crosses the finish line, a pole-vaulter reaches the height of a vault, or a race car gets the checkered flag. Other moments are equally compelling, such as when an athlete takes a spill, the look of disappointment when an athlete comes in second, third, or last in a race — in short, moments of high emotion that tell a rich and compelling story of the person and the event.

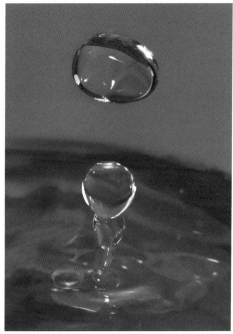

10.1 To capture Keith at the edge of the incline, I used Continuous drive mode and shot a series of images as he approached the top. I also used One-shot AF mode and selected the AF point manually. Exposure: ISO 200, f/5.6, 1/1250 second.

10.2 You can spend hours stopping the motion of water as it drips into a glass. I used the built-in flash and window light for this image. Exposure: ISO 100, f/5, 1/250 second.

Inspiration

Action shooting is a great time to use the techniques of freezing and showing motion as a blur to capture the emotion and give the sense of being in the moment and of the entire event. Also create sequences of images that tell the story of a part or all of an event, or the story of a single athlete during the event.

Action photography techniques are by no means limited to sports. Any event that has energy and motion is an opportunity to apply sports and action shooting techniques, whether it's a baby taking his or her first steps or pets playing in the park, a top spinning, or water dripping from a faucet.

Tip *For ongoing inspiration in shooting action photos, I recommend MSNBC's The Week in Sports Pictures at www.msnbc.msn.com/ id/3784577.*

Taking action and sports photographs

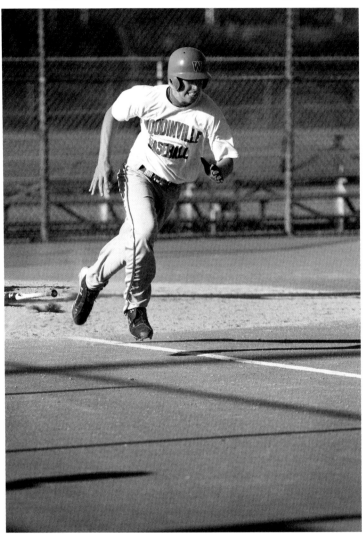

10.3 In this image, I wanted to capture the motion of the bat hitting the ground as well as the batter heading for first base.

Table 10.1
Action and Sports Photography

Setup	**In the Field:** The image in figure 10.3 is one of a series at a high school baseball park. The T1i/500D's fast autofocus helps to capture this type of action. **Additional Considerations:** At sports events, find a good shooting position with a colorful, non-distracting background. If you're shooting JPEG capture and the light is bright, setting a negative Exposure Compensation of up to −1 Exposure Value (EV) can help avoid blowing detail from highlight areas in the image. If you shoot in RAW capture mode, Exposure Compensation may not be necessary because you can recover some highlight detail during image conversion. Be sure to check the histogram to see if exposure modification is necessary regardless of whether you're shooting JPEG or RAW images.
Lighting	**In the Field:** Late afternoon light created deep shadows on the field, but provided nice warmth to the colors. I knew that the light hitting the player on the left side was bright, so I used negative Exposure Compensation to prevent highlights from being blown out on the uniform. **Additional Considerations:** Bright to moderate light is good for freezing subject motion. Moderate light is ideal for showing motion blur, although motion blur can be shown in brightly lit scenes as well.
Lens	**In the Field:** Canon EF 70-200mm, f/2.8L IS USM lens zoomed to 153mm, or 245mm equivalent with the focal length conversion factor. **Additional Considerations:** The lens you choose depends on the subject you're shooting and your shooting distance from the action. A zoom lens is especially useful as subjects move across the playing field or arena because you can zoom the lens as the action advances toward and recedes from you. A telephoto lens also offers the advantage of blurring distracting backgrounds often found at sports events and increases the background blur if you're panning with subject motion.
Camera Settings	**In the Field:** RAW capture, Shutter-priority AE (Tv) shooting mode with the white balance set to Daylight, Evaluative metering mode, Continuous drive mode, and Autofocus mode set to One-shot AF. **Additional Considerations:** In Tv mode, set the shutter speed to 1/250 second for action moving toward you to freeze motion. If action is moving side to side or the subject is jumping, then set 1/500 to 1/1000 second. Also, if you're shooting at a high ISO, and you want to use C.Fn-5, High ISO speed noise reduction, then set it to Low (Option: 1) so that the burst rate for continuous shooting is not significantly reduced as it will be if you use the Strong (Option: 2) setting.

continued

Table 10.1 *(continued)*

Exposure	**In the Field:** ISO 100, f/2.8, 1/4000 second, -1.33 Exposure Compensation, Shutter-priority AE mode (Tv) to ensure a fast shutter speed. The light was bright enough that I could keep the ISO at 100 to maintain the highest image quality. **Additional Considerations:** For indoor sports events, you'll need to increase ISO — a little or a lot — to get a fast enough shutter speed to freeze subject action. It's also important that the shutter speed is fast enough to prevent camera shake from handholding the camera and lens. A reliable guideline for handholding lenses is 1/[focal length]. So if you're shooting with a 200mm lens, the slowest shutter speed you can use and not get blur from handholding the camera is 1/200 second if you are using a non-image-stabilized (IS) lens. If you're shooting late afternoon events, as the light level decreases, you'll need to increase the ISO setting. Set the ISO only as high as necessary to get a fast enough shutter speed to freeze subject motion.
Accessories	At slower shutter speeds and when using a telephoto lens or zoom setting, use a tripod or monopod to ensure sharp focus. With Canon L-series lenses, you can consider using a lens extender to extend the range of a telephoto lens. The lens extenders cost you 1 to 2 f-stops of light, so an extender is a good option in brightly lit scenes, but the light loss often proves too costly in the lower light of indoor stadiums.

Action and sports photography tips

✦ **Capture the thrill.** Regardless of the technique you choose to shoot action photos, set a goal of showing the emotion, thrill, speed, or excitement of the scene in your pictures. For example, use a low shooting position for a child on a trampoline or a pole-vaulter to create a feeling of increased height.

✦ **Choose on a spot and let the action come to you.** If lighting varies across the sports field with areas of very low light, find the best-lit spot on the playing field or court, set the exposure for that lighting, and then wait for the action to move into that area. This technique works well in a low-lit

indoor stadium as well. You can also prefocus on this spot and wait for the athlete or action to move into the area.

✦ **Vary the shutter speed.** To obtain a variety of action pictures, vary the shutter speed for different renderings of the action. At slower shutter speeds, part of the subject will show motion blur, such as a player's arm swinging, while the rest of the subject's motion will be stopped.

✦ **Practice timing and composition.** If you're new to shooting action photos, practice as often as you can to hone your reflexes, and then concentrate on refining image composition. With practice, both timing and composition come together to give you fine action shots.

Macro Photography

Many people think about shooting flowers when they think of macro photography. Certainly, few photographers can resist the temptation to photograph flowers and exotic plants. But macro photography includes more than the subjects offered in nature. With any of Canon's macro lenses, you have the opportunity to make stunning close-up images of everything from stamps and water drops to jewelry and the weathered hands of an elder. At its best, macro photography is a journey in discovering subjects that are overlooked or invisible in nonmacro photography. The enticements of macro subject composition include colors, the allure of symmetry and textures, intricate design variations, and descriptive details found in objects and the human form.

To explore these small worlds, a lineup of Canon macro lenses offers one-half to life-size magnifications. Each lens offers a different working distance from the subject, and with extension tubes, you can reduce the focusing distance of any lens to create dynamic close-up images. In addition, Canon's Macro Twin Lite MT-24EX and the Macro Ring Lite MR-14EX provide versatile lighting options for small subjects.

Cross-Reference *Chapter 8 details Canon's macro lens lineup as well as extension tubes.*

Regardless of the subject, focus is critical in macro work. And at 1:1 magnification, the depth of field is very narrow. For my work, I often maximize depth of field by using a narrow aperture of f/8 to f/16. Of course, the narrow aperture results in slow shutter speeds, so it's critical to use a tripod and have

a stock-still subject. To ensure sharpness, I use the 2-second Self-timer mode to avoid camera shake from the motion of pressing the Shutter button with my finger. I also use Mirror Lockup, which flips up the reflex mirror and keeps it up so that the slap of the mirror doesn't cause blur. Mirror Lockup can be used in combination with a Self-timer mode.

Cross-Reference *To learn how to enable Mirror Lockup, see Chapter 6.*

10.4 Given the unique light on this flower bud, I chose to use a shallow depth of field that would give the bud an abstract quality to keep concentration on the light. With other macro subjects, I often choose the opposite approach and use a narrow aperture to maximize the depth of field. Exposure: ISO 200, f/2.8, 1/500 second.

Inspiration

The beauty of macro photography is showing details that most people commonly overlook. Use your macro lens as a microscope to find the most unique and compelling structures in the subject you're shooting. Reveal to the viewers what they haven't seen before. Combine depth of field with subject position for creative effect. For example, a picture of an insect coming straight at the lens at eye-level foreshortens the body and blurs the back of it creating a sense of power that is disproportionate to the creature's size.

10.5 For nature macro images, I look for compelling natural light that complements the subject and creates a sense of depth or unique illumination of the structures of the subject. Here the tiny cacti bud was spot-lit with late-day filtered sunlight. Exposure: ISO 200, f/3.2, 1/200 second.

Taking macro photographs

10.6 Food is a subject with universal appeal to viewers, and that appeal together with the abundance of potential subjects, makes it a good subject for macro shooting.

Table 10.2
Macro Photography

Setup	**In the Field:** For figure 10.6, I wanted to show the appeal of the caramel-filled chocolate that is one of my favorite treats, especially when working on a tight book deadline. I cut the chocolate to reveal the caramel filling hoping that it would flow out gracefully.
	Additional Considerations: Look for light that compliments the subject and sets the mood for the image. Flowers, plants, insects, and other natural subjects in outdoor light usually offer ready-made setup. If you don't have a garden, local nurseries and greenhouses offer plentiful subjects. And always, always watch the background and find a shooting position that avoids distracting background elements and bright highlights.

continued

Table 10.2 *(continued)*

Lighting	**In the Field:** The scene is backlit with indirect late-afternoon window light. I knew that the white plate would act as a white reflector, throwing light into the shadow areas to soften shadow edges.
	Additional Considerations: Outdoor light ranging from overcast conditions to bright sunshine is suitable for macro shooting. For outdoor flower shots, try taking a low shooting position, and then shoot upward to use the blue sky as a backdrop. For indoor shooting, window light to one side of the subject offers a beautiful light quality, and it is often bright enough for shooting on a tripod. Be sure to use silver or white reflectors to direct light toward the subject. Macro Speedlites are a good option as well.
Lens	**In the Field:** Canon EF 100mm f/2.8 Macro USM lens.
	Additional Considerations: As detailed in Chapter 8, Canon offers excellent Macro lenses, including the EF 180mm f/3.5L Macro USM and the EF-S 60mm f/2.8 Macro USM lenses, as well as the venerable EF 100mm f/2.8 Macro USM lens. The 180mm offers a longer working distance for subjects you can't or don't want to approach from a close shooting distance.
Camera Settings	**In the Field:** RAW capture, Aperture-priority AE (Av) shooting mode, using Custom White Balance, Evaluative metering, One-shot AF mode with manual AF-point selection, and the Self-timer drive mode.
	Additional Considerations: Before you begin shooting, decide on the depth of field that you want, and then select the aperture, camera-to-subject distance, and the lens to get the effect you envision. If there are bright highlights on the subject, you can ensure that the highlights retain detail, particularly with JPEG capture, by using AE Lock or negative Exposure Compensation, techniques described in Chapter 2.
Exposure	**In the Field:** ISO 200, f/29, 1.6 second. For this image, I wanted as much acceptable sharpness as possible throughout the frame; in other words, an extensive depth of field. I also shot at f/11, f/16, and f/20, but the f/29 image delivered more extensive depth of field, and that was how I envisioned this shot.
	Additional Considerations: Unless you want to use selective focusing, where a very small part of the subject is in sharp focus, set a narrow aperture such as f/11 to f/29, depending on the lens, to maximize the depth of field, which is, by virtue of the close focusing distance, very shallow. Also use a tripod, beanbag, or mini-pod to stabilize the camera and use Self-timer mode to fire the shutter. This is also a good time to use Mirror Lockup (detailed earlier) to ensure tack-sharp focus.
Accessories	Consider buying inexpensive plant holders to hold plants steady. I've found that fashioning a plant holder from florist wire works well, too.

Macro photography tips

✦ **Ensure tack-sharp focus.** The Rebel offers several self-timer modes that you can combine with Mirror Lockup, described previously, and a solid tripod for tack-sharp focus. Before you begin shooting, ensure that there is no "drift" of the camera as it is mounted on the tripod head, such as when the camera is pointed down or in vertical shooting position. If you detect any drift, tighten the fitting of the camera on the tripod head's quick-release plate or the fitting that attaches the camera to the tripod.

✦ **Make the most of lighting.** If you want to emphasize depth in textured subjects, use strong sidelight that rakes across the subject. Or if you want controlled, focused light, you can fashion a modifier to reduce the breadth of light from a Speedlite. For example, one photographer fashioned a narrow "snoot" by using black electrical tape on a Speedlite. The snoot concentrates the flash light into a concentrated area for tiny subjects.

✦ **Maximize the area of acceptable focus.** To get the maximum acceptable sharpness throughout the frame, especially for small objects, shoot on a plane that is level with the subject and use a narrow aperture such as f/11 or narrower. Any tilt of the lens will quickly create blur.

✦ **Take advantage of backlighting.** Many flower petals and plant leaves are transparent, and with backlighting, the delicate veins are visible. You can use backlighting to create compelling and very graphic images of flowers and plants. Use Exposure Compensation or AE Lock to ensure that the highlights within the subject maintain good image detail.

Nature and Landscape Photography

With breathtaking vistas of forests, mountains, oceans, plants set against the canvas of the ever-changing sky, God's handiwork remains an awesome wealth of photographic material. From dawn to dusk and sometimes beyond, nature provides an endless source of inspiration for stunning images. Seasonal changes to flora and fauna, passing wildlife, rain, sunshine, fog, and snow all contribute to nature's ever-changing canvas. Photographing landscapes and nature requires both creative and technical skill to create images that capture the sense and details of the scene.

Tip *The image histogram is your best tool for evaluating whether the exposure captured detail in both light and dark areas. If the histogram shows pixels crowded against the left, right, or both sides of the histogram, the camera wasn't able to maintain detail in one or both areas. Filters, such as a graduated neutral density (Grad ND) filter, can help balance the exposure for bright sky areas and darker foreground areas allowing the sensor to hold detail in both areas.*

10.7 This heavy, layered fog settled over Duvall, Washington, the town that's seen in the distance. The rusted red tin barn roof contrasts nicely with the overall green and gray color palette of the scene. Exposure: ISO 100, f/6.3, 1/40 second.

The quality of light plays a starring role in nature photography. Sunrise and sunset provide singularly rich color, and the low angles of the sun create long shadows, adding a sense of depth to landscapes. But also take advantage of the full range of atmospheric conditions, such as fog, which adds a sense of mystery; overcast light, which enriches colors; and rain and dew, which dapple foliage with fascinating patterns of water droplets.

Nature and landscape images are frequently good candidates for using exposure modification such as Auto Exposure Bracketing and Exposure Compensation to capture the range of highlights to shadows in the scene. If the range of highlights to shadows is greater than the Rebel can handle, it often sacrifices detail in the highlights. This is known as "blown" highlights where the brightest areas go completely white with no image detail. As you shoot, check the image histograms on the camera, or the blinking Highlight Alert that shows blown highlights during image playback. To see Highlight Alert, press the Display (DISP.) button one or more times during image playback until the image histogram is displayed with the image preview. Blinking areas of overexposure are a good signal for you to set negative Exposure Compensation that helps preserve detail in the key highlight areas of the image. Then take the image again and check the display and/or histogram to see if the compensation was enough.

Note *Be aware that the effects of bracketing and compensation may not be visible in your images because the T1i/500D has Auto Lighting Optimizer turned on by default for images that you capture in JPEG format. Auto Lighting Optimizer detects images that are too dark or that lack contrast and automatically adjusts them. If you prefer not to have the camera make automatic adjustments, turn off Auto Lighting Optimizer using C.Fn-7.*

10.8 This backlit shot was made using flowers cut from the garden and a sprinkler. The trick is setting a shutter speed that renders the water streaks as long, but not too long. I've found that 1/60 second is the best choice. Exposure: ISO 200, f/29, 1/60 second.

Inspiration

Choose a place that gives you a unique visual or emotional sense. For example, if you find a scene that exudes tranquility, try different positions, focal lengths, and foreground elements to help convey the sense of peace. As you take pictures, look both at the overall scene and the components that make it compelling. Isolate subscenes that make independent compositions or can be used as a center of interest for the overall scene.

As you look around, ask yourself questions such as whether including more or less of the sky will enhance the image. Generally, a gray, cloudless sky adds no visual value to the image. Stormy skies, on the other hand, can add drama as well as beautiful color to outdoor images.

Optional Filters

The most useful filters in nature, landscape, and travel photography — collectively referred to as outdoor photography — include the circular polarizer, neutral density and vari-neutral density filters, and warm-up filters. Here is a brief overview of each type of filter.

✦ **Polarizer.** Polarizers deepen blue skies, reduce glare on surfaces to increase color saturation, and reduce spectral reflections from water and other reflective surfaces. A circular polarizer attaches to the lens, and you rotate it to reduce glare and increase saturation. Maximum polarization occurs when the lens is at right angles to the sun. With wide-angle lenses, uneven polarization can occur causing part of the sky to be darker than the sky closest to the sun. You can use a 1- to 2-stop neutral density (ND) graduation filter to tone down the lighter area of the sky by carefully positioning the Grad ND filter. If you use an ultrawide-angle lens, be sure to get a thin polarizing filter to help avoid vignetting, which can happen when thicker filters are used at small apertures.

✦ **Variable neutral density filters.** Sing-Ray's Vari-ND variable neutral density filter (www.singh-ray.com/varind.html) enables you to continuously control the amount of light passing through your lens up to 8 f-stops, making it possible to use narrow apertures and slow shutter speeds even in brightly lit scenes. Thus you can show the fluid motion of a waterfall or the motion of clouds or flying birds.

✦ **Graduated neutral density filters.** These filters enable you to hold back a bright sky from 1 to 3 f-stops to balance a darker foreground with a brighter sky. With this filter, you can darken the sky without changing its color; its brightness is similar to that of the landscape, and it appears in the image as it appears to your eye. Filters are available in hard- or soft-stop types, in different densities: 0.3 (1 stop), 0.45 (1.5 stops), 0.6 (2 stops), and 0.9 (3 stops).

✦ **Warm-up filters.** Originally designed to correct blue deficiencies in light or certain brands of film, warm-up filters correct the cool bias of the light. You can use them to enhance the naturally warm light of early morning and late afternoon. Warm-up filters come in different strengths, such as 81 (weakest); 81A, B, C, and D; and EF, with 81EF being the strongest. You can also combine a warm-up filter with a polarizer.

Taking nature and landscape photographs

10.9 This scene depicts a small community located in the shadow of the Cascade Mountain range.

Table 10.3
Nature and Landscape Photography

Setup	**In the Field:** In figure 10.9, the peaceful valley lit by early sunset light and the snow-covered mountains characterize this rural area east of Seattle, Washington.
	Additional Considerations: Trust your eye to find compelling images, and always look for the light. It's challenging to find scenic expanses where utility wires, road signs, and other distractions do not factor into the scene. Sometimes you can scout shooting positions and locations that minimize the distractions. For sweeping scenes, include a foreground object such as a person, a rock, or a fence to provide a sense of scale. Also look for lines and shapes that you can use to direct the viewer's eye through the picture.
Lighting	**In the Field:** Sunset light casts a golden glow on the small town and on the trees. But because it was early sunset, the blue sky still retained a "clean" blue color, which I wanted for this shot. During RAW conversion, I opened up shadows to show more detail in the trees.
	Additional Considerations: A variety of lighting conditions is inherent in landscape and nature photography. The best light is during and just after or before sunrise and dawn when the low angle of the sun creates long shadows and enhances the colors of flora and fauna.

continued

Table 10.3 (continued)

Lens	**In the Field:** Canon EF 70-200mm f/2.8L IS USM lens set to 75mm.
	Additional Considerations: Both wide-angle and telephoto zoom lenses are good choices for landscape and nature photography. For distant scenes, a wide-angle lens may render some elements, such as distant mountains, too small in the frame. Use a telephoto lens to bring them closer.
Camera Settings	**In the Field:** RAW capture, Aperture-priority AE (Av) shooting mode with white balance set to Daylight, and then adjusted during RAW conversion, Evaluative metering, One-shot AF mode with manual AF-point selection.
	Additional Considerations: Because some landscape images look better with deeper color, you can set Exposure Compensation to -1/2 or -1/3 stop if you're shooting JPEGs; this also helps to retain detail in bright highlights. Just hold down the Aperture/Exposure Compensation button at the top-right side of the LCD, and then turn the Main dial to the left to set the amount of negative compensation you want. Be sure to check the image histogram after capture to ensure proper exposure. Also consider using C.Fn-9, Mirror Lockup, to prevent vibration from the reflex mirror flipping up at the start of the exposure. You may also want to try the Landscape Picture Style.
Exposure	**In the Field:** ISO 200, f/7.1, 1/200 second, using IS on the 70-200mm lens.
	Additional Considerations: Use the lowest ISO possible to avoid digital noise and to ensure the highest overall image quality. In most landscape and nature photos, extensive depth of field is the best choice, so choose a narrow aperture.

Nature and landscape photography tips

✦ **Look for details that underscore the sense of the place.** A dilapidated fence or a rusted watering trough in a peaceful shot of a prairie, or the furrows of a field helps convey how the land is used.

✦ **Look for unusual and compelling light.** For example, when you shoot in a forest or shaded area, look to include streaming shafts of light coming through the trees or illuminating a single plant.

✦ **Maximize depth of field.** While there are charts and formulas to calculate the hyperfocal distance — the point at which the depth of field extends from half the hyperfocal distance to infinity — a quick substitute is to focus one-third of the way into the scene to maximize the depth of field.

✦ **Use Exposure Compensation in scenes with large areas of light color.** Large areas of light or white, such as snow scenes or white sandy beaches, can fool the camera meter into underexposing the image. To ensure that the snow or white sand appears white in the final image, set Exposure Compensation on the T1i/500D to +1 or +2. Likewise, to get true blacks, set -1 to -2 stops of Exposure Compensation.

Night and Low-Light Photography

There are few images more dramatic than low-light and night shots. And there are few scenes and subjects more challenging to shoot than night and low-light scenes. This area of photography opens a new world of creative challenge, enjoyment, and the potential for stunning images.

For outdoor images, sunset and twilight are magical photography times for shooting of subjects such as city skylines, harbors, and downtown buildings. During twilight, the artificial lights in the landscape, such as street and office lights, and the light from the sky reach approximately the same intensity. This crossover lighting time offers a unique opportunity to capture detail in a landscape or city skyline, as well as in the sky.

For indoor images such as indoor gymnasiums, music concerts, and other events, you have to depend on the T1i/500D's good performance at the higher ISO settings to give you good images. You may also want to consider shooting in RAW capture mode and performing additional noise reduction during image conversion.

Night and low-light scenes often necessitate using a high ISO setting, which increases the potential of getting digital noise. The Rebel T1i/500D offers two excellent Custom Function options to help offset digital noise: C.Fn-4 Long exposure noise reduction and C.Fn-5 High ISO speed noise reduction. Enabling one or both options decreases the maximum burst rate for continuous shooting, but it's great insurance for minimizing or eliminating distracting and annoying digital noise in images.

10.10 Different seasons and different levels of cloud cover offer excellent opportunities for moon shots. I was inspired to take out the tripod to capture the fast-moving colorful clouds as they passed across the moon. Exposure: ISO 1600, f/5.6, 1/5 second using an EF 100-400mm f/4.5-5.6 IS USM lens. I also turned on C.Fn-5, High ISO speed noise reduction and set it to Option 2: Strong.

Fireworks Photography

To capture fireworks, choose a lens in the range of 28 to 200mm or longer depending on your distance from the display and what elements you want to include in the fore-ground. Choose an ISO from 100 to 400. Because the camera may have trouble focusing on distant bursts of light, you can prefocus manually on infinity and get good results at public fireworks displays. Be sure to use a tripod or set the camera on a solid surface to ensure sharp images.

If you want to have more creative control, you should know that capturing fireworks is an inexact science at best. I usually set the camera to ISO 100 or 200, switch to Manual shooting mode, set the aperture to f/11 or f/16, and set the shutter on Bulb, which allows you to keep the shutter open as long as the Shutter button is depressed. You can experiment to find the best time, usually between 1/6 and 1 second. Check the results on the LCD and adjust the time as necessary.

10.11 In my neighborhood, many neighbors have individual fireworks displays, so it's possible for me to capture multiple bursts in a single frame. Exposure: ISO 100, f/11, 1/6 second using a Canon EF 100-400mm f/4.5-5.6 IS USM lens.

Inspiration

Try shooting city skyline shots in stormy weather at dusk when enough light remains to capture compelling colors and the fearsome look of the sky. Busy downtown streets as people walk to restaurants, cafés, and diners; gasoline stations; widely spaced lights on a lonely stretch of a highway in the evening; the light of a ship coming into a harbor; and an outdoor fountain or waterfall that is lit by nearby streetlights are all potential subjects for dramatic pictures, as are indoor events such as concerts and recitals.

Taking night and low-light photographs

10.12 Low-light scenes such as concerts, events, and building interiors offer great photo opportunities, but they are challenging in terms of exposure, timing for capturing the action, and composition.

Table 10.4
Night and Low-Light Photography

Setup	**In the Field:** The primary setup for figure 10.12 was to find the shooting position that allowed me to avoid background distractions around the musician, and hopefully to have the background go to a dramatic black. **Additional Considerations:** If you are photographing outdoor night and low-light images, ensure that the composition has a clear subject. Be aware that passing cars and nearby lights can influence the camera's meter reading. You may need to wait for cars to pass or use Partial or Spot metering.
Lighting	**In the Field:** While the stage had an abundance of twinkle lights in the background, I tried to minimize the number of lights behind the guitarist. I then waited for him to step into a well-lit area of the stage before I began shooting. **Additional Considerations:** If you're shooting scenes with floodlit buildings, bridges, or other night scenes, begin shooting just after sunset so the buildings stand out from the surroundings. And whether you're shooting indoors or outdoors, check the histogram on the LCD to ensure that key highlights are not being blown out. Shadows naturally block up quickly in low light, but if you're shooting RAW capture, you can open the shadows some and apply noise reduction if necessary during image conversion.
Lens	**In the Field:** Canon EF 85mm f/1.2L USM lens. **Additional Considerations:** For concerts and other indoor low-light events, there is no substitute for having a fast lens. The Canon EF 50mm f/1.4 USM lens is an excellent fast lens. A wide-angle zoom lens set to 18mm or 24mm allows you to get a broad expanse of night and evening scenes. Telephoto lenses, of course, are great for bringing distant scenes closer. Regardless of the lens you use, mount the camera or lens on a tripod to ensure tack-sharp focus.
Camera Settings	**In the Field:** RAW capture, Aperture-priority AE (Av) shooting mode, using Auto (AWB) and adjusted during RAW conversion, Evaluative metering, One-shot AF mode with manual AF-point selection. **Additional Considerations:** Shutter-priority (Tv) mode gives you control over the shutter speed to control how motion is rendered, if that's important to the scene or subject you're shooting. If you have to handhold the camera, you can use Tv mode and set a shutter speed that's fast enough for handholding the lens that you're using, and then make adjustments to the ISO as necessary. Low-light scenes are also a good time to use the Self-timer mode to trip the shutter and to use Mirror Lockup, which you can enable using C.Fn-10. For outdoor low-light and night shooting, also consider using C.Fn-3, Long exposure noise reduction, and C.Fn-5, High ISO speed noise reduction. You also can enable C.Fn-9, Mirror Lockup, to avoid any vibration caused by the action of the reflex mirror as it flips up at the start of the exposure.

Exposure　　**In the Field:** ISO 400, f/2.8, 1/180 second.

Additional Considerations: Light changes quickly in late-day outdoor scenes. This is a good time to consider using Auto ISO where the Rebel automatically sets the ISO between 100 and 1600 based on the available light. Just past sunset, you can usually rely on the meter to give a good exposure, but you may choose to bracket exposures at 1/3- or 1/2-stop intervals. However, if bright lights surround the scene, the meter can be thrown off. Check the histogram often, and use a lens hood to avoid having stray light coming into the lens. If you want lights in the scene to have a star-burst effect, use a narrow aperture such as f/11 or smaller.

Accessories　　Using a tripod or setting the camera on a solid surface is essential in low-light scenes.

Night and low-light photography tips

✦ **Be safe and use common sense.** Night shooting presents its own set of photography challenges, including maintaining your personal safety. Always follow safety precautions when shooting during nighttime. Be sure to wear reflective tape or clothing, carry a flashlight, and carry a charged cell phone with you.

✦ **Use a level when using a tripod.** A small bubble level designed to fit on the hot-shoe mount helps avoid tilted horizon shots. Some tripod heads also have built-in levels.

✦ **Try the Self-timer mode.** You can, of course, negate the advantage of using a tripod by pressing the Shutter button with your finger, causing camera shake and a noticeable loss of sharpness. A better solution is to use one of the Self-timer modes with or without Mirror Lockup.

Portrait Photography

Portraiture is likely the most popular of photographic specialties and provides a continuing challenge and opportunity for photographers. Making portraits is a process of discovering the spirit and spark of people and conveying it in images — certainly a compelling and challenging endeavor. Despite the challenges, portrait photography is ultimately very satisfying and rewarding.

The following sections detail some of the considerations involved in portraiture.

10.13 For this portrait, I placed this 3-month-old baby in open shade to prevent him from squinting in brighter light. Exposure: ISO 200, f/4, 1/500 second.

Lens choices

For head and head-and-shoulders portraits, lenses ranging from 35mm to 200mm are excellent. A telephoto lens has the advantage of enhancing the background blur of a wide aperture to bring the subject visually forward in the image. For full-length and environmental portraits, a moderate wide-angle lens is a good choice. Having a fast f/2.8 lens or faster is a great advantage particularly if you move among areas where the light varies from moderate to low light.

Backgrounds

In all portraits, the subject is the center of attention, and that's why it's important to choose a nondistracting background. Even if you have trouble finding a good background, you can de-emphasize the background by using a wide aperture such as f/4 or f/2.8 and by moving the subject well away from the background. Conversely, some portraits benefit by having more background context. For example, when taking high school senior portraits, backgrounds and props that help

show the student's areas of interest are popular. More extensive depth of field by using a narrow f/8 or f/11 aperture is the ticket for showing a star football player in the context of a football field.

Lighting

Lighting differs for portraits of men and women. For men and boys, strong, directional daylight can be used to emphasize strong masculine facial features. For women and girls, soft, diffuse light from a nearby window or the light on an overcast day is flattering. To control light, you can use a variety of accessories, including reflectors to bounce light into shadow areas and diffusion panels to reduce the intensity of bright sunlight. These accessories are equally handy when using the built-in or an accessory flash for portraits. To determine exposure, take a meter reading from the subject's face, use Auto Exposure Lock, and then recompose, focus, and take the picture.

Tip *The Rebel T1i/500D doesn't have a PC terminal to connect a studio strobe system directly to the camera, but several companies make affordable hot-shoe adapters for this purpose. Ensure that the voltage of the strobe system is safe to use with the T1i/500D — the recommended voltage is usually 6 volts. Consider Safe-Sync adapters that regulate and reduce Flash Sync voltage to 6 volts to protect camera circuitry.*

Posing

Entire books are written on posing techniques for portraits. But you won't go wrong with one essential guideline — the best pose is the one that makes the subject look comfortable, relaxed, and natural. In practice, this doesn't mean that the subject slouches on a chair; it means letting the subject find a comfortable position, and then tweaking it to ensure that the subject lines and appearance are crisp and attractive. Key lines are the structural lines that form the portrait. You can also use diagonal and triangular lines formed by the legs, arms, and shoulders to create more dynamic portraits. And placing the subject's body at an angle to the camera is more flattering and dynamic than a static pose with the subject's head and shoulders squared off to the camera.

Rapport and direction

Even if you light and pose the subject perfectly, a portrait will fail if you haven't connected with the subject. Your connection with the subject is mirrored in the subject's eyes. Every minute that you spend building a good relationship with the subject pays big dividends in the final images. Keep in mind that even the most sparking personalities can freeze when the lens is pointed in their direction. To ease their anxiety, you have to be a consummate director, calming the subject, gently guiding him or her into the spirit of the session, and providing encouraging feedback.

Inspiration

Before you begin, talk to the subject about his or her interests. Then see if you can create setups or poses that play off of what you learn. Consider having a prop that the subject can use for inspiration and improvisation. Alternately, play off the subject's characteristics. For example, with a very masculine subject, use angular props or a rocky natural setting that reflects masculinity.

10.14 Portraits are not limited to human subjects, of course. Pet portraiture is a growing specialty area in photography as well. This portrait of an 8-week-old miniature schnauzer was shot using red poster board as the background. Exposure: ISO 100, f/20, 1/125 second.

Taking portrait photographs

10.15 For this very casual father-son portrait, the key was to have the mother standing next to me to elicit a smile from the baby.

Table 10.5
Portrait Photography

Setup
In the Field: For figure 10.15, the background of dense foliage provided a nondistracting backdrop. I also ensured that the father and son were positioned several feet in front of the foliage, and I shot with a wide aperture and short telephoto zoom setting.

Additional Considerations: Uncluttered and simple backgrounds make the subject stand out from the background. If you don't have white paper, use a plain, neutral-color wall, and move the subject 4 to 6 feet or farther from the background. If you're using an accessory Speedlite, moving the subject away from the background also helps reduce or eliminate background shadows. Keep poses simple and straightforward; allow the subject to assume a natural position, and then adjust the pose for the best effect.

Lighting
In the Field: I placed the father and son in open shade just at the edge of bright sunlight on the left side of the subjects.

Additional Considerations: For outdoor portraits, a silver or white reflector is an indispensable tool to bounce light into the faces of the subjects. You can also use fill flash to brighten faces particularly in outdoor settings. If you use the built-in or an accessory flash, I recommend setting C.Fn-3 to Option 0: Auto so that the existing light factors into the exposure. Window light supplemented by silver or white reflectors is the most beautiful portrait lighting. Use a silver reflector on the opposite side of the window to fill shadows, and another reflector at the subject's waist level to fill shadows under the chin.

Lens
In the Field: Canon EF 24-105mm f/4L IS USM lens zoomed to 96mm.

Additional Considerations: Most photographers prefer a focal length of 85mm, 105mm and up to 200mm for portraits. Canon offers a variety of zoom lenses that offer a short telephoto focal length, such as the EF 24-105mm f/4L IS USM and the EF 70-200mm f/2.8L IS USM lenses. Another lens to consider for excellent contrast in portraits is the venerable Canon EF 50mm f/1.4 USM lens (equivalent to 80mm on the Rebel T1i/500D).

Camera Settings
In the Field: RAW capture, Av shooting mode, Shade white balance adjusted during RAW conversion, Evaluative metering, One-shot AF drive mode with manual AF-point selection.

Additional Considerations: For portraits, you want to control depth of field, and Aperture-priority AE (Av) shooting mode gives you that control. Always manually select the AF point that is over the subject's eye that is closest to the lens and focus on the eye. From my experience, tack-sharp focus isn't maintained if you lock focus and then move the camera to recompose the image. So select the AF point that is over the subject's eye, press the Shutter button halfway, and then don't move the camera to recompose the shot. Portrait Picture Style is an excellent choice. And for the best color, set a custom white balance.

Exposure **In the Field:** ISO 200, f/4, 1/1000 second with -0.67 Exposure Compensation.

Additional Considerations: To avoid digital noise in shadow areas, set the lowest ISO possible; I don't recommend using Auto ISO because it can set a very high ISO that can introduce unsightly digital noise. To ensure that features are reasonably sharp throughout the faces of a group of people, set the aperture to f/8 or f/11, and then move the group several feet from the background.

Accessories A tripod ensures sharp focus, but it limits your ability to move around the subject quickly to get different angles. If the light permits, shooting off the tripod frees you to try more creative angles and shooting positions.

Portrait photography tips

✦ **Use the Portrait Picture Style.** I find that Portrait provides the classic skin tone rendition with subdued contrast that makes lovely prints. You can also change the settings of the Portrait Picture Style if you want a bit more contrast or a different rendition of skin tones. See Chapter 3 for details on modifying Picture Styles.

✦ **Prepare a list of setups and poses ahead of time.** People often feel uncomfortable posing for the camera. Having a list of poses or setups enables you to move through the session with good speed.

✦ **Flatter older subjects.** For older adults, ask the subject to lift his or her head and move it forward slightly to reduce the appearance of lines and wrinkles.

✦ **Framing the subject.** As a general rule, keep the subject's head in the upper one-third of the frame.

✦ **Always be ready to take a shot.** When a good rapport is established between you and the subject, be ready to shoot spontaneously even if the setup isn't perfect. A natural, spontaneous expression from the subject is much more important than futzing to get a perfect setup.

✦ **Shoot and keep shooting.** It's possible and probable that something will be amiss with "the perfect" pictures that you think you've captured — even after you examine them on the LCD. So keep shooting.

Appendixes

P A R T

In This Part

Appendix A
Downloading Images
and Updating Firmware

Appendix B
Exploring RAW
Capture

Glossary

Downloading Images and Updating Firmware

You can download digital images from the Rebel T1i/500D using the USB cable that is supplied with your camera, or by using an accessory card reader. After you download the images to the computer, you can use the programs that Canon provides with the camera to view, sort, and edit the images.

One advantage of digital cameras is that manufacturers periodically offer updates to the internal instructions that improve aspects of the camera or resolve minor problems. These internal instructions are called firmware. Canon offers not only firmware updates for the Rebel T1i/500D, but it also offers updates to the software programs such as Digital Photo Professional that come with the camera.

In this appendix, you learn how to download images to your computer and how to update the Rebel firmware when updates are available.

Downloading with a USB Cable

Downloading images using the USB cable supplied with the camera is as simple as connecting the camera to the computer with the USB cable.

 For details on choosing JPEG or RAW capture options, see Chapter 2.

Before you begin downloading images, be sure that:

✦ The camera battery has a full charge

✦ You've installed the programs on the EOS Digital Solution Disk

If you want to transfer only some images to the computer, then you must first select them.

1. **Press the Menu button, and then turn the Main dial to select the Playback 1 (blue) menu.**

2. **Press the down cross key to highlight Transfer order, and then press the Set button.** The Transfer order screen appears.

3. **Press the Set button.** The last captured image appears on the LCD with controls at the top left of the preview image.

4. **To select the image for transfer to the computer, press the up or down cross key.** A checkmark appears in the box at the top left of the image.

5. **Press the left or right cross key to move to the next image, and then repeat Step 4 to select the image for transfer, or continue moving through the images on the card.**

Follow these steps to download pictures to your computer:

1. **Turn off the camera and turn the Mode dial to anything except Movie mode.**

2. **Insert the USB cable into the digital terminal located on the side of the camera under the rubber cover.** Make sure the symbol on the front of the cable is facing the front of the camera, and then insert the other end of the USB cable into an available USB slot on your computer.

3. **Turn the camera power switch On.** The EOS Utility window appears and the Direct transfer screen appears on the camera LCD with several options for transferring images to the computer. The All image option is selected.

4. **Select one of the image transfer options on the camera LCD by pressing the up or down cross key.** You can choose from the following options:

 • **All images.** The camera transfers all images on the media card to the computer.

 • **New images.** The camera automatically chooses and transfers images that haven't already been transferred to the computer.

- **Transfer order images.** To use this option, you must first select the images as described previously.

- **Select and transfer.** Press the Set button. The last captured image appears on the LCD. To select and transfer the image, press the Set button, or press the left or right cross key to select another image, and then press the Set button. Then press the Menu button to exit the screen.

- **Wallpaper.** Select if you want to use one of the images on the media card as the wallpaper for your computer screen. Then press the Menu button to exit the screen. Only JPEG images can be selected as Wallpaper.

5. **To transfer images, press the LiveView shooting/Movie shooting/Print/Share button on the back of the camera or click the Starts to download images option in the EOS Utility screen on your computer.** The Print/Share button, located to the right of the LCD panel, has a printer icon with a jagged arrow under it. The blue Print/Share light blinks as the images transfer to your computer. On the computer, transferred images are displayed in a Quick Preview window, and Digital Photo Professional opens to display all images. Images are stored in the My Pictures folder on a Windows PC or to the Pictures folder on a Mac.

6. **Turn off the camera, and then disconnect the cable from the camera and the computer.**

After the images are downloaded to the computer, you can choose the task that you want to do next from the panel or toolbar in the Digital Photo Professional window.

Downloading with a Card Reader

The easiest way to download images from the camera to the computer is by using a card reader. A card reader is a small device that plugs into the computer with its own USB cable. You can leave the card reader plugged into the computer indefinitely, making it a handy way to download images. Also, with a card reader, you don't have to use the camera battery while you download images. When you're ready to download images, you insert the media card into the card-reader slot. The card reader is displayed on the computer as a drive with an icon. Just double-click the card-reader icon to display the images folder on the SD/SDHC media card.

Card readers come in single and multiple card styles. Multiple-card-style readers accept SD, SDHC (Secure Digital High Capacity), and other media card types. Card readers are inexpensive and have a small footprint on the desktop. All in all, they are a bargain for the convenience that they offer.

Install the card reader according to manufacturer recommendations, and then follow these steps to download images:

 Note *The steps may vary slightly depending on your card reader and computer's preferences.*

1. **Remove the media card from the camera, and insert it into the card reader.** A window opens, displaying the media card folder.

2. **Double-click the folder to display the images, select all the images, and drag them to the folder where you want to store them on your computer.**

Updating the T1i/500D Firmware

One advantage of owning a digital camera such as the T1i/500D is that Canon often posts updates to the firmware (the internal instructions) for the camera to its Web site. New firmware releases can add improved functionality to existing features and, in some cases, fix reported problems with the camera.

New firmware along with ever-improving software keeps your camera and your ability to process images current as technology improves. To determine if you need to update firmware, compare the firmware version number installed on your T1i/500D to the latest release from Canon on its Web site.

To check the current firmware version installed on your camera, follow these steps. Press the Menu button, and then turn the Main dial to select the Setup 3 (yellow) menu. The Firmware Ver. menu item displays the currently installed version of the firmware. Note the firmware version number. If the firmware installed on your camera is older than the firmware offered on the Canon Web site, then your camera firmware needs updating.

 When you update the firmware, you can also choose to download the latest versions of Canon's Digital Photo Professional, Zoom-Browser EX, EOS Utility, and other programs that are provided on the EOS Digital Solution Disk as well as online versions of the printed manuals that come with the T1i/500D.

Before installing firmware updates, be sure that the camera battery has a full charge. If the camera loses power during the firmware update, the camera can become inoperable. Also have a freshly formatted media card available on which to copy the firmware update. Or you can connect the camera to your computer with a USB cable, and then copy the firmware file onto the media card in the camera.

To download firmware updates and install them on the Rebel T1i/500D, follow these steps:

1. **Insert the media card into a card reader attached to your computer, and then go to the Canon Web site at http://www.usa.canon. com/consumer/controller?act= ModelInfoAct&fcategoryid=139& modelid=18385#Download DetailAct.**

2. **Click Drivers & Downloads, and then click the down arrow next to Select OS and select your computer's operating system.**

3. **Scroll down the page to the Firmware section, and then click the firmware link displayed in red.** The Drivers & Downloads page appears with complete instructions for downloading and installing the firmware.

4. **Scroll down the page to the License Agreement, and then click I Agree – Begin Download.** A new window opens with details on the firmware updates and installation instructions. Follow the installation instructions provided on the Web site to download the firmware to your computer.

5. **On your computer, click and drag the firmware file to the SD/SDHC card displayed on your computer.** The card reader is displayed on the computer as a hard drive.

6. **Insert the SD/SDHC card into the camera, and then press the Menu button on the back of the camera.**

7. **Turn the Main dial to select the Setup 3 (yellow) menu, and then press the down cross key to highlight Firmware Ver.** The camera displays the current firmware version number with a message asking you to confirm that you want to update the firmware.

8. **Press the right cross key to highlight OK, and then press the Set button.** The Firmware update program screen appears on the LCD, and then the camera asks you to select the firmware version to update.

9. **Press the Set button, and then press the right cross key to select OK.** The updating process begins and a progress bar appears. Do not turn off the camera or press any buttons until the update is completed.

10. **Press the Set button to select OK.**

Exploring RAW Capture

You may have heard about RAW capture, but you may not understand what the advantages and disadvantages of RAW shooting are. This appendix provides an overview of RAW capture as well as a brief walk-through on converting RAW image data into a final image.

If you're new to RAW conversion, a high-level overview is helpful. With JPEG images, the camera automatically processes, or edits, the image data coming off the sensor, converts the data from 14- to 8-bit files, and then compresses the files in the JPEG format.

> **Note** *JPEG is a popular file format that allows images to be viewed on any computer and to be opened in any image-editing program.*

By contrast, RAW images have very little in-camera processing, and are stored as 14-bit files using Canon's proprietary file format, that has a .CR2 file extension. RAW files cannot be viewed on some computers or opened in some image-editing programs without a program that can display the CR2 proprietary file format. Canon includes a free program, Digital Photo Professional, on the EOS Digital Solution Disk that you can use to view and convert Rebel T1i/500D RAW files.

RAW capture provides significant advantages including the ability to get the best quality from the T1i/500D images. But RAW capture isn't for everyone. If you prefer images that are ready to print straight out of the camera, then JPEG capture is the best option. However, if you enjoy working with images on the computer and having creative control over the quality and appearance of the image, then RAW is the option to explore.

Learning about RAW Capture

RAW capture saves image data that comes off the sensor with virtually no internal camera processing or editing. As a result, you can determine how the image data is interpreted when you convert or process the RAW file. With a RAW file, the only settings that the camera applies are ISO, shutter speed, and aperture. Other camera settings have been noted but not applied in the camera, so you can adjust image brightness, white balance, contrast, and saturation when you convert the RAW image using a program such as Canon's Digital Photo Professional, or alternately, a third-party conversion program such as Adobe Camera Raw, Adobe Lightroom, or Apple Aperture.

RAW capture offers more latitude and stability in processing and editing RAW files than JPEG files offer. With JPEG images, large amounts of image data are discarded when the images are converted to 8-bit mode in the camera, and then the image data is further reduced when JPEG algorithms compress image files to reduce the size. As a result, the image leaves little, if any, wiggle room to correct tonal range, white balance, contrast, and saturation during image editing. Ultimately, this means that if the highlights in an image are overexposed or blown, then they're blown for good. If the shadows are blocked up (meaning they lack detail), then they will likely stay blocked up. It may be possible to make improvements in Photoshop, but the files are not as robust and rich as RAW files.

RAW files have rich, 14-bit data depth and provide far more image data to work with during conversion and subsequent image editing. In addition, RAW files are more forgiving if you need to recover overexposed highlight detail during conversion of the RAW file.

Table B.1 illustrates the general differences in file richness between a RAW image and a JPEG image. Note that the table data assumes a 5-stop dynamic range, the difference between the lightest and darkest values in an image, for an exposure.

 Note *In thinking about dynamic range, think about it this way. The brightest f-stop is a function of the brightest highlight in the scene that the sensor can capture, or the point at which the sensor element is saturated with photons. The darkest tone is determined by the point at which the noise in the system is greater than the comparatively weak signal generated by the photons hitting the sensor element.*

These differences in data richness translate directly to editing leeway. And maximum editing leeway is important because after the image is converted, all the edits you make in an editing program, such as Adobe Photoshop, are destructive.

Proper exposure is important with any image, and it is no less so with RAW images. With RAW images, proper exposure provides a file that captures rich tonal data that withstands conversion and editing well. For example, during RAW image conversion, image brightness levels must be mapped so that the levels look more like what we see with our eyes — a process called gamma encoding. In addition, you will also likely adjust the contrast and midtones and move the endpoints on the histogram. For an image to withstand these conversions and changes, a correctly exposed and data rich file is critical.

RAW exposure is also critical considering that digital capture devotes the lion's share of tonal levels to highlights while devoting far fewer levels to shadows, as shown in Table B.1. In fact, half of all the tonal levels in the image are assigned to the first f-stop of brightness. Half of the rest of the tonal levels account for the second f-stop, and half for the next f-stop, and so on.

Table B.1
Comparison of Brightness Levels

F-stop	Brightness Levels Available	
	12-bit RAW file	8-bit JPEG file
First f-stop (brightest tones)	2048	69
Second f-stop (bright tones)	1024	50
Third f-stop (midtones)	512	37
Fourth f-stop (dark tones)	256	27
Fifth f-stop (darkest tones)	128	20

Clearly, capturing the first f-stop of image data is critical because fully half of the image data is devoted to that f-stop. If an image is underexposed, not only is important image data sacrificed, but the file is also more likely to have digital noise in both shadow and midtone areas. Underexposure also means that during image conversion, the fewer captured levels must be stretched across the entire tonal range. Stretching tonal levels creates gaps between levels that reduce the appearance of continuous gradation between levels.

The general guideline when shooting RAW capture is to bias exposure to the right so that in many, but not in all, scenes, the highlight pixels just touch the right side of the histogram. Thus, when tonal mapping is applied during conversion, the file has significantly more bits that can be redistributed to the midtones and darker tones where the human eye is most sensitive to changes.

If you've always shot JPEG capture, a right-biased exposure approach may just seem wrong. When shooting JPEG images, the guideline is to expose so that the highlights are not blown out because if detail is not captured in the highlights, it's gone for good. This approach is excellent for JPEG images where the tonal levels are encoded and the image is pre-edited inside the camera. However, with RAW capture, gamma encoding as well as other contrast adjustments are made during conversion with a good bit of latitude. And if some highlights are overexposed, conversion programs such as Digital Photo Professional or Adobe Camera Raw can recover varying amounts of highlight detail.

However, if you decide to shoot RAW images, you also sign on for another step in the process from capturing images to getting finished images, and that step is RAW conversion. With RAW capture, the overall

workflow is to capture the images, convert the RAW data in a RAW conversion program, edit images in an image-editing program, and then print them. You may decide that you want to shoot in RAW+JPEG so that you have JPEGs that require no conversion, but you have the option to convert exceptional or problem images from the RAW files with more creative control and latitude.

Sample RAW Image Conversion

Although RAW image conversion adds a step to image processing, this important step is well worth the time. To illustrate the overall process, here is a high-level task flow for converting a T1i/500D RAW image using Canon's Digital Photo Professional. The program is noticeably different from traditional image-editing programs. It focuses on image conversion tasks, including correcting or tweaking white balance, brightness, shadow areas, contrast, saturation, sharpness, noise reduction, and so on. It doesn't include some familiar image-editing tools, nor does it offer the ability to work with layers.

Be sure to install Digital Photo Professional, provided on the EOS Digital Solution Disk, before following this task sequence.

1. **Start Digital Photo Professional, and then open a folder with RAW images in it.** If no images are displayed, you can select a directory and folder from the Folder panel. RAW images are displayed with a lens icon and the word RAW in the lower left of the thumbnail, and the files are prepended with IMG_ and the file extension is .CR2.

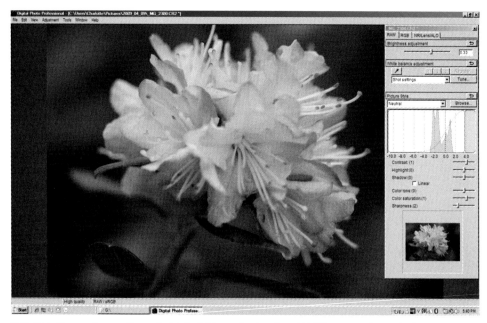

B.1 This figure shows Canon's Digital Photo Professional RAW conversion window.

2. **Double-click the image you want to process.** The RAW image opens with the tool palette next to an image and the RAW tab selected. In this mode, you can:

 - **Drag the Brightness adjustment slider to the left to darken the image or to the right to lighten it.** To quickly return to the original brightness setting, click the curved arrow above and to the right of the slider.

 - **Use the white balance adjustment controls to adjust color.** You can click the Eyedropper button, and then click an area that is white in the image to quickly set white balance, choose one of the preset white balance settings from the Shot Setting drop-down menu, or click the Tune button to adjust the white balance using a color wheel. Once you have the color corrected, you can click Register to save the setting, and then use it to correct other images.

 - **Change the Picture Style by clicking the down arrow next to the currently listed Picture Style and selecting a different Picture Style from the list.** The Picture Styles offered in Digital Photo Professional are the same as those offered on the menu on the T1i/500D. When you change the Picture Style in Digital Photo Professional, the image preview updates to show the change. Then you can adjust the curve, contrast, highlight, color tone, color saturation, and sharpness. Dragging the Color tone slider to the right increases the green tone and dragging it to the left increases the

 magenta tone. Dragging the Color saturation to the right increases the saturation and vice versa. Dragging the Sharpness slider to the right increases the sharpness and vice versa.

 - **Adjust the black and white points on the image histogram by dragging the bars at the far left and right of the histogram toward the center.**

3. **Click the RGB image adjustment tab.** Here you can apply an RGB curve and apply separate curves in each of the three color channels: Red, Green, and Blue. You can also do the following:

 - **Click one of the tonal curve options to the right of Tone curve assist to set a classic "S" curve that lightens the midtones in the image without changing the black and white points.** If you want to increase the curve, click the Tone Curve Assist button marked with a plus (+) sign one or more times to increase the curve. Alternately, you can click the linear line on the histogram, and then drag the line to set a custom tonal adjustment curve. If you want to undo the curve changes, click the curved arrow to the right of Tone curve adjustment or the curved arrow to the right of Tone curve assist.

 - **Click the R, G, or B button next to RGB to make changes to a single color channel.** Working with an individual color channel is helpful when you need to reduce an overall color cast in an image.

• **Drag the Brightness slider to the left to darken the image or to the right to brighten the image.** The changes you make are shown on the RGB histogram as you make them.

• **Drag the Contrast slider to the left to decrease contrast or to the right to increase contrast.**

• **Drag the Hue, Saturation, and Sharpness sliders to make the appropriate adjustments.**

4. **In the image preview window, choose File/Convert and Save.** The Convert and Save dialog box appears. In the dialog box, you can select the file format and bit depth at which you want to save the

image. Just click the down arrow next to Kind of File and choose one of the options such as TIFF 16-bit. Then you can set the Image quality setting if you are saving in JPEG or TIFF plus JPEG format, set the Output resolution, or resize the image. In addition, you can set the Output setting and resize the image.

Note *The Edit menu also enables you to save the current image's conversion settings as a recipe. Then you can apply the recipe to other images in the folder.*

5. **Click Save.** Digital Photo Professional saves the image in the location and format that you choose.

Glossary

720p/1080i/1080p High-definition video recording standards that refer to the vertical resolution, or the number of horizontal lines on the screen — either 720 or 1080 lines. Seven-hundred-twenty vertical lines translate to a width of 1280 pixels, and 1080 translates to 1920 pixels of horizontal resolution. The "p" stands for progressive scan, which displays the video frame all at once, and the "i" stands for interlaced, an analog compression scheme that allows 60 frames per second (fps) to be transmitted in the same bandwidth as 30 fps by displaying 50 percent of the video frame at a time.

A-DEP (Automatic depth of field) The camera mode that automatically calculates sufficient depth of field for near and far subjects within the coverage of the seven AF focusing points, such as when several people are sitting at various distances from the camera.

AE Automatic exposure.

AE Lock (Automatic Exposure Lock) A camera control that lets the photographer lock the exposure from a meter reading. After the exposure is locked, the photographer can then recompose the image.

angle of view The amount or area seen by a lens or viewfinder, measured in degrees. Shorter or wide-angle lenses and zoom settings have a greater angle of view. Longer or telephoto lenses and zoom settings have a narrower angle of view.

aperture The lens opening through which light passes. Aperture size is adjusted by opening or closing the diaphragm. Aperture is expressed in f-numbers such as f/8, f/5.6, and so on. See also *f-number*.

aperture priority (Av Aperture-priority AE) A semiautomatic camera mode in which the photographer sets the aperture (f-stop), and the camera automatically sets the shutter speed for correct exposure.

autofocus A function where the camera focuses on the subject when you press the Shutter button. In Basic Zone modes the camera automatically focuses on the subject using the autofocus point or points shown in the viewfinder, or tracks a subject in motion and creates a picture with the subject in sharp focus. In Creative Zone modes, you can manually select the AF point.

Av (aperture value) Indicates the aperture (f-stop). Also refers to Aperture-priority shooting mode on the Mode dial.

AWB (Automatic White Balance) A white balance setting where the camera determines the color temperature of the light source automatically.

barrel distortion A lens aberration resulting in a bowing of straight lines outward from the center.

bit depth The number of bits (the smallest unit of information used by computers) used to represent each pixel in an image that determines the image's color and tonal range.

blocked up Describes shadow areas of an image lacking detail due to excess contrast.

bracket To make multiple exposures, some above and some below the ideal exposure, calculated by the camera for the scene. Some digital cameras can also bracket white balance to produce variations from the average white balance calculated by the camera.

brightness The perception of the light reflected or emitted by a source. The lightness of an object or image. See also *luminance*.

buffer Temporary storage for data in a camera or computer.

bulb A shutter speed setting that keeps the shutter open as long as the Shutter button is fully depressed.

color balance The color reproduction fidelity of a digital camera's image sensor and of the lens. In a digital camera, color balance is achieved by setting the white balance to match the scene's primary light source. You can adjust color balance in image-editing programs using the color Temperature and Tint controls.

color/light temperature A numerical description of the color of light measured on the Kelvin scale. Warm, late-day light has a lower color temperature. Cool, early-day light has a higher temperature. Midday light is often considered to be white light (5000K).

color space In the spectrum of colors, a subset of colors included in the chosen space. Different color spaces include more or fewer colors.

compression A means of reducing file size. Lossy compression permanently discards information from the original file. Lossless compression does not discard information from the original file and allows you to re-create an exact copy of the original file without any data loss. See also *lossless* and *lossy*.

contrast The range of tones from light to dark in an image or scene.

depth of field The zone of acceptable sharpness in a photo extending in front of and behind the primary plane of focus.

diaphragm Adjustable blades inside the lens that open to a larger or smaller size based on the aperture that is chosen.

dynamic range The difference between the lightest and darkest values in an image as measured in f-stops.

exposure The amount of light reaching the light-sensitive medium — the film or an image sensor. It is the result of the intensity of light multiplied by the length of time the light strikes the medium.

exposure compensation A camera control that enables the photographer to overexpose (plus setting) or underexpose (minus setting) images by a specified amount from the metered exposure.

exposure meter A built-in light meter that measures the amount of light on the subject. EOS cameras use reflective meters. The exposure is shown in the viewfinder and on the LCD panel as a scale with a tick mark under the scale that indicates ideal exposure, overexposure, and underexposure.

extender An attachment that fits between the camera body and the lens to increase the focal length of the lens.

extension tube A hollow ring attached between the camera lens mount and the lens that increases the distance between the optical center of the lens and the sensor, and decreases the minimum focusing distance.

filter A piece of glass or plastic that is usually attached to the front of the lens to alter the color, intensity, or quality of the light. Filters also are used to alter the rendition of tones, reduce haze and glare, and create special effects such as soft focus and star effects.

flare Unwanted light reflecting and scattering inside the lens causing a loss of contrast and sharpness and/or artifacts in the image.

f-number A number representing the maximum light-gathering ability of a lens or the aperture setting at which a photo is taken. It is calculated by dividing the focal length of the lens by its diameter. Wide apertures are designated with small numbers, such as f/2.8. Narrow apertures are designated with large numbers, such as f/22. See also *aperture*.

focal length The distance from the optical center of the lens to the focal plane when the lens is focused on infinity. The longer the focal length is, the greater the magnification.

focal point The point on a focused image where rays of light intersect after reflecting from a single point on a subject.

focus The point at which light rays from the lens converge to form a sharp image. Also the sharpest point in an image achieved by adjusting the distance between the lens and image.

fps (frames per second) In still shooting it refers to the number of frames either in One-shot or Continuous shooting. In video film recording, the standard is 24 fps, but the digital standard is 30 fps.

f-stop See *f-number* and *aperture*.

grain See *noise*.

gray card A card that reflects a known percentage of the light that falls on it. Typical grayscale cards reflect 18 percent of the light. Gray cards are standard for taking accurate exposure-meter readings and for providing a consistent target for color balancing during the color-correction process using an image-editing program.

HDV and AVCHD High Definition Video and Advance Video Codec High Definition refer to video compression and decompression standards.

highlight A light or bright area in a scene, or the lightest area in a scene.

histogram A graph that shows the distribution of tones or colors in an image.

hot shoe A camera mount that accommodates a separate external flash unit. Inside the mount are contacts that transmit information between the camera and the flash unit and that trigger the flash when the Shutter button is pressed.

hue The color of a pixel defined by the measure of degrees on the color wheel, starting at 0 for red depending on the color system and controls.

image stabilization A technology that counteracts unintentional camera movement when the photographer handholds the camera at slow shutter speeds or uses long lenses.

infinity The farthest position on the distance scale of a lens (approximately 50 feet and beyond).

ISO (International Organization for Standardization) A rating that describes the sensitivity to light of film or an image sensor. ISO in digital cameras refers to the amplification of the signal at the photosites. Also commonly referred to as film speed. ISO is expressed in numbers such as ISO 125. The ISO rating doubles as the sensitivity to light doubles. ISO 200 is twice as sensitive to light as ISO 100.

JPEG (Joint Photographic Experts Group) A lossy file format that compresses data by discarding information from the original file to reduce file size.

Kelvin A scale for measuring temperature based around absolute zero. The scale is used in photography to quantify the color temperature of light.

lightness A measure of the amount of light reflected or emitted. See also *brightness* and *luminance*.

linear A relationship where doubling the intensity of light produces double the response, as in digital images. The human eye does not respond to light in a linear fashion. See also *nonlinear*.

lossless A term that refers to image file compression that discards no image data. TIFF is a lossless file format.

lossy A term that refers to compression algorithms that discard image data in the process of compressing image data to a smaller size. The higher the compression rate, the more data that's discarded and the lower the image quality. JPEG is a lossy file format.

luminance The light reflected or produced by an area of the subject in a specific direction and measurable by a reflected light meter.

Manual mode A camera mode in which you set both the aperture and the shutter speed (as well as the ISO). Commonly used in low-light and night scenes and when you want to vary the exposure over or under the camera's ideal exposure.

megapixel A measure of the capacity of a digital image sensor. One million pixels.

metadata Data about data, or more specifically, information about a file. Data embedded in image files by the camera includes aperture, shutter speed, ISO, focal length, date of capture, and other technical information. Photographers can add additional metadata in image-editing programs, including name, address, copyright, and so on.

midtone An area of medium brightness; a medium gray tone in a photographic print. A midtone is neither a dark shadow nor a bright highlight.

neutral density/grad ND filter A filter attached to the lens where half of the filter is darker than the other half to reduce the brightness difference between the sky and ground.

noise Extraneous visible artifacts that degrade digital image quality. In digital images, noise appears as multicolored flecks and as grain that is similar to grain seen in film. Both types of noise are most visible in high-speed digital images captured at high ISO settings.

nonlinear A relationship where a change in stimulus does not always produce a corresponding change in response. For example, if the light in a room is doubled, the room is not perceived as being twice as bright. See also *linear*.

open up The switch to a wider f-stop, which increases the size of the lens diaphragm opening.

panning A technique of moving the camera horizontally to follow a moving subject, which keeps the subject sharp but blurs background details.

photosite The place on the image sensor that captures and stores the brightness value for one pixel in the image.

pincushion distortion A lens aberration causing straight lines to bow inward toward the center of the image.

pixel The smallest unit of information in a digital image. Pixels contain tone and color that can be modified. The human eye merges very small pixels so they appear as continuous tones.

plane of critical focus The most sharply focused part of a scene. Also referred to as the point of sharpest focus.

polarizing filter A filter that reduces glare from reflective surfaces such as glass or water at certain angles.

ppi (pixels per inch) The number of pixels per linear inch on a monitor or image file. Used to describe overall display quality or resolution.

RAW A proprietary file format that has little or no in-camera processing. Processing RAW files requires special image-conversion software such as Canon Digital Photo Professional or Adobe Camera Raw. Because image data has not been processed, you can change key camera settings, including exposure and white balance, in the conversion program after the picture is taken.

reflected light meter A built-in device that measures light emitted by a photographic subject back to the camera.

reflector A surface, such as white cardboard, used to redirect light into shadow areas of a scene or subject.

resolution The number of pixels in a linear inch. Resolution is the amount of data in a digital image that represents detail. Also, the resolution of a lens that indicates the capacity of reproduction of a subject point of the lens. Lens resolution is expressed as a numerical value such as 50 or 100 lines, which indicates the number of lines per millimeter of the smallest black and white line pattern that can be clearly recorded.

RGB (Red, Green, Blue) A color model based on additive primary colors of red, green, and blue. This model is used to represent colors based on how much light of each color is required to produce a given color.

saturation As it pertains to color, a strong, pure hue undiluted by the presence of white, black, or other colors. The higher the color purity is, the more vibrant the color.

shutter A mechanism that regulates the amount of time during which light is let into the camera to make an exposure. Shutter time or shutter speed is expressed in seconds and fractions of seconds such as 1/30 second.

shutter priority (Tv Shutter-priority AE) A semiautomatic camera mode allowing the photographer to set the shutter speed and the camera to automatically set the aperture (f-number) for correct exposure.

slave A flash unit that is synchronized to and controlled by another flash unit.

sRGB A relatively small color space or gamut that encompasses a typical computer monitor.

stop See *aperture*.

stop down To switch to a narrower f-stop, thereby reducing the size of the diaphragm opening.

telephoto A lens or zoom setting with a focal length longer than 50 to 60mm in 35mm format.

TIFF (Tagged Image File Format) A universal file format that most operating systems and image-editing applications can read. Commonly used for images, TIFF supports 16.8 million colors and offers lossless compression to preserve all the original file information.

tonal range The range from the lightest to the darkest tones in an image.

TTL (Through-the-Lens) A system that reads the light passing through a lens that will expose film or strike an image sensor.

UD (Ultralow Dispersion) A lens made of special optical glass with optical processing characteristics similar to fluorite. UD lenses are effective in correcting chromatic aberrations in super-telephoto lenses.

white balance The relative intensity of red, green, and blue in a light source. On a digital camera, white balance compensates for light that is different from daylight to create correct color balance.

wide angle Describes a lens or zoom setting with a focal length shorter than 50 to 60mm in full-frame 35mm format.

Index

Guides to go.

Colorful, portable *Digital Field Guides* are packed with essential tips and techniques about your camera equipment, iPod, or notebook. They go where you go; more than books—they're *gear*. Each $19.99.

978-0-470-16853-0

978-0-470-38087-1

978-0-470-17148-6

978-0-470-38627-9

978-0-470-17461-6

978-0-470-04527-5

Also available
Nikon D300 Digital Field Guide • 978-0-470-26092-0
Canon EOS 40D Digital Field Guide • 978-0-470-26044-9
Canon EOS Digital Rebel XTi/400D Digital Field Guide • 978-0-470-11007-2
Nikon D80 Digital Field Guide • 978-0-470-12051-4
Sony Alpha DSLR-A700 Digital Field Guide • 978-0-470-27031-8.

Available wherever books are sold.

WILEY

Now you know.